CODE
THE
CLASSICS
VOLUME I

Devised by **Russell Barnes**

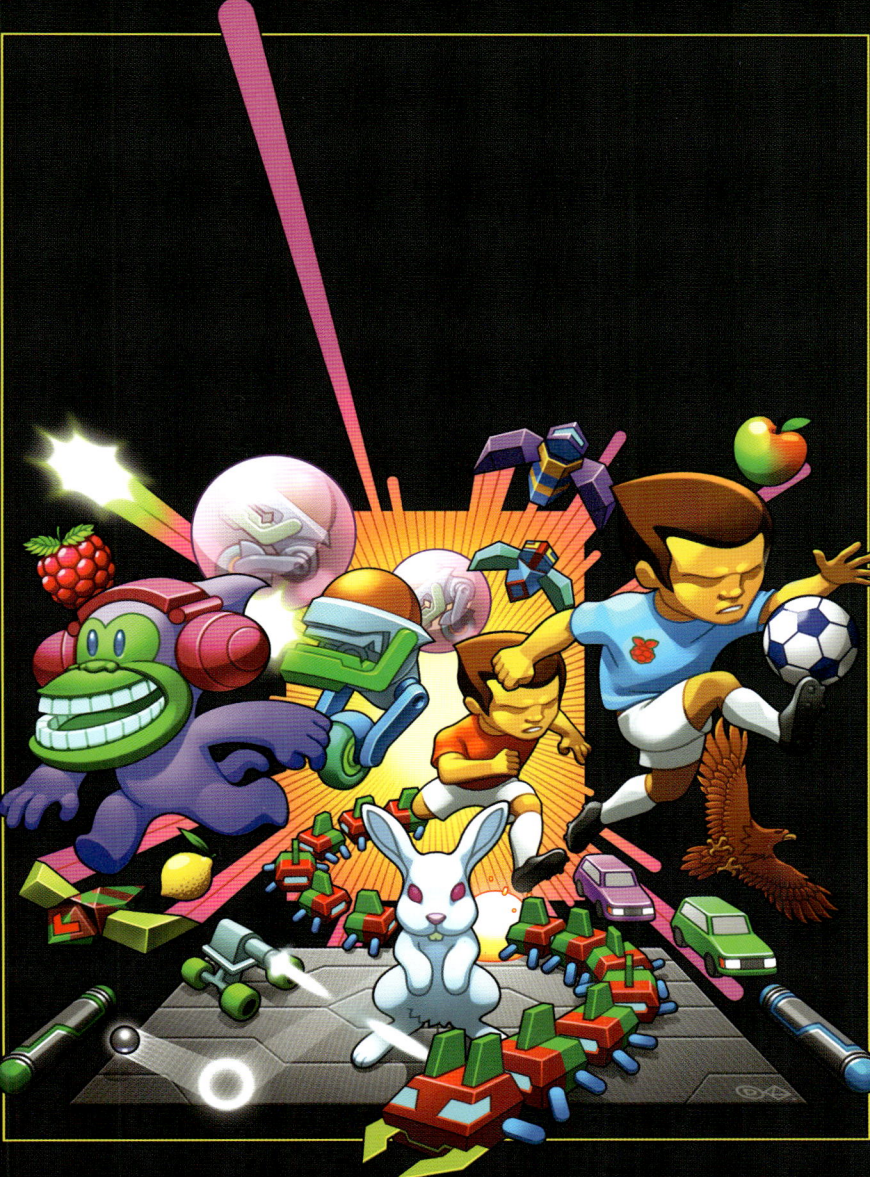

Published by Raspberry Pi Ltd,
194 Cambridge Science Park,
Milton Road, Cambridge
CB4 0AB.

Code the Classics Volume I
Copyright © 2024 Raspberry Pi Ltd.
Printed in Lithuania

Devised by
Russell Barnes

Sub Editor
Nicola King

Illustrations
Dan Malone

Publishing Director
Brian Jepson

Editor
Phil King

Design
Critical Media

Head of Design
Lee Allen

CEO
Eben Upton

ISBN 978-1-916868-19-9

June 2024: Second Edition
December 2019: First Edition

The publisher, and contributors accept no responsibility in respect of any omissions or errors relating to goods, products or services referred to or advertised in this book. Except where otherwise noted, the content of this book is licensed under a Creative Commons Attribution-NonCommercial-ShareAlike 3.0 Unported (CC BY-NC-SA 3.0)

CODE THE CLASSICS
VOLUME I

David Crookes began his career as a journalist in 1994 as a freelance writer for Amstrad Action. He has since written and worked for regional newspapers, The Independent, BBC Radio 5 Live, gamesTM, Wireframe, and Retro Gamer, among many others. His previous books include *Cloud Computing In Easy Steps* and *Facebook for Beginners In Easy Steps*. He also curated Videogame Nation, an exhibition celebrating the rise of gaming, which toured the UK.

Andrew Gillett grew up with early computers such as the ZX Spectrum, and was writing simple programs from the age of five. Since then, he's worked on games that have sold millions, including *Rollercoaster Tycoon 3*, *Kinectimals*, and *Kinect Disneyland Adventures*. After working in the games industry for 13 years, he is now a computer science/programming tutor and indie developer.

Liz Upton was an award-winning journalist before becoming one of the co-founders of Raspberry Pi along with her husband Eben. She now works as Executive Director of Communications at Raspberry Pi. Liz plays the piano, collects and restores old fountain pens, and has an uncanny knack of getting toddlers to consume vegetables.

Contributors

GAMES

Eben Upton co-founded the Raspberry Pi Foundation, and serves as the CEO of Raspberry Pi Ltd, its commercial and engineering subsidiary. He is the co-author, with Gareth Halfacree, of the *Raspberry Pi User Guide*; with Jeff Duntemann and others, of *Learning Computer Architecture with Raspberry Pi*; and with his father, Professor Clive Upton, of the *Oxford Rhyming Dictionary*.

Sean M. Tracey calls himself a technologist, which is his way of saying he hasn't decided what he wants to do with technology yet – other than everything. Sean has spent his career trying to avoid getting 'proper' jobs, and as such has had a hand in making a variety of fun and interesting projects, and every now and then he writes a book about those things too.

Dan Malone has been involved in the UK games industry for over 30 years and has been writing stories, games, designing characters, and drawing comics for most of his life. His work includes design and graphics on games from *Speedball 2* and *The Chaos Engine* (Amiga/Atari ST) to character model design on *SSX Blur* (Nintendo Wii).

Allister Brimble is a music and sound designer and has created the audio for over 400 video games since the early 1990s. During his time in the industry, Allister has worked on almost every format, from the early 8- and 16-bit home computers to hand-held devices and beyond, into today's current consoles, phones, and tablets.

CODE
THE
CLASSICS

Table of Contents

Foreword xi
By David Perry

Chapter 1 2
Tennis
Much can be learned from recreating the simple bat-and-ball action of Pong

Chapter 2 30
Action Platformer
Code your single-screen platform game in the mould of the classic Bubble Bobble

Chapter 3 64
Top-down Platformer
Take a different perspective and create a vertically scrolling tribute to Frogger

Chapter 4 98
Fixed Shooter
Have a blast recreating the arcade action of classic single-screen shooter, Centipede

Chapter 5 132
Football Game
Your goal is to code a top-down-view game of football, in the style of Sensible Soccer

Setting Up 170
Everything you need to know to run and edit the games featured in this book

An Introduction to 178
Python
Key features of the popular programming language that you'll need to understand

An Introduction to 186
Pygame Zero
This user-friendly Python library makes it easier to display graphics and play sounds

Git and Version 190
Control
Learn how to use the Git version control system to synchronise changes to your game code

Interview 198
Dan Malone
Talking graphics with the veteran artist behind the visuals for some classic video games

Interview 212
Allister Brimble
Some sound advice from the musician who's supplied audio for numerous games

CODE THE CLASSICS

Foreword

by David Perry

When I was starting out in gaming, I bought magazines and books that contained video game programs and I had to type in the code if I wanted to experience them.

David Perry is one of the gaming industry's most successful developers. He started his career reading books like these and even wrote some of them himself. Since then he has produced many popular games such as Aladdin and Earthworm Jim.

Some were short and sweet; some were flight simulators and would take days to type in. But they served two purposes: they helped me to get better at typing and they allowed me to study the code and learn from the masters. I'd see their tricks and I'd see how their games functioned from the inside out.

Soon I was writing my own magazine articles and books, and later ended up making full games. Thankfully, the publishers wanted to put them on game retail shelves.

I've now been in the industry professionally for well over 30 years. I have had number-one hits and sold more than $1 billion of video games.

I get asked 'What's the secret to making your game design a hit?', but I only explain the 'simple' version of the answer: all addictive games need to incorporate skill, risk, and strategy at every moment. If you're missing one of these, it's going to get boring fast! *Tetris*? Yep. *Call of Duty*? Yep. *Angry Birds*? Yep.

But, just for you… I'm going to give the full answer to the question. So here we have the real secret to making your game design a hit.

There has to be blame. The player must blame themselves for any loss. If they blame the game balance or things outside their control, you lose.

There has to be a retry rate. The player must be able to try again – in seconds – if they fail. *Tetris* would have failed if we had to watch a CG movie before we could try again.

CODE THE CLASSICS

There has to be progress. Players must see progress after everything they do. We used to have scores, and that's also why *World of Warcraft* levels up constantly.

And there has to be feedback. If you do something impressive or amazing, the game should respond accordingly. Like *Bejeweled* would get crazy if long chains fall into place. Or when pinball machines would enter super multi-ball mode with all lights flashing. Think of the game as having its own emotional state.

Now here's the X-factor. These are multipliers to make your game even more addictive:

Revenge. Let gamers fight back someone or something that's been really frustrating them. 'Payback time!' Yes you can even remind them: 'This guy over here, killed you last time!'

Social / multiplayer / viewers. Other people, even if they are only spectating, definitely add to the experience. So, embrace other players and community as much as possible.

Time accelerators. Surprise the gamer by letting them make progress faster than they expected. This is why you see 'experience boosts' in massively multiplayer games: they are incredibly popular as they save time.

My final tip?

Humour. It's the most rare and valuable thing in the video game industry. People never forget the games they laugh at. Even a slight bit of humour helps: for example, there were lots of boring catapult games before *Angry Birds* became a big hit.

If you follow these ideas, you'll have a fantastic head-start on other people that want to make games.

I can't wait to see what you make!

> **People never forget the games they laugh at. Even a slight bit of humour helps**

CODE THE CLASSICS

Foreword

CODE
THE
CLASSICS

Chapter 1

Tennis

In the earliest days of gaming, all it took was a couple of lines and a dot, and gamers would be queuing up to play

This simple game takes ping-pong as its inspiration and boils it down to the bare minimum. In the early 1970s, developers were forced to work with the most basic of technology, but even primitive graphics and sound couldn't detract from *Pong*'s addictive gameplay. In many ways, games like *Pong* are the ultimate in pick-up-and-play. The basic principle is easy to grasp for a player and it captures the essence of the sport perfectly. To play, gamers control one of two paddles on either side of the screen to knock a ball back and forth until one of them misses. This requires concentration and skill while opening up the possibilities for two-player gameplay. *Pong*, which kick-started this kind of competitive gaming, was very successful for developer and publisher Atari, which shipped thousands of arcade cabinets across the world.

Inspiration

Pong was created by Allan Alcorn as a training exercise assigned to him by Nolan Bushnell, the co-founder of Atari. Video gaming was in its infancy and various people were playing around with ideas, experimenting with simple gameplay mechanics that would cause the first wave of gamers to become hooked. Since the games were being played on large arcade cabinets that required players to pump in coins to continue, the rules had to be simple enough to understand at a glance and addictive enough to encourage further plays. Nolan's Atari was hugely successful and he eventually sold the company to Warner Communications for $28 million.

Pong

Released 1972

Platforms Arcade

Dedicated consoles

Atari 2600

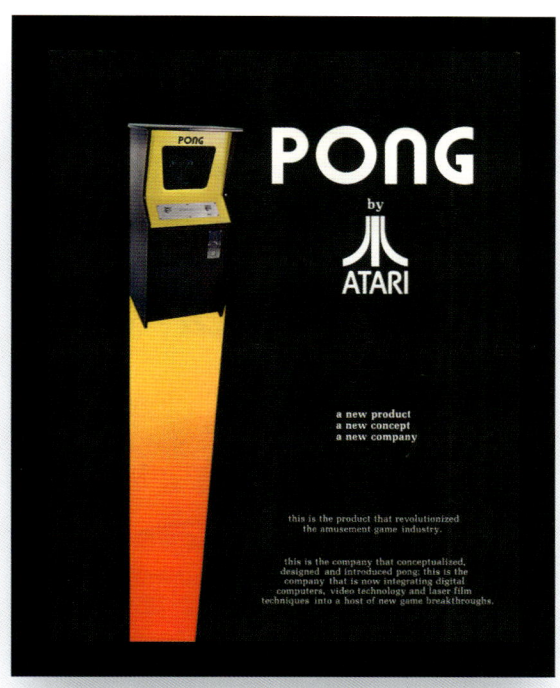

CODE THE CLASSICS

The success of Pong *led to the creation of* Pong *home consoles (and numerous unofficial clones) that could be connected to a television. Versions have also appeared on many home computers.*

Other Notables Sanrio World Smash Ball! / Gnop! / Windjammers

Ask anyone to describe a game of table tennis and they'll invariably tell you the same thing: the sport involves a table split into quarters, a net dividing the two halves, a couple of paddles, and a nice round ping-pong ball to bat back and forth between two players. Take a look at the 1972 video game *Pong*, however, and you'll notice some differences. The table, for instance, is simply split in half and it's viewed side-on, the paddles look like simple lines, and the ball is square. Yet no one – not even now – would have much trouble equating the two.

Back in the early 1970s, this was literally as good as it got. The smattering of low-powered arcade machines of the time were incapable of realistic-looking graphics, so developers had to be creative, hoping imaginative gamers would fill the gaps and buy into whatever they were trying to achieve. It helped enormously that there was a huge appetite for the new, emerging video game industry at that time. Nolan Bushnell was certainly hungry for more – and had he turned his nose up at *Spacewar!*, a space combat game created by Steve Russell in 1962, then *Pong* would never even have come about.

"The most important game I played was *Spacewar!* on a PDP-1 when I was in college," he says, of the two-player space shooter that was popular among computer scientists and required a $120,000 machine to run. Although the visuals were nothing to write home about, the game was one of the first graphical video games ever made. It pitted two spaceships against each other and its popularity spread, in part, because the makers decided the code could be distributed freely to anyone who wanted it. "It was a great game, fun, challenging, but only playable on a very expensive computer late at night and the wee hours of the morning," Nolan says. "In my opinion, it was a very important step."

The arcade machines of the time were incapable of realistic-looking graphics

Nolan was so taken by *Spacewar!* that he made a version of the game with a colleague, Ted Dabney. Released in 1971, *Computer Space* allowed gamers to control a rocket in a battle against flying saucers, with the aim being to get more hits than the enemy in a set period of time. To make it attractive to players, it was placed in a series of colourful, space-age, moulded arcade cabinets. Nolan and Ted sold 1500 of them; even though they made just $500 from the venture, it was enough to spur them into continuing. They came up with the idea for *Pong* and created a company called Atari.

One of their best moves was employing engineer Al Alcorn, who had worked with Nolan at the American

1 An original 1972 flyer to promote the launch of the *Pong* arcade game

THE NEWEST 2 PLAYER VIDEO SKILL GAME

PONG

from **ATARI CORPORATION**
SYZYGY ENGINEERED

The Team That Pioneered Video Technology

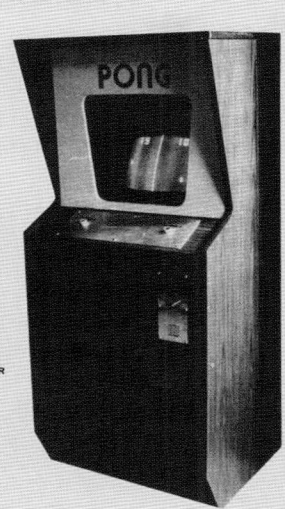

FEATURES
- STRIKING Attract Mode
- Ball Serves Automatically
- Realistic Sounds of Ball Bouncing, Striking Paddle
- Simple to Operate Controls
- ALL SOLID STATE TV and Components for Long, Rugged Life
- ONE YEAR COMPUTER WARRANTY
- Proven HIGH PROFITS in Location After Location
- Low Key Cabinet, Suitable for Sophisticated Locations
- 25¢ per play

THIS GAME IS AVAILABLE FROM YOUR LOCAL DISTRIBUTOR

Manufactured by
ATARI, INC.
2962 SCOTT BLVD.
SANTA CLARA, CA.
95050

Maximum Dimensions:
WIDTH - 26"
HEIGHT - 50"
DEPTH - 24"
SHIPPING WEIGHT:
150 Lb.

electronics company Ampex. Al was asked to create a table tennis game based on a similar title that had been released on the Magnavox Odyssey console, on the pretence that the game would be released by General Electric. In truth, Nolan simply wanted to work out Al's potential, but he was blown away by what his employee came up with. Addictive and instantly recognisable, Atari realised *Pong* could be a major hit. The game's familiarity with players meant it could be picked up and played by just about anyone.

Even so, Nolan had a hard time convincing others. Manufacturers turned the company down, so he visited the manager of a bar called Andy Capp's in Sunnyvale, California and asked them to take *Pong* for a week. The manager soon had to call Nolan to tell him the machine had broken: it had become stuffed full of quarters from gamers who loved the game. By 1973, production of the cabinet was in overdrive and 8000 were sold. It led to the creation of a *Pong* home console which sold more than 150,000 machines. People queued to get their hands on one and Atari was on its way to become a legendary games company.

For Nolan, it was justification for his perseverance and belief. Suddenly, the man who had become interested in electronics at school, where he would spend time creating devices and connecting bulbs and batteries, was being talked of as a key player in the fledgling video game industry. But what did Nolan, Ted, Al, and the rest of the Atari team do to make the game so special? "We made it a good, solid, fun game to play," says Nolan. "And we made it simple, easy, and quickly understood. Keeping things simple is more difficult to do than building something complex. You can't dress up bad gameplay with good graphics."

Making Pong

On the face of it, *Pong* didn't look like much. Each side had a paddle that could be moved directly up and down using the controller, and the ball would be hit from one side to the other. The score was kept at the top of the screen and the idea was to force the opposing player to miss. It meant the game program needed to determine how the ball was hit and where the ball would go from that point. And that's the crux of *Pong*'s success: the game encouraged people to keep playing and learning in the hope of attaining the skills to become a master.

When creating *Pong*, then, the designers had a few things in mind. One of the most important parts of the game was the movement of the paddles. This involved a simple, vertical rectangle that went up and down. One of the benefits Atari had when it created *Pong* was that it controlled not just the software but the hardware too. By

The objectives

Short term: Make sure you get the ball motion working perfectly so that the movement is fluid and it looks like it would in real life when hitting the paddles.

Medium term: Work on the paddle angles. By ensuring the ball reacts in a realistic manner when it hits various parts of a moving paddle, skill is introduced.

Long term: Nolan says you need to have a proper escalation of difficulty. Think about ways in which you can keep the best players wanting more.

building the cabinet, it was able to determine how those paddles should be moved. "The most important thing if you want to get the gameplay right is to use a knob to move the paddle," advises Nolan. "No one has done a good *Pong* using touchscreens or a joystick."

Look at a *Pong* cabinet close up – there are plenty of YouTube videos which show the game in action on the original machine – and you will see what Nolan means. You'll notice that players turned a knob anticlockwise to move the paddle down, and clockwise to move it up. Far from being confusing, it felt intuitive.

Movement of the ball

With the paddles moving, Atari's developers were able to look at the movement of the ball. At its most basic, if the ball continued to make contact with the paddles, it would constantly move back and forth. If it did not make contact, then it would continue moving in the direction it had embarked upon and leave the screen. At this stage, a new ball was introduced in the centre of the screen and the advantage was given to the player who had just chalked up a point. If you watch footage of the original *Pong*, you will see that the new ball was aimed at the player who had just let the ball go past. There was a chance he or she would miss again.

To avoid defeat, players had to be quite nifty on the controls and stay alert. Watching the ball go back and forth at great speed could be quite mesmerising as it left a blurred trail across the cathode ray tube display. There was no need to waste computing power by animating the ball because the main attention was focused on what would happen when it collided with the paddle. It had to behave as you'd expect. "The game did not exist without collisions of the ball to the paddle," says Nolan.

Al realised that the ball needed to behave differently depending on where it hit the paddle. When playing a real game of tennis, if the ball hits the centre of the racket, it will behave differently from a ball that hits the edge. Certainly, the ball is not going to be travelling in a simple, straight path back and forth as you hit it; it is always likely to go off at an angle. This, though, is the trickiest part of making *Pong*.

> **One of the most important parts of the game was the movement of the paddles**

Learn from the master

Nolan Bushnell tells us what made *Pong* great.

Simplicity is key: Nolan says *Pong*-like games must be simple to learn. Players should be able to pick up the fundamentals with hardly any instruction.

Introduce complexity: The game should be designed so that it is difficult to master. This way, players will want to try to beat the game and have an incentive to do so.

Bushnell's Law: Both of these mechanics are encapsulated in what has come to be known as Bushnell's Law. It says games "should reward the first quarter and the hundredth".

ATARI SYZYGY
CORP
and
HUNTER ELECTRONICS PTY. LTD.
PRESENT

BARREL-PONG

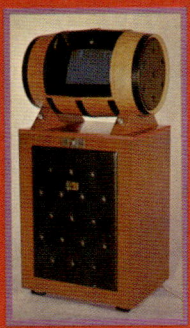

"The ball should bounce up from an upper collision with more obtuse angles as the edge of the paddle is approached," Nolan says. "This balances the risk of missing with the fact that an obtuse angle is harder to return." This is what *Pong* is all about: making sure you hit the ball with the paddle, but in a manner that makes it difficult for the opposing player to return it. "A player wants the ball to be just out of reach for the opponent or be hard for him or her to predict."

2 Various novelty *Pong* cabinets were released, including *Barrel-Pong* (pictured) and *Snoopy Pong*

3 The original version of the *Pong* arcade cabinet

The ball should bounce with more obtuse angles as the edge of the paddle is approached

Producing boundaries

For this to work effectively, there had to be another element in the game: a boundary at the top and bottom of the screen. As the player hit the ball with the paddle, it could fly upwards. If there were nothing to stop it, then it would continue moving off the screen. *Pong* had an invisible top and bottom perimeter which would interact with the ball. Send the ball flying upwards and it would hit this boundary and come back into the field of play at another angle. This allowed the action to take place solely at the left and right edges of the game while introducing an extra dimension of unpredictability. "*Pong* was about seamless movement," says Nolan. So all of this had to happen without the player really noticing what was happening behind the scenes.

Good collision detection was crucial, and the developers had to define the height and width of the paddles. As the ball hit the paddle, the code needed to work out what to do with the ball by assessing the vertical and horizontal speeds. It did this by checking the position of the ball in relation to the paddle. It then needed to change the direction of the ball accordingly to send it back across the screen.

Nolan says the original *Pong* code also had to take something else into account: "It needed to consider the reaction time from the controls to where there was a screen response. Tiny delays made a difference." This is because *Pong* was designed to be fast-paced, so the response had to be as speedy as possible so that the player could react quickly to what is occurring on the screen. Too much of a delay would lead to immense frustration. *Pong*'s developers needed the controls to be responsive. Handing a game to the opponent is not fun.

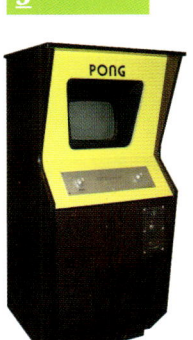

3

Keeping score

With all of this in place, the developers could look at the scoring system, which was relatively simple. The idea was that each time a player missed the ball and allowed it to go behind their paddle, the opposing player was given a point. In *Pong*, the game ended when one of the players reached eleven points, and this was an important aspect of games from that

CODE THE CLASSICS

time period. Since the coin-operated machines on which *Pong* ran required players to insert coins, there had to be a level at which the game could be won, otherwise someone would be able to pump in a single payment and enjoy the game all day.

"We had a limit in the coin-op because the game needed to average three minutes or less," explains Nolan. This was typical of arcade games at the time: the idea was to allow gamers to play for just enough time to feel satisfied. If they lost, they could make a further payment or they could give someone else the chance to have a go.

4 Atari co-founder Nolan Bushnell knows the value of addictive gameplay and simple rules

5 The original *Pong* coin-op featured monochrome graphics

6 Fifty variants of *Pong* were included in *Video Olympics* for the Atari 2600

Moving on

After creating *Pong*, Nolan's career went from strength to strength. Atari launched the Video Computer System (VCS) console in 1977, which proved hugely successful in introducing gaming into people's homes and cemented the company's place in history, selling more than 30 million units. Nolan left a year later and concentrated on the Chuck E. Cheese Pizza Time Theatre which he had founded in his bid to put video games into family-friendly venues, in this case a restaurant. Nolan also produced personal entertainment robots and founded the digital entertainment company uWink in 2000: "I believed that there was a huge market opportunity in the social gaming space."

Today, Atari may not be the force it once was (although it launched a new Atari 2600+ console in 2023), but Nolan is regarded as one of the most important people in video game history. He heads up an educational software company called BrainRush and he has long been inducted into the Video Game Hall of Game. Thanks to *Pong*, his legacy has been well and truly cemented.

Remaking the game

When it comes to making your own *Pong*-style tennis game, you can be creative and add your own touches. For instance, you could mix things up a bit by allowing gamers to move the paddle more freely around the screen to chase the ball in more complex ways. But do think carefully about the type of controller you use, whether it be a gamepad, joystick, rotary knob paddle, or keyboard.

When it comes to the scoring system, you could set up the playing area to test whether or not the ball is passing through the section immediately behind the area where the paddle moves up and down. If this happens, then the code works out which side – left or

Top tips

- Nolan Bushnell says you should make sure the difficulty increases as the number of volleys increases.

- He also says you should try to always make the most beneficial offensive shot have the highest probability of a miss.

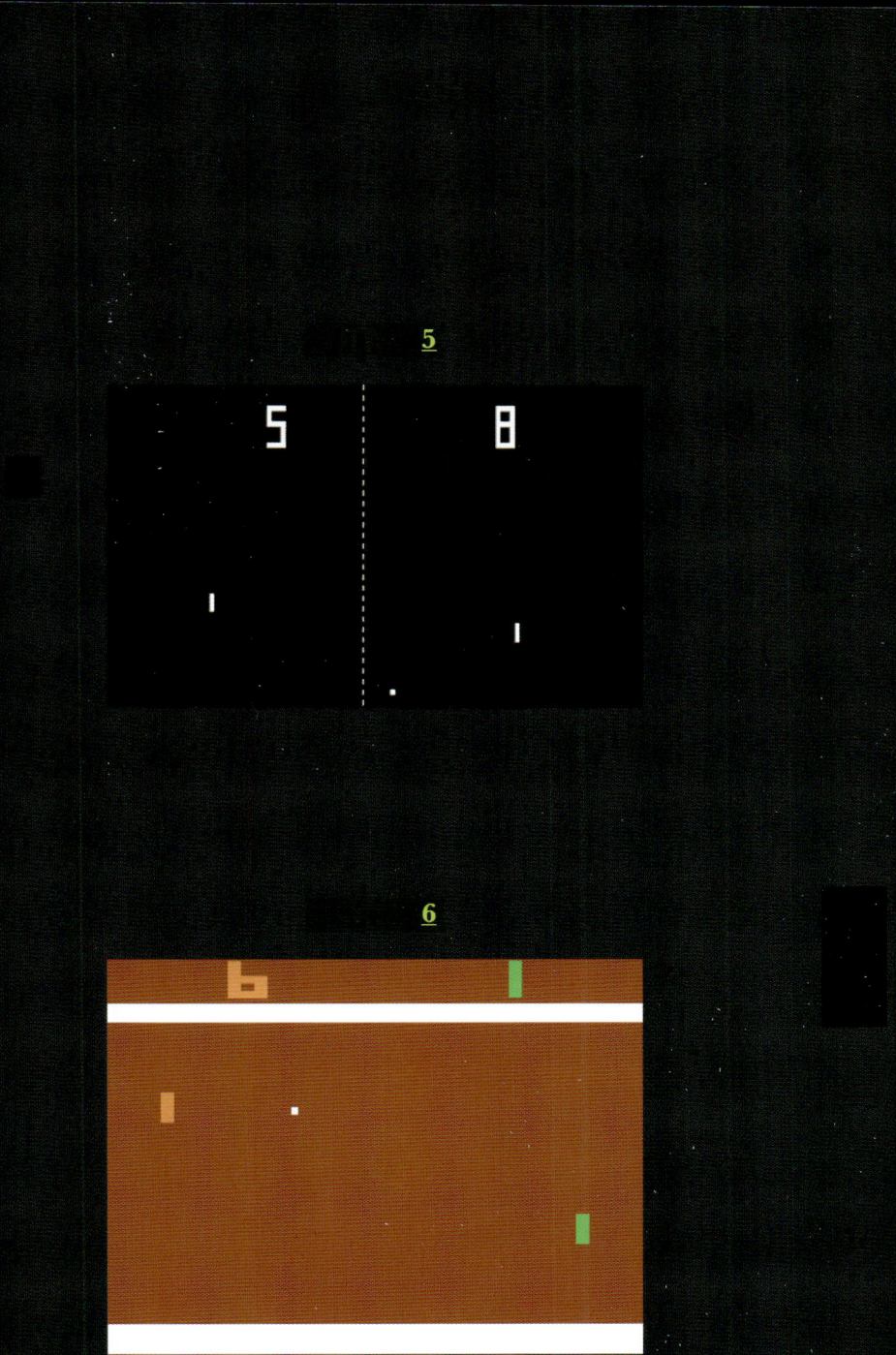

5

6

CODE THE CLASSICS

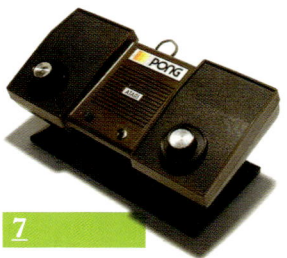

7 Atari's *Home Pong* console was released in 1975

right – has been breached, telling the computer to make a noise and then adding a point to the player operating the opposing paddle.

All you need to keep in mind is how players achieve a win. While you don't have to worry about inducing players to feed coins into an arcade machine, it is still worth having a cut-off point. With this in place, you can turn your attention to creating an end-game, which kicks in when either player has reached the desired points total. This could be accompanied by another sound, perhaps some music to indicate that you have a winner. You could also program in some sounds whenever the ball hits the paddle to lend some added atmosphere.

Besides adding sound effects, you can jazz up the graphics in any way you want. The limitations of early technology meant the original *Pong* was monochrome, but you don't have to stick with that. ("We actually didn't have colours available in the coin-op version when we started," recalls Nolan. "The colours on the home *Pong* consoles were also difficult to activate.") Your computer will have no such issues, so include colour, perhaps change the background from black to something else, and bring this old game into the 21st century with some flair.

The beauty of Pong is that it teaches some great fundamentals of gameplay and collision detection

You can really have fun, with little flourishes at set stages in the play – perhaps when a player goes five points clear or if the player achieves the top number of points against an opponent scoring nothing – and you can also think about adding extras. "Make changes that make it more fun for yourself," advises Nolan. "Programming a game for fun is the best way to learn."

Pong was actually used in just this way when the games industry was in its infancy. Atari's 1976 release *Breakout*, for example, which has a paddle running along the bottom of the screen from left to right and asks players to destroy bricks with

How to control the game

Instead of joysticks and joypads, *Pong* used a paddle. This had at least one fire button and a round wheel which was used to control the movement of the on-screen action. *Pong* was pioneering in that it was the first to use such paddles. One of the easiest ways to play around with a paddle controller is to look on eBay for old Atari 2600 paddles and buy an adapter to allow it to be connected to a computer via USB (one is available at **2600-daptor.com**). You could also seek to make one of your own if you are a dab hand at electronics. Of course, you can control the game with a traditional gamepad and keyboard keys too. Explore the different methods to get a good feel for how they potentially affect the game.

a bouncing ball, was based on *Pong*. Taito's *Arkanoid* later added power-ups to the *Breakout* concept and varied the levels and the types of bricks used. "As programmers feel confident and go beyond the basics, they can use the *Pong* engine to move from *Pong* to *Breakout* or *Arkanoid* – a Japanese rip-off," says Nolan.

The beauty of *Pong* is that it teaches some great fundamentals of gameplay and collision detection and it touches on some complex coding. It's a great introduction to coding which allows you to play around and expand upon the concept once you have grasped it.

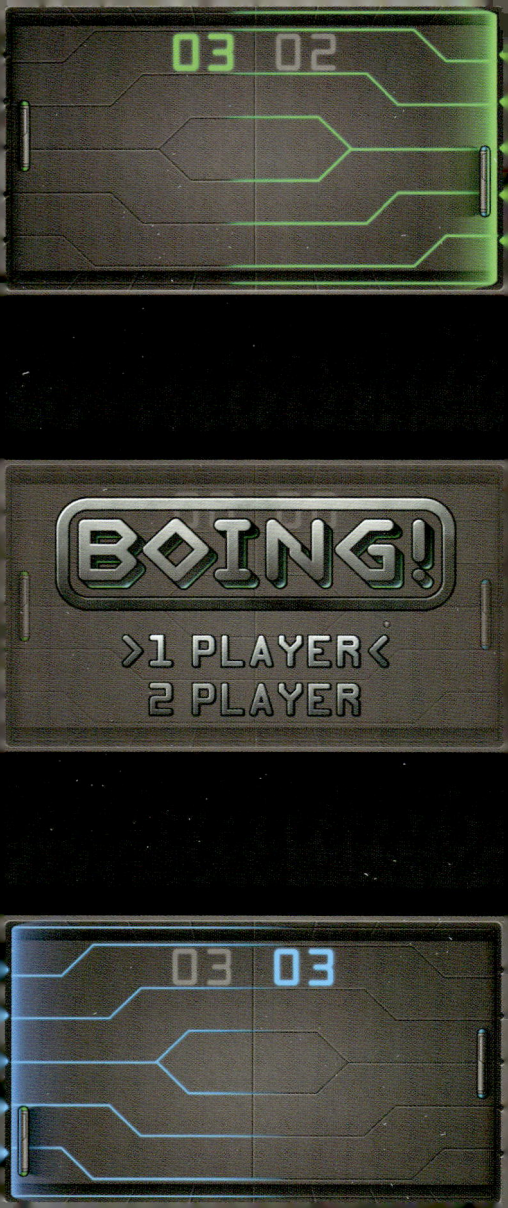

Coding Today
Boing!

To show how a game like *Pong* can be coded, we've created *Boing!* using Pygame Zero, a beginner-friendly tool for making games in Python. It's a good starting point for learning how games work – it takes place on a single screen without any scrolling, there are only three moving objects in the game (two bats and a ball), and the artificial intelligence for the computer player can be very simple – or even non-existent, if you're happy for the game to be multiplayer only. In this case, we have both single-player and two-player modes.

The code can be divided into three parts. First, there's the initial startup code. We import from other Python modules so we can use their code from ours. Then we check to make sure that the player has sufficiently up-to-date versions of Python and Pygame Zero. We set the `WIDTH` and `HEIGHT` variables, which are used by Pygame Zero when creating the game window. We also create two small helper functions which are used by the code below.

Download the code

Download the fully commented *Boing!* game code, along with all the graphics and sounds, from **rptl.io/ctc-one-code**

The next section is the largest. We create four classes: `Impact`, `Ball`, `Bat`, and `Game`. The first three classes inherit from Pygame Zero's Actor class, which amongst other things keeps track of an object's location in the game world, and takes care of loading and displaying sprites. `Bat` and `Ball` define the behaviour of the corresponding objects in the game, while `Impact` is used for an animation which is displayed briefly whenever the ball bounces off something. The `Game` class's job is to create and keep track of the key game objects, such as the two bats and the ball.

Further down, we find the `update` and `draw` functions. Pygame Zero calls these each frame, and aims to maintain a frame rate of 60 frames per second. Gameplay logic, such as updating the position of an object or working out if a point has been scored, should go in `update`, while in `draw` we tell each of the Actor objects to draw itself, as well as displaying backgrounds, text, and suchlike.

Our `update` and `draw` functions make use of two global variables: `state` and `game`. At any given moment, the game can be in one of three states: the main menu, playing the game, or the game-over screen. The `update` and `draw` functions read the `state` variable and run only the code relevant to the current state. So if `state` is currently `State.MENU`, for example, `update` checks to see if the **SPACE** bar or the up/down arrows are pressed and updates the menu accordingly, and `draw` displays the menu on the screen. The technical term for this kind of system is 'finite state machine'.

The `game` variable references an instance of the `Game` class as described above. The `__init__` (constructor) method of `Game` optionally receives a parameter named `controls`. When we create a new `Game` object for the main menu, we

> **The Game class's job is to create and keep track of the key game objects**

Stepping through time

The ball starts moving at five pixels per frame and speeds up by one pixel per frame each time it hits a bat. The simplest way of dealing with an object's speed is to simply update its position by the desired distance each frame. However, there can be some issues with this, especially when an object is moving very fast. Let's say the ball is moving horizontally at ten pixels

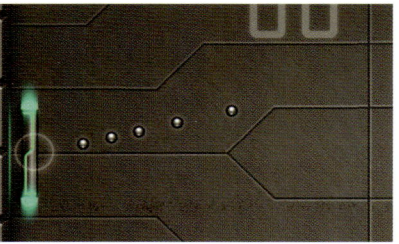

per frame and is about to hit a bat which is two pixels away. If we update the ball's position by ten pixels, it's going to have gone eight pixels further than it should have done. In some games, this kind of issue can lead to objects passing right through each other, or through walls, when travelling very fast. There are a number of ways to deal with this – the approach we've taken here (and in other games in this book) is to break down the movement of the ball into a series of small steps, checking for collisions after each step. For a complex game with many moving objects, this kind of approach can be inefficient, but for a simpler game like this it's ideal.

don't provide this parameter and so the game will therefore run in attract mode – in other words, while you're on the main menu, you'll see two computer-controlled players playing against each other in the background. When the player chooses to start a new game, we replace the existing `Game` instance with a new one, initialising it with information about the controls to be used for each player – if the controls for the second player are not specified, this indicates that the player has chosen a single-player game, so the second will be computer-controlled.

Challenges

- The `Game` class contains an attribute `ai_offset`, which is changed to a random value each time the ball bounces off a bat. Can you work out what this is for? Try changing the arguments given to `random.randint` and see what happens. What if you keep it fixed at zero, then start a new game and don't touch the controls?

- There are several ways you can make the game easier or harder – how many can you think of?

- We use Python's `math.hypot` function to calculate the length of a vector. Which famous mathematical theorem does this make use of? See if you can work it out yourself before you Google it!

- In the downloadable code (**rptl.io/ctc-one-code**), we've included an alternative, more advanced AI system. Can you work out how to enable it?

Two types of movement

In *Boing!*, the `Bat` and `Ball` classes inherit from Pygame Zero's Actor class, which provides a number of ways to specify an object's position. In this game, as well as games in later chapters, we're setting positions using the `x` and `y` attributes, which by default specify where the centre of the sprite will be on the screen. Of course, we can't just set an object's position at the start and be done with it – if we want it to move as the game progresses, we need to update its position each frame. In the case of a `Bat`, movement is very simple. Each frame, we check to see if the relevant player (which could be a human or the computer) wants to move – if they do, we either subtract or add 4 from the bat's Y coordinate,

I for one welcome our new AI overlords

In single-player mode, the movement of the second bat is determined by calling the `ai` method in the `Bat` class. There are many ways to approach artificial intelligence, even for a game as simple as *Boing!*. At the simplest level, the AI could simply make the computer player try to exactly follow the movement of the ball (while taking into account the maximum speed the bat is allowed to move). At the most advanced level, cutting-edge machine learning could be employed – but that's way beyond the scope of this book. In this game, the AI we've written is one small step up from the simplest system described above. When the ball is far away from the bat, the AI keeps the bat at the centre of the screen on the Y axis – ready for the ball to go either above or below it – but as the ball gets closer, the AI increasingly takes its position into account. This reflects the idea that as the ball gets closer, we have a better idea of where it's going to end up.

depending on whether they want to move up or down. We also ensure that the bat does not go off the top or bottom of the screen. So, not only are we only moving along a single axis, our Y coordinate will always be an integer (i.e. a whole number). For many games, this kind of simple movement is sufficient. Even in games where an object can move along both the X and Y axes, we can often think of the movement along each axis as being separate. For example, in the next chapter's game, *Cavern*, the player might be pressing the right arrow key and therefore moving along the X axis at 4 pixels per frame, while also moving along the Y axis at 10 pixels per frame due to gravity. The movement along each axis is independent of the other.

Able to move at any angle, the ball needs to move at the same speed regardless of its direction

For the `Ball`, things get a bit more complicated. Not only can it move at any angle, it also needs to move at the same speed regardless of its direction. Imagine the ball moving at one pixel per frame to the right. Now imagine trying to make it move at a 45° angle from that by making it move one pixel right and one pixel up per frame. That's a longer distance, so it would be moving faster overall. That's not great, and that's before we've even started to think about movement in any possible direction.

The solution is to make use of vector mathematics and trigonometry. In the context of a 2D game, a vector is simply a pair of numbers: X and Y. There are many ways in which vectors can be used, but most commonly they represent positions or directions.

You'll notice that the `Ball` class has a pair of attributes, `dx` and `dy`. Together these form a vector representing the direction in which the ball is heading. If `dx` and `dy` are 1 and 0.5, then each time the ball moves, it'll move by one pixel on the X axis

Figure 1

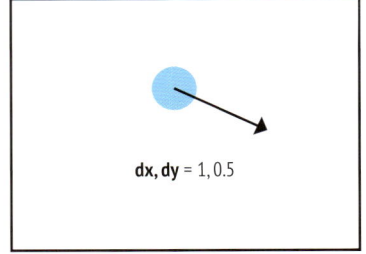

`dx` and `dy` represent a direction vector. The ball will move 1 pixel to the right and half a pixel down each time it moves. This vector can also be written as (1,0.5)

Figure 2

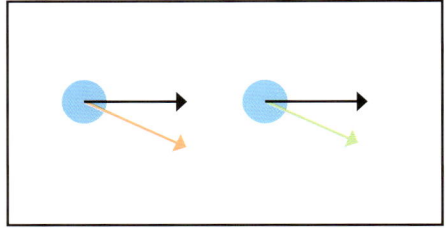

However, direction vectors should always be unit vectors – they should have a length of 1 unit (in the case of this game, 1 unit is 1 pixel). The black (1,0) vector is 1 unit long, but the orange (1,0.5) vector is approximately 1.12 units long. Dividing the x and y components of a vector by the vector's length gives a unit vector – this is known as normalisation, hence the function `normalised`. Doing this for the vector (1,0.5) gives approximately (0.89,0.45) – shown above by the green vector.

and a half a pixel on the Y axis. What does it mean to move half a pixel? When a sprite is drawn, Pygame Zero will round its position to the nearest pixel. So the end result is that our sprite will move down the screen by one pixel every other frame, and one pixel to the right every frame (**Figure 1**).

We still need to make sure that our object moves at a consistent speed regardless of its direction. What we need to do is ensure that our direction vector is always a 'unit vector' – a vector which represents a distance of one (in this case, one means one pixel, but in some games it will represent a different distance, such as one metre). Near the top of the code you'll notice a function named `normalised`. This takes a pair of numbers representing a vector, uses Python's `math.hypot` function to calculate the length of that vector, and then divides both the X and Y components of the vector by that length, resulting in a vector which points in the same direction but has a length of one (**Figure 2**).

Vector maths is a big field, and we've only scratched the surface here. You can find many tutorials online, and we also recommend checking out the Vector2 class in Pygame (the library on top of which Pygame Zero is built).

CODE THE CLASSICS

How to run the game

Open the **boing.py** file in a Python editor, such as IDLE, and select Run > Run Module.
For more details, see the 'Setting Up' section on page 170.

Download the code `rptl.io/ctc-one-code`

```
001.    import pgzero, pgzrun, pygame
002.    import math, sys, random
003.    from enum import Enum
004.
005.    if sys.version_info < (3,6):
006.        print("This game requires at least version 3.6 of Python. Please download"
007.              "it from www.python.org")
008.        sys.exit()
009.
010.    pgzero_version = [int(s) if s.isnumeric() else s
011.                      for s in pgzero.__version__.split('.')]
012.    if pgzero_version < [1,2]:
013.        print(f"This game requires at least version 1.2 of Pygame Zero. You are"
014.              "using version {pgzero.__version__}. Please upgrade using the command"
015.              "'pip install --upgrade pgzero'")
016.        sys.exit()
017.
018.    WIDTH = 800
019.    HEIGHT = 480
020.    TITLE = "Boing!"
021.
022.    HALF_WIDTH = WIDTH // 2
023.    HALF_HEIGHT = HEIGHT // 2
024.    PLAYER_SPEED = 6
025.    MAX_AI_SPEED = 6
026.
027.    def normalised(x, y):
028.        length = math.hypot(x, y)
029.        return (x / length, y / length)
030.
031.    def sign(x):
032.        return -1 if x < 0 else 1
033.
034.    class Impact(Actor):
035.        def __init__(self, pos):
036.            super().__init__("blank", pos)
037.            self.time = 0
038.
039.        def update(self):
```

```
040.            self.image = "impact" + str(self.time // 2)
041.            self.time += 1
042.
043.    class Ball(Actor):
044.        def __init__(self, dx):
045.            super().__init__("ball", (0,0))
046.            self.x, self.y = HALF_WIDTH, HALF_HEIGHT
047.            self.dx, self.dy = dx, 0
048.            self.speed = 5
049.
050.        def update(self):
051.            for i in range(self.speed):
052.                original_x = self.x
053.                self.x += self.dx
054.                self.y += self.dy
055.
056.                if abs(self.x - HALF_WIDTH) >= 344 and abs(original_x - HALF_WIDTH) < 344:
057.                    if self.x < HALF_WIDTH:
058.                        new_dir_x = 1
059.                        bat = game.bats[0]
060.                    else:
061.                        new_dir_x = -1
062.                        bat = game.bats[1]
063.
064.                    difference_y = self.y - bat.y
065.
066.                    if difference_y > -64 and difference_y < 64:
067.                        self.dx = -self.dx
068.                        self.dy += difference_y / 128
069.                        self.dy = min(max(self.dy, -1), 1)
070.                        self.dx, self.dy = normalised(self.dx, self.dy)
071.                        game.impacts.append(Impact((self.x - new_dir_x * 10, self.y)))
072.                        self.speed += 1
073.                        game.ai_offset = random.randint(-10, 10)
074.                        bat.timer = 10
075.
076.                        game.play_sound("hit", 5)
077.                        if self.speed <= 10:
078.                            game.play_sound("hit_slow", 1)
079.                        elif self.speed <= 12:
080.                            game.play_sound("hit_medium", 1)
081.                        elif self.speed <= 16:
082.                            game.play_sound("hit_fast", 1)
083.                        else:
084.                            game.play_sound("hit_veryfast", 1)
085.
086.                if abs(self.y - HALF_HEIGHT) > 220:
```

```
087.                self.dy = -self.dy
088.                self.y += self.dy
089.                game.impacts.append(Impact(self.pos))
090.                game.play_sound("bounce", 5)
091.                game.play_sound("bounce_synth", 1)
092.
093.        def out(self):
094.            return self.x < 0 or self.x > WIDTH
095.
096.    class Bat(Actor):
097.        def __init__(self, player, move_func=None):
098.            x = 40 if player == 0 else 760
099.            y = HALF_HEIGHT
100.            super().__init__("blank", (x, y))
101.
102.            self.player = player
103.            self.score = 0
104.
105.            if move_func != None:
106.                self.move_func = move_func
107.            else:
108.                self.move_func = self.ai
109.
110.            self.timer = 0
111.
112.        def update(self):
113.            self.timer -= 1
114.            y_movement = self.move_func()
115.            self.y = min(400, max(80, self.y + y_movement))
116.
117.            frame = 0
118.            if self.timer > 0:
119.                if game.ball.out():
120.                    frame = 2
121.                else:
122.                    frame = 1
123.
124.            self.image = "bat" + str(self.player) + str(frame)
125.
126.        def ai(self):
127.            x_distance = abs(game.ball.x - self.x)
128.            target_y_1 = HALF_HEIGHT
129.            target_y_2 = game.ball.y + game.ai_offset
130.            weight1 = min(1, x_distance / HALF_WIDTH)
131.            weight2 = 1 - weight1
132.            target_y = (weight1 * target_y_1) + (weight2 * target_y_2)
133.
```

```
134.            return min(MAX_AI_SPEED, max(-MAX_AI_SPEED, target_y - self.y))
135.
136.    class Game:
137.        def __init__(self, controls=(None, None)):
138.            self.bats = [Bat(0, controls[0]), Bat(1, controls[1])]
139.            self.ball = Ball(-1)
140.            self.impacts = []
141.            self.ai_offset = 0
142.
143.        def update(self):
144.            for obj in self.bats + [self.ball] + self.impacts:
145.                obj.update()
146.
147.            for i in range(len(self.impacts) - 1, -1, -1):
148.                if self.impacts[i].time >= 10:
149.                    del self.impacts[i]
150.
151.            if self.ball.out():
152.                scoring_player = 1 if self.ball.x < WIDTH // 2 else 0
153.                losing_player = 1 - scoring_player
154.
155.                if self.bats[losing_player].timer < 0:
156.                    self.bats[scoring_player].score += 1
157.                    game.play_sound("score_goal", 1)
158.                    self.bats[losing_player].timer = 20
159.
160.                elif self.bats[losing_player].timer == 0:
161.
162.                    direction = -1 if losing_player == 0 else 1
163.                    self.ball = Ball(direction)
164.
165.        def draw(self):
166.            screen.blit("table", (0,0))
167.
168.            for p in (0,1):
169.                if self.bats[p].timer > 0 and game.ball.out():
170.                    screen.blit("effect" + str(p), (0,0))
171.
172.            for obj in self.bats + [self.ball] + self.impacts:
173.                obj.draw()
174.
175.            for p in (0,1):
176.                score = f"{self.bats[p].score:02d}"
177.
178.                for i in (0,1):
179.                    colour = "0"
180.                    other_p = 1 - p
```

```
181.                if self.bats[other_p].timer > 0 and game.ball.out():
182.                    colour = "2" if p == 0 else "1"
183.                image = "digit" + colour + str(score[i])
184.                screen.blit(image, (255 + (160 * p) + (i * 55), 46))
185.
186.    def play_sound(self, name, count=1):
187.        if self.bats[0].move_func != self.bats[0].ai:
188.            try:
189.                getattr(sounds, name + str(random.randint(0, count - 1))).play()
190.            except:
191.                pass
192.
193. def p1_controls():
194.     move = 0
195.     if keyboard.z or keyboard.down:
196.         move = PLAYER_SPEED
197.     elif keyboard.a or keyboard.up:
198.         move = -PLAYER_SPEED
199.     return move
200.
201. def p2_controls():
202.     move = 0
203.     if keyboard.m:
204.         move = PLAYER_SPEED
205.     elif keyboard.k:
206.         move = -PLAYER_SPEED
207.     return move
208.
209. class State(Enum):
210.     MENU = 1
211.     PLAY = 2
212.     GAME_OVER = 3
213. num_players = 1
214. space_down = False
215.
216. def update():
217.     global state, game, num_players, space_down
218.     space_pressed = False
219.     if keyboard.space and not space_down:
220.         space_pressed = True
221.     space_down = keyboard.space
222.
223.     if state == State.MENU:
224.         if space_pressed:
225.             state = State.PLAY
226.             controls = [p1_controls]
227.             controls.append(p2_controls if num_players == 2 else None)
```

```
228.                    game = Game(controls)
229.               else:
230.                   if num_players == 2 and keyboard.up:
231.                       sounds.up.play()
232.                       num_players = 1
233.                   elif num_players == 1 and keyboard.down:
234.                       sounds.down.play()
235.                       num_players = 2
236.
237.                   game.update()
238.
239.           elif state == State.PLAY:
240.               if max(game.bats[0].score, game.bats[1].score) > 9:
241.                   state = State.GAME_OVER
242.               else:
243.                   game.update()
244.
245.           elif state == State.GAME_OVER:
246.               if space_pressed:
247.                   state = State.MENU
248.                   num_players = 1
249.                   game = Game()
250.
251.       def draw():
252.           game.draw()
253.
254.           if state == State.MENU:
255.               menu_image = "menu" + str(num_players - 1)
256.               screen.blit(menu_image, (0,0))
257.
258.           elif state == State.GAME_OVER:
259.               screen.blit("over", (0,0))
260.
261.       try:
262.           pygame.mixer.quit()
263.           pygame.mixer.init(44100, -16, 2, 1024)
264.
265.           music.play("theme")
266.           music.set_volume(0.3)
267.       except:
268.           pass
269.
270.       state = State.MENU
271.       game = Game()
272.
273.       pgzrun.go()
```

CODE
THE
CLASSICS

[1]

[2]

[3]

[4]

[1] The background needs to be not too busy, so the ball stays visible

[2] Colour-coded overlays appear when a point is won by either side

[3] The ball sprite is simple; its movement is not

[4] Each bat has three versions: normal, with shadow (when a point is lost), and hitting the ball

Coding Today
Boing!

5 The title screen offers a choice of one- or two-player mode

6 Digits used to show the scores, colour-coded for each player

7 There are five impact sprites numbered 0 to 4

Tennis – Coding Today: Boing!

CODE THE CLASSICS

Chapter 2

Action Platformer

Enduringly popular, the platform game genre is still packed with creative possibilities

Platformers involve moving a character around a series of obstacle-strewn platforms, jumping, shooting, and avoiding any baddies along the way. They can be played alone or with a friend: produced by Taito, *Bubble Bobble* was a tough (and incredibly popular) coin-op, two-player cooperative platformer which made a successful transition to home computers. It featured two brothers called Bubby and Bobby who had been turned into a pair of cuddly creatures, affectionately known as Bub and Bob, by the evil Baron Von Blubba. With their girlfriends kidnapped, 100 levels of tricky, fast-paced action awaited them as they tried their hardest to rescue them, battling all manner of beasties along the way. As the game's name suggests, bubbles played a major role in the gameplay – you had to fire them at enemies to stun them, then pop them for the kill. Once a screen was cleared of rivals, it was time to advance to the next level.

Inspiration

Bubble Bobble was designed by Fukio Mitsuji, who also created an incredibly popular follow-up in *Rainbow Islands*. It was ported to many machines including the Commodore 64, where it was overseen by Stephen Ruddy, who worked on games such as *Target: Renegade*, *FIFA 99*, and *MotoGP 09/10*. Ruddy still works in gaming for Yippee Entertainment. Sadly, Mitsuji-san died on 11 December 2008, aged 48. In the 1990s, he went on to put his skills as a game designer to good use by teaching coders new tricks. He also freelanced on titles including *Magical Puzzle Popils* on the Sega Game Gear.

Bubble Bobble

Released 1986

Platforms Arcade

Commodore 64

ZX Spectrum

Amiga

Atari ST

MSX 2

Amstrad CPC

Sharp X68000

PC

Apple II

FM Towns Marty

Sega Master System

Game Boy

Game Boy Color

PlayStation

Sega Saturn

NES

SNES

Game Gear

CODE THE CLASSICS

Like many classic games of the past, Bubble Bobble originated in the arcades and was later made available on many other machines.

Other Notables Donkey Kong / Mario / Prince of Persia

There are games where you can choose weapons of devastating effectiveness. Gravity guns, magical swords, BFGs, and frag grenades are all fine choices. There's no doubt that each one of these has the potential to inflict damage on foes, making them highly effective in combat. But what if there was no choice? What if the only thing you had to hand was merely a bubble – yes, a simple thin film of soapy water filled with air? As daft as that may sound, one game of the 1980s made use of just that. Its name? *Bubble Bobble*.

Anyone who has been lucky enough to have some fun with this iconic 1986 arcade platformer will understand just how effective bubbles can be. They would be used to trap enemies and, when burst, dispatch them with ease. With a bit of finesse, multiple bubbles could get rid of enemies at once for extra points. And later in the game, they come into their own as temporary – and occasionally deadly – floating platforms to get the player from level to level.

The game's designer, Fukio Mitsuji, was looking for something new. Back in the 1980s, platformers were a strong staple of gaming, making up a large (and often homogeneous) slice of the industry. Developers like Mitsuji realised that they needed to create something which made their title stand out. In the case of *Bubble Bobble*, two kawaii characters called Bub and Bob were introduced, and the action took place over 100 static screens. Despite its simple premise, the game proved highly addictive and also rather complex.

Gameplay was compulsive and kept players coming back for more. The wobbly action of the bubbles themselves, which acted as weapons and as (fiendishly tricky) temporary platforms to jump off, was unpredictable. There were hidden bonuses and power-ups, and different ways of seeing enemies off (special bubbles could be produced which, when burst, would attack foes with water, lightning, or fire). A stage would be cleared when all of the enemies were destroyed, but the difficulty level increased the further you progressed. And there was clarity for the player: the basic structure of the game remained the same from start to finish, following the same genre-defining rules laid down by *Space Panic* at the beginning of the decade.

Platform jumping

In general, platformers offered players the opportunity to jump around an environment strewn with platforms, with obstacles to avoid and enemies to slay. One of the most popular was *Donkey Kong*, which starred Mario – or Jumpman as he was known back then. Over time, platformers were married up with other genres such as beat-'em-ups and adventures.

But even at their purest, they often proved compelling. Developers would seek to inject their own little twists to the gameplay, introducing new and original concepts. Nintendo's 1983 arcade game *Mario Bros.* introduced two-player simultaneous

cooperative play, a concept which *Bubble Bobble* emulated. "In this game, you had to play cooperatively in order to reach the true ending," said Mitsuji.

Bubble Bobble was Mitsuji's first game. He developed it for Taito, a coin-op game manufacturer which had achieved huge success in 1978 with the launch of *Space Invaders*, although it had made other titles prior to that, including *Speed Race* in 1974. With games such as *Qix* in 1981 and *Elevator Action* in 1983 under its belt, Taito had built a solid reputation. It was always on the lookout for games that would get players pumping coin after coin into its machines. *Bubble Bobble* brought with it the right mixture of innovation and addictiveness.

Mitsuji put his game's enduring popularity down to Bub and Bob, but he also said the unique ability to shoot bubbles was a major attraction for gamers looking for something new (his desire to innovate was so strong, he was adamant that he would never produce a direct sequel). The fact that it was an arcade game meant it also needed to be accessible and easy to learn. For that reason, it came with little in the way of razzmatazz, preferring to let the game speak for itself. This aspect was also ported to the home computer versions.

> **The unique ability to shoot bubbles was a major attraction for gamers looking for something new**

Stephen Ruddy was responsible for the Commodore 64 port, which he created while working for Software Creations. At the time, the publisher and developer was based above a computer shop opposite the BBC's North West studios on Oxford Road in Manchester, and Stephen had been offered a job after responding to an advertisement in the Manchester Evening News. It was his task to identify the structure of the game and re-code it.

"The basic structure of games is that you have a front-end and a back-end," he explains. "The front-end is normally made up of some kind of attract mode [that is, something to draw the player to the game and excite them] and the user interface that sets up the game. The back-end is normally a game manager that manages some user interface, a bunch of game objects, and an environment they operate in. Being an arcade game, *Bubble Bobble* had very little in the way of a front-end. A title screen, an attract loop, and a high-score table were about all it contained."

By concentrating on the back-end, Mitsuji aimed to eliminate any wasteful preamble that would otherwise slow down the speed at which player coins would be deposited into the slot. It meant he could focus on the game manager. "The manager essentially concentrated on the lives of the player – three in the case of *Bubble Bobble* – as well as the introduction user interface and the game cycle," Stephen continues.

Non-scrolling screen

Since all of the action in *Bubble Bobble* took place on a series of single, non-scrolling screens, it was much easier for developers such as Stephen to replicate it on home computers and consoles. It removed the need for a scene management system, for example, because with such a small environment, there was only a need for a limited number of objects.

The objectives

Short term: Enjoy yourself. Stephen Ruddy says the biggest thing is the sheer creative enjoyment of the whole process – you start with nothing every time. So work on the basics.

Medium term: Start building up the levels. Have fun with the level design and see what designs you come up with.

Long term: Begin to think about what else you will be able to throw into the mix. Once you move beyond simple 2D sprites, rendering with complex shaders and 3D-skinned meshes is an interesting and rewarding area for games designers.

"A scene management system is complex, but it is only needed if you have a large environment with potentially many thousands of game objects," Stephen explains. "It will identify and update only those objects that need to be updated and it will only render the objects that are on screen. Likewise, it will only collide the relevant collision primitives.

"With a single-screen system and a limited number of objects, none of this is required. You can simply assume all objects must be updated and all objects must be rendered. The objects can also take on collision themselves rather than have a separate physics/collision/collision-resolution system of some kind or other."

Bubble Bobble had many objects. There were Bub and Bob themselves of course, but there was also a variety of weapons. Aside from the bubbles themselves, players would have to dodge fireballs, water drops, fire, lightning, rocks, and bombs. They also had to avoid the enemies, with baddies made up of robots, ghosts, whales, teddies, springs, bugs, dwarves, invaders, and a boss. In addition, there were collectables such as fruit, bonuses, and power-ups.

"With some games the environment can be stunningly complex and may well be made up of games objects itself, but in *Bubble Bobble* the environment was a simple 2D tiled map with several environmental effects attached," says Stephen. "In *Bubble Bobble*'s case the tiled map was really just collision data, a flag to indicate whether it contained a platform or not, and an 'airflow' direction setting to indicate which way bubbles should float through the time (0–3 for up, down, left, right)."

Blowing bubbles

Of all of these objects, the bubbles were the most important. A lot of time and attention was paid to this mechanic to ensure they behaved in the way the player expected. When a bubble was spawned by the player, it would be given a specific horizontal velocity. Crucially, it would also include a "baddie collision lifetime" which indicated how long an enemy could remain in a bubble before it popped itself and allowed them to escape. There was also a total lifetime setting to prevent the bubble from lingering for too long.

"When the player fired a bubble, it would take care of itself, travelling horizontally as configured and changing to a 'captured baddie' bubble if it touched an enemy," Stephen explains. "The baddie setting would then match the baddie it captured and it would check itself for a collision with the

[1] **A 1986 flyer for the US coin-op release; the rear explained the game mechanics**

player." In other words, if a spiky part of the player – the back, head, or feet if the jump button was not pressed – touched the bubble, then it would pop. If it came into contact with the front of Bub or Bob, the bubble would simply be pushed along. The code would wait until one of these events happened and then act on it.

The code would also know if there was no contact at all between the bubble and the enemies. "If the bubble never touched a baddie at the end of its collision lifetime, then it would change itself to a 'float bubble' which would simply drift along with the airflow as defined in the tile map," says Stephen. It may sound complicated but, in essence, the coders were simply working out the interaction between the bubbles and both the player and enemy characters.

"The player was only concerned with the actions the player could do (that is, movement and firing); the other objects took care of themselves, colliding with the player or each other," Stephen continues. "So, for example, a bubble would test if it was in collision with the player and either pop or be pushed out of the way, and a baddie would test if it was in collision with the player and either kill the player or kill itself (if the player was invulnerable due to a power-up)."

Figuring it out

Since Stephen was porting a pre-existing arcade game, he and the team at Software Creations had no input into the design of the game. So, in order to get to grips with all of the various aspects of *Bubble Bobble* during the conversion, the developers had to play the game over and over again, noting all of the different nuances of the gameplay. It was then up to them to figure out the mechanics of the game and replicate it for the home market.

Deep mechanics in the game, like a time limit on capturing an enemy, were a challenge to tease out. "'Captured baddie' bubbles would pop and release the baddie they contained, but the baddie that was released would be set in a 'hurry up' state," explains Stephen.

"This was visually different since it used a red colouring. The movement speed was also doubled. In later levels this was used as a driver to make the player plan when to fire a bubble and when to pop the baddies because the bubbles would

Deep mechanics, like a time limit on capturing an enemy, were a challenge to tease out

Learn from the master

Stephen Ruddy offers some excellent advice for anyone looking to program their own games.

Never fear: Stephen says you mustn't be afraid of learning new skills or asking for help.

Use your knowledge: The more techniques you master, the easier it will be when faced with something new.

Know when to stop: When it's finished it's finished. You have to learn to ignore the temptation to rework your code and move on.

whizz off to specific areas of the screen." Players also had to stay on their toes when it came to grabbing bonus letters, which had a finite lifetime too. Hazards like lightning, water, and fire had infinite lifetimes and had to be treated differently.

All of this was a good learning curve for Stephen, who had only developed three previous games on the Commodore 64: *Mystery of the Nile* in 1986 and both *Kinetik* and *The Big KO!* the following year. But since *Bubble Bobble* was more complex than he first imagined, some mechanics were missed. "We weren't aware of the rules regarding when the arcade game decided on which items appeared," he says, "but we did figure out some simply by playing the game."

Bubble Bobble had a bonus collectable and a power-up collectable which appeared on every level. "The bonus collectable simply awarded the player points and it was selected by how quickly the player completed the previous level – the quicker the player completed the level, the better-scoring the bonus collectable would be. The power-up collectable was selected by a complex rule set which also reflected how the player completed the previous level. Today, these nuances are found on the internet, but in our conversions we noticed some but not others and ended up with a weighted default system."

Just as troublesome was the way in which players controlled the characters. In *Bubble Bobble*, Bub and Bob could move left and right and they could also jump. In the arcade version, there was a simple two-way joystick and two buttons to achieve this – one to jump and one to fire. In most home systems, joysticks did not have two-button setups, so a workaround had to be found in order to better replicate the experience on machines like the Commodore 64.

"Controls are always the trickiest part of games development," says Stephen. "Really there aren't any short cuts, so you need to keep iterating over them until they 'feel' right. For the Commodore 64 version, the main issue was having one less button than the arcade machine. It made use of a four-way joystick as well as fire, as opposed to a two-way joystick together with jump and fire." The solution was to use the up direction on the joystick as jump, but even then, movement in *Bubble Bobble* was more complicated than it first appeared.

"The player moved across platforms and was obstructed by any solid tile cell blocking the player character's 'feet'," Stephen says. "But the logic for moving sideways was different when not on a platform. The player could move regardless if their character's 'feet' were already embedded in a solid cell. Similarly, when falling, player characters would only land on platforms that had empty space about them."

Racking up the points

To keep players motivated, they could build a high score as they made their way through the stages. When an enemy was killed, for instance, it was turned into food which could then be collected for points. Many

Top tips

- Experiment with different bubbles. The game had three elemental bubbles – lightning, water, and fire – that could destroy enemies in different ways.

- Consider a boss in your game so that when all of the creatures are defeated, there is a monster of a challenge to be had that will keep players on their toes and add variety.

different items carried differing point values, which introduced a healthy dollop of strategy to the game.

A green pepper had 10 points, for example, a turnip 60, a banana 500, and French fries 1000. There was beer at 4000 points, red jewels at 7000, and gold crowns at 10,000. There were also lots of associated triggers which could depend on how quickly you finished a previous stage.

"The core competitive element of every arcade game is the player's score and a high-score table: it's the hook that keeps you returning back for one more go to improve on your own personal previous best and to be the best at the game," says Stephen. "Today this has been extended with leaderboards, which incorporate a social aspect where you can see, challenge, and beat your friends' scores as well as all the scores worldwide – it's still a key driver that keeps players coming back to improve."

The two-player mode of the game was also crucial in hooking players in. *Bubble Bobble* could be played by one or two people, and it was the cooperative mode which made it such an enduring joy. Indeed, Mitsuji wanted *Bubble Bobble* to be a game that couples would enjoy playing together. He saw gaming as a hobby that anyone could enjoy, regardless of gender, and he wanted to encourage more female gamers in particular, since they were rarely seen in Japanese arcades.

The core competitive element of every arcade game is the player's score and a high-score table

At times, it was almost as if Mitsuji had a bag of holding into which he was throwing ideas. You could collect letters that spelt 'EXTEND' to get an extra life, grab an umbrella and skip levels, or enter secret rooms and access hidden bonuses. There were even multiple endings. The first was a 'bad' ending for single players who only rescued Betty and not Patty, and told the gamer to "never forget your friend". The good ending needed two players and it saved both Betty and Patty while unlocking a Super Mode which encouraged a replay of the game (obviously, to get players to pump in more coins). Once that was completed, Bub and Bob's parents were finally revealed.

"We didn't implement the multiple endings of the arcade, simply because we weren't aware of them," admits Stephen. Thankfully, that didn't ruin the attraction of the ported games. Virtually every home system has been blessed with the presence of Bub and Bob, either as a conversion of the original coin-op or in one of many spin-offs.

The fact that the direct ports were still considered brilliant despite not being entirely faithful, shows that the core mechanics of *Bubble Bobble* could more than stand alone as a classic. Indeed, the only port that was accurate to a large degree was the Sega Master System version which Taito itself coded. But that's not to say Taito had been miserly and kept the source code to itself for the other versions. On the contrary, it shared it with the developers of the other versions, but the comments were in Japanese, making it difficult for teams that didn't speak the language to follow.

2 After trapping enemies in bubbles, you still need to burst them

3 A high score table is always a good way to make gamers competitive

2

3

CODE THE CLASSICS

Adding complexity

Although *Bubble Bobble* was a simple enough game to create – albeit challenging to pull off satisfactorily – there are many areas of game programming that become more complex the more your game relies on them. According to Stephen Ruddy, scene management becomes more important and entails breaking a large environment up into smaller more manageable pieces for updating or rendering. For larger 2D or 3D worlds this becomes essential. Similarly, he says: "Physics simulation, collision, and restitution in 2D and 3D can be very complex and reliant on probably the most complex mathematics you'll come across in game development." Enjoying these subjects is helpful, though not essential, for making games. And finally, he opines: "Audio is often overlooked as mostly people just play a sample when an event occurs. But software mixing, complex fading, and multi-track streaming may also be required if your game requires complex audio."

Still, it was a good learning curve for Stephen. "You never stop learning, so don't be afraid of anything," he advises. "You may be required to program something you've never done before, so you mustn't be afraid of learning new skills or asking for help. The simple fact is that no one knows every methodology, algorithm, or technology as of course new ones are created, extruded, or manufactured all the time. Fortunately, the more you do get to grips with will reduce apprehension when faced with something new and unknown."

4 Bursting a water bubble releases a torrent that clears any enemies in its path

5 Special power-ups such as lightning are useful on the trickier later levels

4

5

LEVEL 10 43000

CAVERN
PRESS SPACE

LEVEL 7 24300

Coding Today
Cavern

Like *Bubble Bobble*, our game *Cavern* takes place on a single screen. `Robot` enemies are created just off the top of the screen, and fall into the level. The `Player` can fire `Orbs` – if a robot touches an orb, it will become trapped inside. The orbs pop either after four seconds, or when they reach the top of the screen. Robots can fire `Bolt`s which can pop orbs or hurt the player. There are two types of robot: a standard type, and a more aggressive type which has the ability to deliberately fire at orbs.

Download the code

> Download the fully commented *Cavern* game code, along with all the graphics and sounds, from **rptl.io/ctc-one-code**

The `Fruit` class represents items the player can collect. Normally these items are, as the name suggests, pieces of fruit, which increase the player's score. However, there are also pick-ups which increase the player's health or give an extra life. Fruit pick-ups are dropped when an orb containing a robot reaches the top of the screen, and are also created in random positions every 100 frames. The extra health and extra life power-ups have a chance of being created when an orb containing the more aggressive type of robot is popped.

Each of the classes mentioned above inherits from either `CollideActor` or `GravityActor` – `CollideActor`, which inherits from Pygame Zero's `Actor` class, provides a move method which moves the object in the specified direction, but won't allow it to go through walls. `GravityActor` inherits from `CollideActor`, and allows objects to be affected by gravity.

The `Game` class maintains a reference to the player object, as well as lists of fruit, bolts, enemies, orbs, and pops (objects which display an orb's popping animation – similar to `Impact` objects in *Boing!*). At the start of each level, the `game` object sets up the grid of blocks which will form the level, decides how many enemies of each type there will be on this level, and creates a randomly shuffled list of enemy types, which determines the order in which different enemy types will appear.

Level with me

Levels in *Cavern* are formed of blocks, each block being 25×25 pixels. At the top of the code you'll see a list called `LEVELS`, containing three further lists which correspond to the three level layouts in the game. Each level list contains 17 strings, where each string represents a row. Within each row, a space character means there's no block at that position; any other character (we've used X) represents a block. An empty string indicates a row with no blocks. You might notice that the variable `NUM_ROWS` is 18, which doesn't seem to match with the number of rows in the level lists. In the `Game.next_level` method, we add a copy of the first row to the end of the level data, so that the first and last rows are the same.

Cavern

As with *Boing!*, the final part of the code uses a simple state machine system to update and draw the game objects. There are also functions for drawing text and the player's score, health, and lives.

Challenges

- In *Bubble Bobble*, bubbles don't automatically burst when they reach the top of the screen – instead they float around and, if left long enough, enemies in bubbles can escape (and come back angrier, moving at an increased speed). The player can burst bubbles by walking, falling, or jumping into them. Bursting bubbles could also cause a chain reaction, bursting other nearby bubbles. How would you change the game to match this?

- Currently, holding the **SPACE** bar causes the player to blow an orb further across the level. What if instead of this, holding the **SPACE** bar caused the player to create a series of orbs in quick succession? To keep the game balanced, there are a number of other things you'd need to change, such as the total number, maximum on-screen number, and creation rate of enemies.

Incomprehensible?

You'll sometimes see code similar to `[x*2 for x in range(10)]`. This makes use of a very useful Python feature known as list comprehension. In this case, the code generates the numbers 0 to 9, multiplies each one by two, and puts the resulting numbers in a list. In *Cavern*, we use this feature to remove objects from lists. For example, take the line `self.enemies = [e for e in self.enemies if e.alive]`. This creates a new list which consists of the entries from the existing `self.enemies` list, excluding those which are no longer alive. The new list then replaces the existing enemies list. Bear in mind that if there were any other variables besides `self.enemies` which referred to the same list, this technique wouldn't affect those variables, and they would continue to refer to the old version of the list. In *Cavern* this isn't an issue, and list comprehensions allow us to do in a single line what would otherwise take at least three lines.

CODE THE CLASSICS

How to run the game

Open the **cavern.py** file in a Python editor, such as IDLE, and select Run > Run Module.
For more details, see the 'Setting Up' section on page 170.

Download the code rptl.io/ctc-one-code

```
001.    from random import choice, randint, random, shuffle
002.    from enum import Enum
003.    import pygame, pgzero, pgzrun, sys
004.
005.    if sys.version_info < (3,6):
006.        print("This game requires at least version 3.6 of Python. Please download"
007.              "it from www.python.org")
008.        sys.exit()
009.
010.    pgzero_version = [int(s) if s.isnumeric() else s
011.                      for s in pgzero.__version__.split('.')]
012.    if pgzero_version < [1,2]:
013.        print(f"This game requires at least version 1.2 of Pygame Zero. You are"
014.              "using version {pgzero.__version__}. Please upgrade using the command"
015.              "'pip install --upgrade pgzero'")
016.        sys.exit()
017.
018.    WIDTH = 800
019.    HEIGHT = 480
020.    TITLE = "Cavern"
021.
022.    NUM_ROWS = 18
023.    NUM_COLUMNS = 28
024.
025.    LEVEL_X_OFFSET = 50
026.    GRID_BLOCK_SIZE = 25
027.
028.    ANCHOR_CENTRE = ("center", "center")
029.    ANCHOR_CENTRE_BOTTOM = ("center", "bottom")
030.
031.    LEVELS = [ ["XXXXX        XXXXXXXX        XXXXX",
032.                "" ,  "" ,  "" ,  "",
033.                "     XXXXXXX          XXXXXXX    ",
034.                "" , "" ,  "",
035.                "    XXXXXXXXXXXXXXXXXXXX      ",
036.                "" , "" ,  "",
037.                "XXXXXXXXX                XXXXXXXXX",
038.                "" , "" , ""],
039.
040.               ["XXXX         XXXXXXXXXXX        XXXX",
```

```
041.                    "","","","",
042.                    "    XXXXXXXXXXXXXXXXXXXX    ",
043.                    "","","","",
044.                    "XXXXXX                XXXXXX",
045.                    "      X                X     ",
046.                    "       X              X      ",
047.                    "        X            X       ",
048.                    "         X          X        ",
049.                    "","","",""],
050.
051.                   ["XXXX    XXXX    XXXX    XXXX",
052.                    "","","","",
053.                    "   XXXXXXXX        XXXXXXXX   ",
054.                    "","","","",
055.                    "XXXX      XXXXXXXX      XXXX",
056.                    "","","","",
057.                    "    XXXXXX        XXXXXX    ",
058.                    "","","",""]]
059.
060.        def block(x,y):
061.            grid_x = (x - LEVEL_X_OFFSET) // GRID_BLOCK_SIZE
062.            grid_y = y // GRID_BLOCK_SIZE
063.            if grid_y > 0 and grid_y < NUM_ROWS:
064.                row = game.grid[grid_y]
065.                return grid_x >= 0 and grid_x < NUM_COLUMNS and len(row) > 0 and \
066.                       row[grid_x] != " "
067.            else:
068.                return False
069.
070.        def sign(x):
071.            return -1 if x < 0 else 1
072.
073.        class CollideActor(Actor):
074.            def __init__(self, pos, anchor=ANCHOR_CENTRE):
075.                super().__init__("blank", pos, anchor)
076.
077.            def move(self, dx, dy, speed):
078.                new_x, new_y = int(self.x), int(self.y)
079.
080.                for i in range(speed):
081.                    new_x, new_y = new_x + dx, new_y + dy
082.
083.                    if new_x < 70 or new_x > 730:
084.                        return True
085.
086.                    if ((dy > 0 and new_y % GRID_BLOCK_SIZE == 0 or
087.                         dx > 0 and new_x % GRID_BLOCK_SIZE == 0 or
```

```
088.                    dx < 0 and new_x % GRID_BLOCK_SIZE == GRID_BLOCK_SIZE-1)
089.                    and block(new_x, new_y)):
090.                    return True
091.
092.             self.pos = new_x, new_y
093.
094.         return False
095.
096.  class Orb(CollideActor):
097.     MAX_TIMER = 250
098.
099.     def __init__(self, pos, dir_x):
100.         super().__init__(pos)
101.
102.         self.direction_x = dir_x
103.         self.floating = False
104.         self.trapped_enemy_type = None
105.         self.timer = -1
106.         self.blown_frames = 6
107.
108.     def hit_test(self, bolt):
109.         collided = self.collidepoint(bolt.pos)
110.         if collided:
111.             self.timer = Orb.MAX_TIMER - 1
112.         return collided
113.
114.     def update(self):
115.         self.timer += 1
116.
117.         if self.floating:
118.             self.move(0, -1, randint(1, 2))
119.         else:
120.             if self.move(self.direction_x, 0, 4):
121.                 self.floating = True
122.
123.         if self.timer == self.blown_frames:
124.             self.floating = True
125.         elif self.timer >= Orb.MAX_TIMER or self.y <= -40:
126.             game.pops.append(Pop(self.pos, 1))
127.             if self.trapped_enemy_type != None:
128.                 game.fruits.append(Fruit(self.pos, self.trapped_enemy_type))
129.             game.play_sound("pop", 4)
130.
131.         if self.timer < 9:
132.             self.image = "orb" + str(self.timer // 3)
133.         else:
134.             if self.trapped_enemy_type != None:
```

```
135.                    self.image = "trap" + str(self.trapped_enemy_type) + \
136.                            str((self.timer // 4) % 8)
137.             else:
138.                 self.image = "orb" + str(3 + (((self.timer - 9) // 8) % 4))
139.
140.     class Bolt(CollideActor):
141.         SPEED = 7
142.
143.         def __init__(self, pos, dir_x):
144.             super().__init__(pos)
145.
146.             self.direction_x = dir_x
147.             self.active = True
148.
149.         def update(self):
150.             if self.move(self.direction_x, 0, Bolt.SPEED):
151.                 self.active = False
152.             else:
153.                 for obj in game.orbs + [game.player]:
154.                     if obj and obj.hit_test(self):
155.                         self.active = False
156.                         break
157.
158.             direction_idx = "1" if self.direction_x > 0 else "0"
159.             anim_frame = str((game.timer // 4) % 2)
160.             self.image = "bolt" + direction_idx + anim_frame
161.
162.     class Pop(Actor):
163.         def __init__(self, pos, type):
164.             super().__init__("blank", pos)
165.
166.             self.type = type
167.             self.timer = -1
168.
169.         def update(self):
170.             self.timer += 1
171.             self.image = "pop" + str(self.type) + str(self.timer // 2)
172.
173.     class GravityActor(CollideActor):
174.         MAX_FALL_SPEED = 10
175.
176.         def __init__(self, pos):
177.             super().__init__(pos, ANCHOR_CENTRE_BOTTOM)
178.
179.             self.vel_y = 0
180.             self.landed = False
181.
```

```
182.            def update(self, detect=True):
183.                self.vel_y = min(self.vel_y + 1, GravityActor.MAX_FALL_SPEED)
184.
185.                if detect:
186.                    if self.move(0, sign(self.vel_y), abs(self.vel_y)):
187.                        self.vel_y = 0
188.                        self.landed = True
189.
190.                    if self.top >= HEIGHT:
191.                        self.y = 1
192.                else:
193.                    self.y += self.vel_y
194.
195.        class Fruit(GravityActor):
196.            APPLE = 0
197.            RASPBERRY = 1
198.            LEMON = 2
199.            EXTRA_HEALTH = 3
200.            EXTRA_LIFE = 4
201.
202.            def __init__(self, pos, trapped_enemy_type=0):
203.                super().__init__(pos)
204.
205.                if trapped_enemy_type == Robot.TYPE_NORMAL:
206.                    self.type = choice([Fruit.APPLE, Fruit.RASPBERRY, Fruit.LEMON])
207.                else:
208.                    types = 10 * [Fruit.APPLE, Fruit.RASPBERRY, Fruit.LEMON]
209.                    types += 9 * [Fruit.EXTRA_HEALTH]
210.                    types += [Fruit.EXTRA_LIFE]
211.                    self.type = choice(types)
212.
213.                self.time_to_live = 500
214.
215.            def update(self):
216.                super().update()
217.
218.                if game.player and game.player.collidepoint(self.center):
219.                    if self.type == Fruit.EXTRA_HEALTH:
220.                        game.player.health = min(3, game.player.health + 1)
221.                        game.play_sound("bonus")
222.                    elif self.type == Fruit.EXTRA_LIFE:
223.                        game.player.lives += 1
224.                        game.play_sound("bonus")
225.                    else:
226.                        game.player.score += (self.type + 1) * 100
227.                        game.play_sound("score")
228.
```

```
229.                self.time_to_live = 0
230.            else:
231.                self.time_to_live -= 1
232.
233.            if self.time_to_live <= 0:
234.                game.pops.append(Pop((self.x, self.y - 27), 0))
235.
236.            anim_frame = str([0, 1, 2, 1][(game.timer // 6) % 4])
237.            self.image = "fruit" + str(self.type) + anim_frame
238.
239.    class Player(GravityActor):
240.        def __init__(self):
241.            super().__init__((0, 0))
242.
243.            self.lives = 2
244.            self.score = 0
245.
246.        def reset(self):
247.            self.pos = (WIDTH / 2, 100)
248.            self.vel_y = 0
249.            self.direction_x = 1
250.            self.fire_timer = 0
251.            self.hurt_timer = 100
252.            self.health = 3
253.            self.blowing_orb = None
254.
255.        def hit_test(self, other):
256.            if self.collidepoint(other.pos) and self.hurt_timer < 0:
257.                self.hurt_timer = 200
258.                self.health -= 1
259.                self.vel_y = -12
260.                self.landed = False
261.                self.direction_x = other.direction_x
262.                if self.health > 0:
263.                    game.play_sound("ouch", 4)
264.                else:
265.                    game.play_sound("die")
266.                return True
267.            else:
268.                return False
269.
270.        def update(self):
271.            super().update(self.health > 0)
272.
273.            self.fire_timer -= 1
274.            self.hurt_timer -= 1
275.
```

```
276.              if self.landed:
277.                  self.hurt_timer = min(self.hurt_timer, 100)
278.
279.              if self.hurt_timer > 100:
280.                  if self.health > 0:
281.                      self.move(self.direction_x, 0, 4)
282.                  else:
283.                      if self.top >= HEIGHT*1.5:
284.                          self.lives -= 1
285.                          self.reset()
286.              else:
287.                  dx = 0
288.                  if keyboard.left:
289.                      dx = -1
290.                  elif keyboard.right:
291.                      dx = 1
292.
293.                  if dx != 0:
294.                      self.direction_x = dx
295.
296.                      if self.fire_timer < 10:
297.                          self.move(dx, 0, 4)
298.
299.                  if space_pressed() and self.fire_timer <= 0 and len(game.orbs) < 5:
300.                      x = min(730, max(70, self.x + self.direction_x * 38))
301.                      y = self.y - 35
302.                      self.blowing_orb = Orb((x,y), self.direction_x)
303.                      game.orbs.append(self.blowing_orb)
304.                      game.play_sound("blow", 4)
305.                      self.fire_timer = 20
306.
307.                  if keyboard.up and self.vel_y == 0 and self.landed:
308.                      self.vel_y = -16
309.                      self.landed = False
310.                      game.play_sound("jump")
311.
312.              if keyboard.space:
313.                  if self.blowing_orb:
314.                      self.blowing_orb.blown_frames += 4
315.                      if self.blowing_orb.blown_frames >= 120:
316.                          self.blowing_orb = None
317.              else:
318.                  self.blowing_orb = None
319.
320.              self.image = "blank"
321.              if self.hurt_timer <= 0 or self.hurt_timer % 2 == 1:
322.                  dir_index = "1" if self.direction_x > 0 else "0"
```

```
323.                    if self.hurt_timer > 100:
324.                        if self.health > 0:
325.                            self.image = "recoil" + dir_index
326.                        else:
327.                            self.image = "fall" + str((game.timer // 4) % 2)
328.                    elif self.fire_timer > 0:
329.                        self.image = "blow" + dir_index
330.                    elif dx == 0:
331.                        self.image = "still"
332.                    else:
333.                        self.image = "run" + dir_index + str((game.timer // 8) % 4)
334.
335.        class Robot(GravityActor):
336.            TYPE_NORMAL = 0
337.            TYPE_AGGRESSIVE = 1
338.
339.            def __init__(self, pos, type):
340.                super().__init__(pos)
341.
342.                self.type = type
343.
344.                self.speed = randint(1, 3)
345.                self.direction_x = 1
346.                self.alive = True
347.
348.                self.change_dir_timer = 0
349.                self.fire_timer = 100
350.
351.            def update(self):
352.                super().update()
353.
354.                self.change_dir_timer -= 1
355.                self.fire_timer += 1
356.
357.                if self.move(self.direction_x, 0, self.speed):
358.                    self.change_dir_timer = 0
359.
360.                if self.change_dir_timer <= 0:
361.                    directions = [-1, 1]
362.                    if game.player:
363.                        directions.append(sign(game.player.x - self.x))
364.                    self.direction_x = choice(directions)
365.                    self.change_dir_timer = randint(100, 250)
366.
367.                if self.type == Robot.TYPE_AGGRESSIVE and self.fire_timer >= 24:
368.                    for orb in game.orbs:
369.                        if orb.y >= self.top and orb.y < self.bottom and \
```

```
370.                        abs(orb.x - self.x) < 200:
371.                        self.direction_x = sign(orb.x - self.x)
372.                        self.fire_timer = 0
373.                        break
374.
375.            if self.fire_timer >= 12:
376.                fire_probability = game.fire_probability()
377.                if game.player and self.top < game.player.bottom and \
378.                    self.bottom > game.player.top:
379.                    fire_probability *= 10
380.                if random() < fire_probability:
381.                    self.fire_timer = 0
382.                    game.play_sound("laser", 4)
383.
384.            elif self.fire_timer == 8:
385.                game.bolts.append(Bolt((self.x + self.direction_x * 20, self.y - 38),
386.                                        self.direction_x))
387.
388.            for orb in game.orbs:
389.                if orb.trapped_enemy_type == None and self.collidepoint(orb.center):
390.                    self.alive = False
391.                    orb.floating = True
392.                    orb.trapped_enemy_type = self.type
393.                    game.play_sound("trap", 4)
394.                    break
395.
396.            direction_idx = "1" if self.direction_x > 0 else "0"
397.            image = "robot" + str(self.type) + direction_idx
398.            if self.fire_timer < 12:
399.                image += str(5 + (self.fire_timer // 4))
400.            else:
401.                image += str(1 + ((game.timer // 4) % 4))
402.            self.image = image
403.
404.
405.    class Game:
406.        def __init__(self, player=None):
407.            self.player = player
408.            self.level_colour = -1
409.            self.level = -1
410.
411.            self.next_level()
412.
413.        def fire_probability(self):
414.            return 0.001 + (0.0001 * min(100, self.level))
415.
416.        def max_enemies(self):
```

```
417.                return min((self.level + 6) // 2, 8)
418.
419.         def next_level(self):
420.             self.level_colour = (self.level_colour + 1) % 4
421.             self.level += 1
422.             self.grid = LEVELS[self.level % len(LEVELS)]
423.             self.grid = self.grid + [self.grid[0]]
424.             self.timer = -1
425.
426.             if self.player:
427.                 self.player.reset()
428.
429.             self.fruits = []
430.             self.bolts = []
431.             self.enemies = []
432.             self.pops = []
433.             self.orbs = []
434.
435.             num_enemies = 10 + self.level
436.             num_strong_enemies = 1 + int(self.level / 1.5)
437.             num_weak_enemies = num_enemies - num_strong_enemies
438.             self.pending_enemies = num_strong_enemies * [Robot.TYPE_AGGRESSIVE] + \
439.                                    num_weak_enemies * [Robot.TYPE_NORMAL]
440.
441.             shuffle(self.pending_enemies)
442.             self.play_sound("level", 1)
443.
444.         def get_robot_spawn_x(self):
445.             r = randint(0, NUM_COLUMNS-1)
446.
447.             for i in range(NUM_COLUMNS):
448.                 grid_x = (r+i) % NUM_COLUMNS
449.                 if self.grid[0][grid_x] == ' ':
450.                     return GRID_BLOCK_SIZE * grid_x + LEVEL_X_OFFSET + 12
451.
452.             return WIDTH/2
453.
454.         def update(self):
455.             self.timer += 1
456.
457.             for obj in self.fruits + self.bolts + self.enemies + self.pops + \
458.                 [self.player] + self.orbs:
459.                 if obj:
460.                     obj.update()
461.
462.             self.fruits = [f for f in self.fruits if f.time_to_live > 0]
463.             self.bolts = [b for b in self.bolts if b.active]
```

```
            self.enemies = [e for e in self.enemies if e.alive]
            self.pops = [p for p in self.pops if p.timer < 12]
            self.orbs = [o for o in self.orbs if o.timer < 250 and o.y > -40]

            if self.timer % 100 == 0 and len(self.pending_enemies + self.enemies) > 0:
                self.fruits.append(Fruit((randint(70, 730), randint(75, 400))))

            if self.timer % 81 == 0 and len(self.pending_enemies) > 0 and \
                len(self.enemies) < self.max_enemies():
                robot_type = self.pending_enemies.pop()
                pos = (self.get_robot_spawn_x(), -30)
                self.enemies.append(Robot(pos, robot_type))

            if len(self.pending_enemies + self.fruits + self.enemies + self.pops) == 0:
                if len([orb for orb in self.orbs if orb.trapped_enemy_type != None]) == 0:
                    self.next_level()

        def draw(self):
            screen.blit("bg%d" % self.level_colour, (0, 0))

            block_sprite = "block" + str(self.level % 4)

            for row_y in range(NUM_ROWS):
                row = self.grid[row_y]
                if len(row) > 0:
                    x = LEVEL_X_OFFSET
                    for block in row:
                        if block != ' ':
                            screen.blit(block_sprite, (x, row_y * GRID_BLOCK_SIZE))
                        x += GRID_BLOCK_SIZE

            all_objs = self.fruits + self.bolts + self.enemies + self.pops + self.orbs
            all_objs.append(self.player)
            for obj in all_objs:
                if obj:
                    obj.draw()

        def play_sound(self, name, count=1):
            if self.player:
                try:
                    sound = getattr(sounds, name + str(randint(0, count - 1)))
                    sound.play()
                except Exception as e:
                    print(e)

CHAR_WIDTH = [27, 26, 25, 26, 25, 25, 26, 25, 12, 26, 26, 25, 33, 25, 26,
              25, 27, 26, 26, 25, 26, 26, 38, 25, 25, 25]
```

```python
    def char_width(char):
        index = max(0, ord(char) - 65)
        return CHAR_WIDTH[index]

    def draw_text(text, y, x=None):
        if x == None:
            x = (WIDTH - sum([char_width(c) for c in text])) // 2

        for char in text:
            screen.blit("font0"+str(ord(char)), (x, y))
            x += char_width(char)

    IMAGE_WIDTH = {"life":44, "plus":40, "health":40}

    def draw_status():
        number_width = CHAR_WIDTH[0]
        s = str(game.player.score)
        draw_text(s, 451, WIDTH - 2 - (number_width * len(s)))
        draw_text("LEVEL " + str(game.level + 1), 451)

        lives_health = ["life"] * min(2, game.player.lives)
        if game.player.lives > 2:
            lives_health.append("plus")
        if game.player.lives >= 0:
            lives_health += ["health"] * game.player.health

        x = 0
        for image in lives_health:
            screen.blit(image, (x, 450))
            x += IMAGE_WIDTH[image]

    space_down = False

    def space_pressed():
        global space_down
        if keyboard.space:
            if space_down:
                return False
            else:
                space_down = True
                return True

    class State(Enum):
        MENU = 1
        PLAY = 2
        GAME_OVER = 3
```

```
558.    def update():
559.        global state, game
560.
561.        if state == State.MENU:
562.            if space_pressed():
563.                state = State.PLAY
564.                game = Game(Player())
565.            else:
566.                game.update()
567.
568.        elif state == State.PLAY:
569.            if game.player.lives < 0:
570.                game.play_sound("over")
571.                state = State.GAME_OVER
572.            else:
573.                game.update()
574.
575.        elif state == State.GAME_OVER:
576.            if space_pressed():
577.                state = State.MENU
578.                game = Game()
579.
580.    def draw():
581.        game.draw()
582.
583.        if state == State.MENU:
584.            screen.blit("title", (0, 0))
585.            anim_frame = min(((game.timer + 40) % 160) // 4, 9)
586.            screen.blit("space" + str(anim_frame), (130, 280))
587.
588.        elif state == State.PLAY:
589.            draw_status()
590.
591.        elif state == State.GAME_OVER:
592.            draw_status()
593.            screen.blit("over", (0, 0))
594.
595.    pygame.mixer.quit()
596.    pygame.mixer.init(44100, -16, 2, 1024)
597.
598.    music.play("theme")
599.    music.set_volume(0.3)
600.
601.    state = State.MENU
602.    game = Game()
603.    pgzrun.go()
```

CODE THE CLASSICS

1. The *Cavern* title for the attract screen

2. A variety of enemy sprite frames, including for them being trapped in bubbles

3. The pop animation for when fruit is collected or expires

4. The player sprite has several animation frames, including for running and jumping

Coding Today
Cavern

5 Four backgrounds are used for the various levels

6 The bubble popping animation

7 The fall animation is shown upon losing a life

8 Getting hit by enemy fire results in the recoil animation

9 Make sure to grab an extra life power-up if you spot one

10 Collect fruit left behind by defeated enemies for extra points

Action Platformer – Coding Today: Cavern

CODE THE CLASSICS

Chapter 3

Top-down Platformer

Play around with the benefits that a different perspective can lend to a game

F<i>rogger</i> turned traditional platform games on their head by adopting a top-down perspective. It's still fondly regarded more than three decades on – and continues to inspire programmers building games like modern mobile hit *Crossy Road*. The premise was simple: players guided frogs across a busy road and a river packed full of floating obstacles until they reached the safety of their home. Unusually, the player viewed the game as if they were hovering above the action. The game resembles a free-form maze, with players needing to plot a correct path from A to B to survive. Given that there are lots and lots of ways to die in this game, that's easier said than done.

Inspiration

Frogger was ported from the arcade to Atari computers by John D. Harris, who worked for On-Line Systems. He ended up having a long association with Atari machines, for which he also produced *Jawbreaker* and *Mouskattack*, while working for On-Line Systems. He pioneered new practices from early in his career, not only creating a copy-protection system for Atari but being the first to have a continuous music score playing during a game. As well as working on a 3D system for the Atari Jaguar, he has produced games for the PlayStation and has constantly sought to push the limits of design. Having been a partner in Pulsar Interactive Corp and now Platoteam Inc, he is acclaimed as one of gaming's legendary figures.

Frogger

Released 1981

Platforms Arcade

Atari 8-bit

Intellivision

Atari 2600

Atari 5200

ColecoVision

Commodore VIC-20

Commodore 64

Amstrad CPC

ZX Spectrum

TRS-80/Dragon 32

Timex Sinclair 1000

Timex Sinclair 2068

CODE THE CLASSICS

The game was originally ported to just about every machine possible at the time, but in 1998 it also appeared late on the Sega Mega Drive, SNES, Game Boy, and Game Boy Color.

Other Notables Ultima / Legend of Zelda / Pokémon

Why did the frog cross the road? To get to the other side, of course. But *how* did it cross the road? Well, that's an entirely different question and one which many players of the classic arcade game *Frogger* often asked themselves – especially when the green anthropomorphic amphibian under their control got squished beneath the wheels of yet another lorry.

And the frog did cross that road – millions of times over. The squishing aspect of this iconic highway/river crossing game may sound gruesome, but it sure made for a rewarding challenge, ensuring that, back in 1981, *Frogger* was a surefire hit for maker Konami. The combination of pure playability and a simple premise made it perfect for a coin-operated machine.

Back in the late 1970s and early 1980s, arcades flourished, leading to intense competition among games developers. The trick was to encourage players to insert as much of their (parents') hard-earned cash as possible, and the perceived wisdom was that games needed to be easily explained and understood in order to get those initial coins moving.

In *Frogger*'s case, all a player had to do was get the frog from the bottom of the screen to the top, dodging vehicles and crossing a hazardous river in order to scramble to safety. To keep players coming back for more, the developers made it difficult enough to ensure that failure would, at some point, be inevitable. The frustration resulting from not being able to get all five frogs to their various homes on the river bank was all that was needed to ensure the flow of cash into the arcade cabinet.

Fledgling programmer John D. Harris was at the start of his career when *Frogger* was released. He had started working as an independent developer in March 1981 and had cut his teeth developing versions of *Starhawk*, *Head-on*, and a *Berzerk*-style title – three games which, unfortunately, never saw the light of day. His breakthrough came with *Jawbreaker*, released that year by On-line Systems for the Atari 400 and 800 computers. It went down a storm with reviewers and gamers.

Even so, it attracted some controversy. *Jawbreaker* was the subject of an unsuccessful injunction from Atari due to its similarities to another arcade hit, *Pac-Man*. But it showcased John's flair for coding and he was subsequently given the task of officially converting *Frogger* from the arcades to Atari 8-bit computers. There was massive demand among gamers to be able to enjoy the coin-op hits at home, and it become the game that defined and truly kick-started his career.

Spawning ground

John grew up in the United States, and had been interested in gaming and coding from an early age. "My first exposure to game programming happened in junior high," he says. He recalls his school having an old Teletype terminal: machines like electromechanical typewriters which allowed typed messages to be sent from one

point to another. "We used it to play mainframe games like *Star Trek* or *Colossal Cave Adventure*," he continues, talking about two text-based computer games released in 1971 and 1976, respectively. "At the time, I was only vaguely aware that computers could do anything else."

Star Trek made a huge impression on him. As he watched someone playing the game, he noticed it was behaving differently to what he was used to seeing. "I asked him what was going on, and he said that he 'changed the program'. The blank look on my face let him know that I had no clue what he was talking about, so he graciously explained further about the BASIC programming language, and he showed me how to 'break' the game execution and list the program instructions. It was the definitive 'light bulb moment' that opened up a whole new world for me."

In the late 1970s, more and more home computers appeared on the market. The Olivetti P6060 was released in April 1975 and it boasted just 8kB of RAM in its lowest-priced incarnation (which, incidentally, cost an eye-watering $7950). Meanwhile, the 8-bit Apple II was released for $1298 in June 1977. A few months later, Commodore released the PET, a futuristic-looking home computer based around the MOS Technology 6502 processor which had up to 96kB of RAM. This machine made a big impression on John.

The PET was able to output monochrome graphics while software could be stored on cassette tape, a 5.25-inch floppy, 8-inch floppy, or a hard disk. "I really liked the Commodore PET and I knew a few people who had them," John says. "They would let me play with them from time to time and I had been saving money for one. But then a friend got an Apple II and it was an interesting contrast. While it was missing fundamental features like full-screen editing that made working with the machine much more cumbersome, I could see the extra graphics potential of the Apple." Still, John decided he would buy the PET and went to the store with his saved-up cash, excited about making his new purchase.

"But fate stepped in and provided an alternative choice," he recalls. "On the day I went into the store to buy the machine, they had just received an Atari 800. It didn't take long to discover that it had all of the ease-of-use features of the PET, and then some, plus the colour graphics capabilities of the Apple. There was no hint yet of how vastly superior it really was, but this combination of features resolved a nagging concern within me that I was settling for lesser capabilities in the PET in order to get a machine that was more fun to work with. Now I could have the best of both worlds."

Even so, John had the problems that come with early adoption. "There were no programs for the Atari other than the BASIC and Educational System cartridges, and there were no tapes. Yet I bought the Atari 800 and I couldn't have been happier with it." That decision had a major influence on John's life, leading to the porting of *Frogger* to that machine. "It's crazy to think how much different my life would have been had I entered that store one day earlier and been a PET owner," he adds.

Creating Frogger

In order to start porting *Frogger* to the Atari 400 and 800, John amassed some extra hardware. As well as his 48kB Atari 800, he had an Axlon RAMDISK that lent an extra 128kB of memory, a high-speed floppy disk interface made by LE Systems, and an Austin-Franklin 80-Column Board which presented an 80-column by 25-character

screen display on a monitor. With those in hand, he began to deconstruct the original game and make notes about the various aspects of its gameplay.

Simple, distinct sections made up the playing screen. In order for the frogs to get from the bottom of the screen to the top, they had to cross five lanes of highway (which is why the game was very nearly called *Highway Crossing Frog*). From there, they had to reach the pavement on the other side and then negotiate a river. In each of those two sections, the frogs had to avoid busy traffic and then avoid falling in the water by hopping on logs while staying clear of alligators' mouths and other floating hazards.

In order to be faithful to the original, these aspects had to be retained. John worked on recreating the visual look of the background, producing the graphics that separate out the screen into the various sections, taking care to include the starting pavement where the frogs began their perilous journey and the five homes at the top of the screen which allowed them to rest safely. John also created the frog itself and worked on its movement.

Thankfully, this was a straightforward task because the original designers had decided to go with four-way controls. "Eight-way movement would have offered more control, but it's also more likely to move in a diagonal when it wasn't intended, or vice versa," he explains. "Often that would come with fatal consequences." Indeed, keeping the movements simple worked well because it not only removed the potential margin for error, but allowed players to concentrate on the timing of the movements.

The arcade version had five rows of traffic, each of which would move in a different direction

"There's always a balance between having enough control depth to keep the player interested and challenged, but not too much to where the controls become a downfall," John adds. So the frogs were able to move left, right, up, and down, with the latter option tending only to be used when players made an error and had to resort to going back a step in order to avoid losing a life. At each step of the game, players had to keep those obstacles in mind.

The first set of obstacles were the vehicles. The arcade version had five rows of traffic, each of which would move in a different direction to the adjacent ones. This meant the bottom row would move right-to-left, the next left-to-right and so on, producing a challenging game environment. If all of the vehicles headed in the same direction, then it might have been possible for a player to quickly make their way from one corner of the traffic to another.

As it was, the game forced the brain to work with more complex movement patterns. In gaming, keeping a player on their toes and heightening the sense of danger is always a good thing. The arcade game also spiced things up by using different vehicles, some of which were longer or had different behaviours than the others.

"There are multiple simultaneous objectives in creating a game world," explains John. "It needs to be fun, but it should also have interesting visuals and sounds for

1 **A flyer for the US version of the coin-op, released by Sega/Gremlin**

LEAP FOR YOUR LIFE!

Life for frogs has never been more dangerous than with Sega/Gremlin's newest video game, Frogger™. The lily pads and ponds of yesterday are only a dream as players attempt to save Frogger from wreckless hot rods and hungry crocodiles.

Frogger is crazy. It's danger and fun rolled into one. Frogger leaps from speeding cars and trucks on a busy highway to slippery logs and diving turtles in a rushing river. His life is constantly in jeopardy, safe only in a protected swamp home along the treacherous river.

A one or two player game, Frogger has a special place among other games, with happy, toe-tapping music and intriguing game play that's fun for the whole family. Your profit skyrockets because Frogger scores big with every crowd.

©1981 Gremlin Industries, Inc.

FROGGER™
SEGA/Gremlin

3

4

a more complete experience. Most of the vehicle types are really only there for visual variety, with the play variety handled through the different regions of the screen. That said, a few types offer gameplay differences like faster movement or longer length."

The river section worked in much the same way, except instead of having to dodge through the gaps of the traffic, players needed to use the logs and the backs of turtles and alligators to step across. Since the gap here is water, it causes the instant loss of a life, and put a different spin on the second section, almost turning it into a level of its own.

"The two parts are very similar, but they are a way to get both visual and subtle variety in play," says John. "At their heart, both sections are still about navigating across scrolling safe or danger segments, with the water being the opposite of the roadway. So you hop through the gaps in the road, but avoid the gaps and hop onto the solid objects in the water. The water, however, offers additional options of having the turtles occasionally dive, adding an extra dimension to the player's navigation and planning. So as you progress up the screen from bottom to top, the game is able to add some additional challenge as you're getting closer to the home goals."

> **Players needed to use the logs and the backs of turtles and alligators to step across the river**

These home goals were the five safe places for the players' frogs to reside. Only one frog was able to stay on any one lily pad, so this added some extra pressure and required players to employ some clever tactics. This was doubly vital because there was no safe banking once the frog had hopped off the final log: the frog had to leap straight onto an empty lily pad. Timing and positional planning at this point became essential.

Collision detection

Without solid collision detection, obstacles don't mean much. "When a player makes a move, the code needs to work out where all the other objects on the screen are, according to their directions and speeds in relation to the character. It checks for collisions based on where you are: being hit by a vehicle in the street, landing in open water, and so on." If there was a collision, then the code needed to act upon it and kill the frog, resulting in a fun animation to show that the character has died (a skull and crossbones appeared in the original). There were many ways to lose a life.

A frog could be hit by a vehicle or end up in the water. It could collide with a snake, an otter, or the jaws of an alligator. It could try to use a turtle that was about to dive under water, taking the frog with it. It could also stay on a log for too long and end up going off the edge of the screen. When it came to trying to find a home, any frog which hopped into the bush by mistake, tried to take over an already

2 **Advert for the Atari 2600 console version of** *Frogger*

3 **Magazine advert for Sega's home computer conversions**

4 **A** *Frogger* **coin-op was featured in 'The Frogger' episode of the sitcom** *Seinfeld*

CODE THE CLASSICS

occupied home, or found the home had an alligator in it would also perish. All of this served to heighten the player's sense of peril – hopefully without causing them to slam down their controller in exasperation.

"As long as all of the mechanisms for one's demise are reasonable and consistent, then we're just increasing variety and not adding frustration," says John. "Granted, you can make the case that landing in water should not be fatal to a frog, but that's the rule defined by the game world – and the main point is that it's consistently that way, and part of the core gameplay. Frustration sets in if the rules aren't consistent or if players die from threats that aren't readily obvious in nature."

There was one other way in which a frog could die. Players could run out of time, since each of the levels had to be completed within a time limit. In *Frogger*, this was very important because it sped up a game that might otherwise be played rather slowly. Forget everything you've learned about crossing a real-life road with this game: getting across fast, albeit in one piece, was everything.

"With no time pressure, it would be too easy to casually wait for perfect opportunities," confirms John. "You could retreat into safer areas until the best gaps and alignments came along. The timer is really the only element that forces the player to keep driving forwards. It's what turns a stroll across the screen into a challenge in which the player needs to figure out paths in real-time while under pressure."

But how much time should a player have? "Figuring out the details of how much time to give is usually a matter of play-testing," says John. "If you lose lives too often because you're running out of time, then the timer needs to be increased. If you always have lots of time left, and you don't feel pressured to complete the level in a reasonable amount of time, then the timer needs to be shorter. Such tests need to be performed by people other than the primary developers, since they are usually too familiar with the game and would give times skewed on the faster side."

> **You can make the case that landing in water should not be fatal to a frog, but that's the rule**

With so much scope for losing a life, there also had to be a consideration over how many lives a player had. "Lives in games were generally picked to adjust how much time someone can continue to play on one quarter, back when arcades were the primary and intended audience for the game," John explains. "But ultimately, it is good design to let players survive a few mistakes, or else it would be too frustrating. If the number is too high, then there isn't enough urgency placed on survival. So three lives tends to be a good balance."

High-score table

Frogger also spurred people on with a scoring system, with points being awarded for each step of progress made. A high-score table was created for bragging rights, but there were also bonuses to collect along the way. This encouraged replays in the arcade version: "Bonuses are generally ways to give players something else to strive for once they have conquered the basic mechanics," says John – and bonuses also allowed them to gain more points for that all-important high-score table advantage.

"Once you can play successfully, then the challenge is whether you can also score the most points."

Working out how such a structured game could continue to be fun and keep people playing was all-important. When the original developers were creating *Frogger* in the arcades, the feeling of progression meant that players would keep putting more money into the coin-op machines, but even in home versions there is a need to give players a feeling they are getting value from their purchase.

"You always want early levels to be fairly easy for players to complete, so that they receive some immediate rewards and progress," advises John. "Then, as they learn the mechanics and become more skilled at navigating them, the game needs to increase the challenge or else players will become bored."

He says *Frogger* accomplished that in two ways: "It makes the paths more difficult and dangerous, and it gives the player less time to make the decisions on how to get through them. So it both increases the challenge, along with the sense of urgency. More specifically, it reduces the size of the gaps between vehicles, speeds up some of the vehicles, and reduces the number and size of the river turtles.

"Finally, it will replace some turtles with alligators, which are functionally just smaller turtles – there's no difference between landing on an alligator's head versus landing in the water – but they really do provide a more visceral threat. Having the greatest perceived threat also be right at the end, near the home goals, gives it maximum emotional impact, and maximum relief and satisfaction upon success."

Starting over

Initially, development of *Frogger* ran reasonably smoothly and the more John got to grips with his Atari 800, the more he began to fall in love with it. He dedicated himself to gaming, enjoying *Star Raider*, *Robotron 2084*, *Shamus*, and *Mouskattack*, and he almost became inseparable from his computer, taking it with him on trips so he could continue working.

"In the years to come, the Atari would forever establish itself in my mind as one of the greatest computers ever made," he says. "People were still discovering new graphic tricks and techniques ten years after the machine was introduced. If you compare the latest programs written for the Atari with the earliest programs, the huge difference between them is a testament to the magic they accomplished with its design."

But then disaster struck. His original saved *Frogger* code was stolen, along with all of his backups. "All I had left was an older backup that was near the beginning of

The objectives

Short term: Start with the background elements – this way you can get the largest amount of visual progress done early on.

Medium term: Add the frog movement, player controls, and collision detection – enough for a basic playable game.

Long term: Throw in the remaining elements like snakes, alligators, bonus items, and a timer. Here is also where the game should be tested for balance, excitement, and frustration.

stage 3," he says. "I had the basic gameplay, but all the additional elements, and all the balancing, were gone." It meant John ended up writing *Frogger* not once but twice, and he says the second time didn't feel as good as the first.

"I kept trying to remember and recreate what I had already done, mixed with the emotions of the loss," John continues. "If I could have separated myself from all that, and just re-solved the issues rather than reconstruct earlier solutions, I probably could have saved myself a lot of time and grief." Fortunately, though, the version he created sparkled, and it communicated the very essence of what made *Frogger* a major hit. Sales were helped by the game's long-lived popularity in the arcades. Indeed, the game – along with *Joust*, *Millipede*, *Super Pac-Man*, and *Donkey Kong Jr* – was used in the first video game world championships held in January 1983. The highest-ever score for the arcade game is 970,440 points, achieved in 2012, which shows the game's enduring popularity.

Frogger wasn't the end of the road for the green hero, though. It gained a number of follow-ups including *Frogger II: ThreeeDeep!*, which introduced three consecutive screens, while *Ribbit!* allowed the frogs to gobble wasps, flies, and crabs. *Frogger 2* on the Game Boy Color allowed players to control Frogger's girlfriend Lily. "It's the only genre I can think of where you have so many options, and so much control," says John. "The creative limits are boundless and it's an excellent mix between creative energies and technical challenges. I wish you all the best if you choose to follow this path."

But how does John view the earliest days of the industry, when *Frogger* was still set to leap on to the masses? "The most interesting detail about the early computer scene, and also one of the things I miss the most, is that everyone was very open about their efforts, and each new discovery was enthusiastically shared," John says. "It was an era of experimentation, and the first thing we'd do after finding something new was tell everyone else about it. This was only partially due to the desire to 'look cool' for figuring it out. There was also a genuine desire for others to benefit from it, because the more people we had using the best techniques, the better programs we would get at every level."

5 **The *Frogger* coin-op featured a vertical screen arrangement**

6 **Home versions, including John's Atari 800 game, had to convert this to a horizontal TV screen**

Learn from the master

John D. Harris has constantly looked to improve his design skills, learning new techniques as he's moved from one platform to another.

Difficulty level: You always want early levels to be fairly easy for players to complete, so that they receive some immediate rewards and progress.

Easy controls: The simpler the control scheme is, the more intuitive your game will be to play and the less potential there will be for input mistakes or confusion.

5

6

Infinite BUNNER

START

89 182

Coding Today
Infinite Bunner

Infinite Bunner is our take on the classic *Frogger* gameplay. The original game takes place on a single screen, with a busy road at the bottom and a river at the top. In our game, the level is procedurally generated and scrolls continuously. The player must progress fast enough to avoid falling off the bottom of the screen – if this happens, an `Eagle` flies down the screen and catches the player, resulting in Game Over.

The level is divided into a series of sections, each of a particular type – `Grass`, `Dirt`, `Road`, `Pavement`, `Rail`, or `Water`. Each section is made up of a series of rows, where each row corresponds to one sprite from the images folder. Rows are 40 pixels high, although you may notice that some of the sprites are 60 pixels high; this is just a visual effect – the sprite overhangs the row above, but the row is still considered 40 pixels high for gameplay purposes.

Download the code

Download the fully commented *Infinite Bunner* game code, along with all the graphics and sounds, from **rptl.io/ctc-one-code**

CODE THE CLASSICS

Challenges

- `ActiveRow.update` ensures a minimum distance of 240 pixels between the start of one child object and the start of the next – or half that for rows where child objects have a speed of 2. A random factor varies the distance between each child object. These rules apply to both `Road` and `Water` rows – but how would you make it so that each of those row types could have its own custom values or rules for the spacing of child objects?

- Try adding a new type of row to the game – perhaps lava, ice, or space? The graphics could initially be a copy and recolouring of an existing row type's. More importantly, you'll need to think about whether the new row will be a variation on an existing one, or have a completely new gameplay mechanic.

`Road`, `Water`, and `Rail` sections all feature moving objects: `Cars`, `Logs`, and trains (the latter has no class of its own). `Grass` sections may contain `Hedges`, which the player must walk around. Because these objects always stay within their rows, we classify them as child objects of the rows. Child objects are drawn relative to their parent rows – e.g. if a road row has a Y coordinate of 200, and a car on the road has a Y coordinate of 10, the car would be drawn at Y coordinate 210. To provide this functionality, all objects in the game inherit from a class called `MyActor`, which in turn inherits from Pygame Zero's built-in `Actor` class. `MyActor` works just like `Actor` except that it overrides the update and draw methods in order to update and draw the list of child objects. It also ensures objects are drawn at the correct position on screen, taking the scrolling of the level into account.

All rows inherit from the `Row` class. This performs several important tasks, such as collision detection. Some of the methods provide default results, which can be overridden in inherited classes. For example, the `push` method – called by the player to determine movement on the x-axis – returns zero, resulting in no movement. In the `Water` class, however, this method is overridden, and causes the player to move on the x-axis if they're currently sitting on a log.

The `ActiveRow` class inherits from `Row`, and is the base class for `Water` and `Road`. What those two classes have in common is that they both feature moving objects (logs and cars) which start just off-screen and move horizontally. `ActiveRow` deals with creating and destroying these child objects. The two subclasses override a number of methods – one key example being

Colliding with a car kills the player and replaces the player sprite with the 'splat' image

`check_collision`. The `Bunner.update` method calls this to find out if the player has collided with something, and if so, what to do about it. In the case of `Road`, colliding with a car kills the player and replaces the player sprite with the 'splat' image. For `Water`, however, colliding with a log is a good thing, whereas not colliding with a log ends the game and replaces the player sprite with the 'splash' animation.

The `Game` class maintains a reference to the player object, and is also responsible for creating, updating, and deleting rows. The final part of the code uses a simple state machine system to update and draw the game objects.

Infinite Bunner
Coding Today

Rows after rows after rows

The `__init__` (constructor) method of the `Game` class creates a list to contain the rows. To begin with, this just contains a single `Grass` row. This will be the first row, and will appear at the bottom of the screen – but how does the game decide which types of rows to create after that? Each row class – `Grass`, `Road`, `Dirt`, `Rail`, `Pavement`, and `Water` – has a `next` method, which decides what the next row will be. Each method makes a decision based on the current row's `index` – in other words, the number of the row's sprite.

There are 16 grass and dirt sprites, four rail sprites, six road sprites, three pavement sprites, and eight water sprites. These sprites only tile together correctly in certain combinations – for example, Grass 6 must be followed by Grass 7. So some of the rules in the next methods ensure that such rows occur in the correct sequence. Other rules make random choices as to which row comes next. For example, a sequence of `Grass` or `Dirt` rows is followed by either `Road` or `Water`.

Random probabilities of rows can also be used to determine how many rows of certain types occur in sequence. In the case of `Water` rows, there are always at least two in sequence, but after the second one there's always a 50-50 chance of another, up to a maximum of seven. The use of randomness ensures that the level is different each time you play.

Solving the Hedge-mask

`Grass` rows sometimes contain `Hedges`. These block certain parts of the row, requiring the player to make a detour around them. The function `generate_hedge_mask` decides the layout of hedge segments in a row. A mask is a series of Boolean values which allow or prevent parts of an underlying image from showing through. This function creates a mask representing the presence or absence of hedges in a `Grass` row. `False` means a hedge is present; `True` represents a gap.

Initially we create a list of twelve elements. For each element there is a small chance of a gap, but often all elements will be `False`, representing a hedge with no gaps. We then randomly set one element to `True`, to ensure that there is always at least one gap that the player can get through. Single-tile gaps aren't wide enough for the player to fit through, so the next step is to widen any gaps to a minimum of three tiles. Once the mask has been generated, the function `classify_hedge_segment` is used to determine which sprite to use for each hedge segment.

CODE THE CLASSICS

How to run the game

Open the **bunner.py** file in a Python editor, such as IDLE, and select Run > Run Module.
For more details, see the 'Setting Up' section on page 170.

Download the code `rptl.io/ctc-one-code`

```
001.    import pgzero, pgzrun, pygame, sys
002.    from random import *
003.    from enum import Enum
004.
005.    if sys.version_info < (3,6):
006.        print("This game requires at least version 3.6 of Python. Please download"
007.              "it from www.python.org")
008.        sys.exit()
009.
010.    pgzero_version = [int(s) if s.isnumeric() else s
011.                     for s in pgzero.__version__.split('.')]
012.    if pgzero_version < [1,2]:
013.        print(f"This game requires at least version 1.2 of Pygame Zero. You are"
014.              "using version {pgzero.__version__}. Please upgrade using the command"
015.              "'pip install --upgrade pgzero'")
016.        sys.exit()
017.
018.    WIDTH = 480
019.    HEIGHT = 800
020.    TITLE = "Infinite Bunner"
021.
022.    ROW_HEIGHT = 40
023.    DEBUG_SHOW_ROW_BOUNDARIES = False
024.
025.    class MyActor(Actor):
026.        def __init__(self, image, pos, anchor=("center", "bottom")):
027.            super().__init__(image, pos, anchor)
028.            self.children = []
029.
030.        def draw(self, offset_x, offset_y):
031.            self.x += offset_x
032.            self.y += offset_y
033.
034.            super().draw()
035.            for child_obj in self.children:
036.                child_obj.draw(self.x, self.y)
037.
038.            self.x -= offset_x
039.            self.y -= offset_y
```

Infinite Bunner
Coding Today

```
040.
041.        def update(self):
042.            for child_obj in self.children:
043.                child_obj.update()
044.
045.    class Eagle(MyActor):
046.        def __init__(self, pos):
047.            super().__init__("eagles", pos)
048.            self.children.append(MyActor("eagle", (0, -32)))
049.
050.        def update(self):
051.            self.y += 12
052.
053.    class PlayerState(Enum):
054.        ALIVE = 0,
055.        SPLAT = 1,
056.        SPLASH = 2,
057.        EAGLE = 3
058.
059.    DIRECTION_UP = 0
060.    DIRECTION_RIGHT = 1
061.    DIRECTION_DOWN = 2
062.    DIRECTION_LEFT = 3
063.
064.    direction_keys = [keys.UP, keys.RIGHT, keys.DOWN, keys.LEFT]
065.
066.    DX = [0,4,0,-4]
067.    DY = [-4,0,4,0]
068.
069.    class Bunner(MyActor):
070.        MOVE_DISTANCE = 10
071.
072.        def __init__(self, pos):
073.            super().__init__("blank", pos)
074.            self.state = PlayerState.ALIVE
075.            self.direction = 2
076.            self.timer = 0
077.            self.input_queue = []
078.            self.min_y = self.y
079.
080.        def handle_input(self, dir):
081.            for row in game.rows:
082.                if row.y == self.y + Bunner.MOVE_DISTANCE * DY[dir]:
083.                    if row.allow_movement(self.x + Bunner.MOVE_DISTANCE * DX[dir]):
084.                        self.direction = dir
085.                        self.timer = Bunner.MOVE_DISTANCE
086.                        game.play_sound("jump", 1)
```

```
087.                    return
088.         def update(self):
089.             for direction in range(4):
090.                 if key_just_pressed(direction_keys[direction]):
091.                     self.input_queue.append(direction)
092.
093.             if self.state == PlayerState.ALIVE:
094.                 if self.timer == 0 and len(self.input_queue) > 0:
095.                     self.handle_input(self.input_queue.pop(0))
096.
097.                 land = False
098.
099.                 if self.timer > 0:
100.                     self.x += DX[self.direction]
101.                     self.y += DY[self.direction]
102.                     self.timer -= 1
103.                     land = self.timer == 0
104.
105.                 current_row = None
106.                 for row in game.rows:
107.                     if row.y == self.y:
108.                         current_row = row
109.                         break
110.
111.                 if current_row:
112.                     self.state, dead_obj_y_offset = current_row.check_collision(self.x)
113.
114.                     if self.state == PlayerState.ALIVE:
115.                         self.x += current_row.push()
116.
117.                         if land:
118.                             current_row.play_sound()
119.                     else:
120.                         if self.state == PlayerState.SPLAT:
121.                             current_row.children.insert(0, MyActor("splat" + \
122.                                 str(self.direction), (self.x, dead_obj_y_offset)))
123.                         self.timer = 100
124.                 else:
125.                     if self.y > game.scroll_pos + HEIGHT + 80:
126.                         game.eagle = Eagle((self.x, game.scroll_pos))
127.                         self.state = PlayerState.EAGLE
128.                         self.timer = 150
129.                         game.play_sound("eagle")
130.
131.                 self.x = max(16, min(WIDTH - 16, self.x))
132.             else:
133.                 self.timer -= 1
```

Infinite Bunner
Coding Today

```
134.
135.                self.min_y = min(self.min_y, self.y)
136.                self.image = "blank"
137.
138.                if self.state == PlayerState.ALIVE:
139.                    if self.timer > 0:
140.                        self.image = "jump" + str(self.direction)
141.                    else:
142.                        self.image = "sit" + str(self.direction)
143.                elif self.state == PlayerState.SPLASH and self.timer > 84:
144.                    self.image = "splash" + str(int((100 - self.timer) / 2))
145.
146.        class Mover(MyActor):
147.            def __init__(self, dx, image, pos):
148.                super().__init__(image, pos)
149.                self.dx = dx
150.
151.            def update(self):
152.                self.x += self.dx
153.
154.        class Car(Mover):
155.            SOUND_ZOOM = 0
156.            SOUND_HONK = 1
157.
158.            def __init__(self, dx, pos):
159.                image = "car" + str(randint(0, 3)) + ("0" if dx < 0 else "1")
160.                super().__init__(dx, image, pos)
161.                self.played = [False, False]
162.                self.sounds = [("zoom", 6), ("honk", 4)]
163.
164.            def play_sound(self, num):
165.                if not self.played[num]:
166.                    game.play_sound(*self.sounds[num])
167.                    self.played[num] = True
168.
169.        class Log(Mover):
170.            def __init__(self, dx, pos):
171.                image = "log" + str(randint(0, 1))
172.                super().__init__(dx, image, pos)
173.
174.        class Train(Mover):
175.            def __init__(self, dx, pos):
176.                image = "train"   +str(randint(0, 2)) + ("0" if dx < 0 else "1")
177.                super().__init__(dx, image, pos)
178.
179.        class Row(MyActor):
180.            def __init__(self, base_image, index, y):
```

```
181.                super().__init__(base_image + str(index), (0, y), ("left", "bottom"))
182.                self.index = index
183.                self.dx = 0
184.
185.            def next(self):
186.                return
187.
188.            def collide(self, x, margin=0):
189.                for child_obj in self.children:
190.                    if x >= child_obj.x - (child_obj.width / 2) - margin \
191.                            and x < child_obj.x + (child_obj.width / 2) + margin:
192.                        return child_obj
193.
194.                return None
195.
196.            def push(self):
197.                return 0
198.
199.            def check_collision(self, x):
200.                return PlayerState.ALIVE, 0
201.
202.            def allow_movement(self, x):
203.                return x >= 16 and x <= WIDTH-16
204.
205.        class ActiveRow(Row):
206.            def __init__(self, child_type, dxs, base_image, index, y):
207.                super().__init__(base_image, index, y)
208.                self.child_type = child_type
209.                self.timer = 0
210.                self.dx = choice(dxs)
211.
212.                x = -WIDTH / 2 - 70
213.                while x < WIDTH / 2 + 70:
214.                    x += randint(240, 480)
215.                    pos = (WIDTH / 2 + (x if self.dx > 0 else -x), 0)
216.                    self.children.append(self.child_type(self.dx, pos))
217.
218.            def update(self):
219.                super().update()
220.                self.children = [c for c in self.children if c.x > -70 and c.x < WIDTH + 70]
221.                self.timer -= 1
222.
223.                if self.timer < 0:
224.                    pos = (WIDTH + 70 if self.dx < 0 else -70, 0)
225.                    self.children.append(self.child_type(self.dx, pos))
226.                    self.timer = (1.0 + random()) * (240.0 / abs(self.dx))
227.
```

```
228.    class Hedge(MyActor):
229.        def __init__(self, x, y, pos):
230.            super().__init__("bush"+str(x)+str(y), pos)
231.
232.    def generate_hedge_mask():
233.        mask = [random() < 0.01 for i in range(12)]
234.        mask[randint(0, 11)] = True
235.        mask = [sum(mask[max(0, i-1):min(12, i+2)]) > 0 for i in range(12)]
236.
237.        return [mask[0]] + mask + 2 * [mask[-1]]
238.
239.    def classify_hedge_segment(mask, previous_mid_segment):
240.        if mask[1]:
241.            sprite_x = None
242.        else:
243.            sprite_x = 3 - 2 * mask[0] - mask[2]
244.
245.        if sprite_x == 3:
246.            if previous_mid_segment == 4 and mask[3]:
247.                return 5, None
248.            else:
249.                if previous_mid_segment == None or previous_mid_segment == 4:
250.                    sprite_x = 3
251.                elif previous_mid_segment == 3:
252.                    sprite_x = 4
253.                return sprite_x, sprite_x
254.        else:
255.            return sprite_x, None
256.
257.    class Grass(Row):
258.        def __init__(self, predecessor, index, y):
259.            super().__init__("grass", index, y)
260.            self.hedge_row_index = None
261.            self.hedge_mask = None
262.
263.            if not isinstance(predecessor, Grass) or predecessor.hedge_row_index == None:
264.                if random() < 0.5 and index > 7 and index < 14:
265.                    self.hedge_mask = generate_hedge_mask()
266.                    self.hedge_row_index = 0
267.            elif predecessor.hedge_row_index == 0:
268.                self.hedge_mask = predecessor.hedge_mask
269.                self.hedge_row_index = 1
270.
271.            if self.hedge_row_index != None:
272.                previous_mid_segment = None
273.                for i in range(1, 13):
274.                    sprite_x, previous_mid_segment = \
```

```python
275.                            classify_hedge_segment(self.hedge_mask[i - 1:i + 3],
276.                            previous_mid_segment)
277.                    if sprite_x != None:
278.                        self.children.append(Hedge(sprite_x, self.hedge_row_index,
279.                            (i * 40 - 20, 0)))
280.
281.        def allow_movement(self, x):
282.            return super().allow_movement(x) and not self.collide(x, 8)
283.
284.        def play_sound(self):
285.            game.play_sound("grass", 1)
286.
287.        def next(self):
288.            if self.index <= 5:
289.                row_class, index = Grass, self.index + 8
290.            elif self.index == 6:
291.                row_class, index = Grass, 7
292.            elif self.index == 7:
293.                row_class, index = Grass, 15
294.            elif self.index >= 8 and self.index <= 14:
295.                row_class, index = Grass, self.index + 1
296.            else:
297.                row_class, index = choice((Road, Water)), 0
298.
299.            return row_class(self, index, self.y - ROW_HEIGHT)
300.
301.    class Dirt(Row):
302.        def __init__(self, predecessor, index, y):
303.            super().__init__("dirt", index, y)
304.
305.        def play_sound(self):
306.            game.play_sound("dirt", 1)
307.
308.        def next(self):
309.            if self.index <= 5:
310.                row_class, index = Dirt, self.index + 8
311.            elif self.index == 6:
312.                row_class, index = Dirt, 7
313.            elif self.index == 7:
314.                row_class, index = Dirt, 15
315.            elif self.index >= 8 and self.index <= 14:
316.                row_class, index = Dirt, self.index + 1
317.            else:
318.                row_class, index = choice((Road, Water)), 0
319.
320.            return row_class(self, index, self.y - ROW_HEIGHT)
321.
```

```python
322.    class Water(ActiveRow):
323.        def __init__(self, predecessor, index, y):
324.            dxs = [-2,-1]*(predecessor.dx >= 0) + [1,2]*(predecessor.dx <= 0)
325.            super().__init__(Log, dxs, "water", index, y)
326.
327.        def update(self):
328.            super().update()
329.
330.            for log in self.children:
331.                if game.bunner and self.y == game.bunner.y \
332.                    and log == self.collide(game.bunner.x, -4):
333.                    log.y = 2
334.                else:
335.                    log.y = 0
336.
337.        def push(self):
338.            return self.dx
339.
340.        def check_collision(self, x):
341.            if self.collide(x, -4):
342.                return PlayerState.ALIVE, 0
343.            else:
344.                game.play_sound("splash")
345.                return PlayerState.SPLASH, 0
346.
347.        def play_sound(self):
348.            game.play_sound("log", 1)
349.
350.        def next(self):
351.            if self.index == 7 or (self.index >= 1 and random() < 0.5):
352.                row_class, index = Dirt, randint(4,6)
353.            else:
354.                row_class, index = Water, self.index + 1
355.
356.            return row_class(self, index, self.y - ROW_HEIGHT)
357.
358.    class Road(ActiveRow):
359.        def __init__(self, predecessor, index, y):
360.            dxs = list(set(range(-5, 6)) - set([0, predecessor.dx]))
361.            super().__init__(Car, dxs, "road", index, y)
362.
363.        def update(self):
364.            super().update()
365.
366.            for y_offset, car_sound_num in [(-ROW_HEIGHT, Car.SOUND_ZOOM),
367.                    (0, Car.SOUND_HONK), (ROW_HEIGHT, Car.SOUND_ZOOM)]:
368.                if game.bunner and game.bunner.y == self.y + y_offset:
```

```
369.                    for child_obj in self.children:
370.                        if isinstance(child_obj, Car):
371.                            dx = child_obj.x - game.bunner.x
372.                            if abs(dx) < 100 and ((child_obj.dx < 0) != (dx < 0)) \
373.                                    and (y_offset == 0 or abs(child_obj.dx) > 1):
374.                                child_obj.play_sound(car_sound_num)
375.
376.        def check_collision(self, x):
377.            if self.collide(x):
378.                game.play_sound("splat", 1)
379.                return PlayerState.SPLAT, 0
380.            else:
381.                return PlayerState.ALIVE, 0
382.
383.        def play_sound(self):
384.            game.play_sound("road", 1)
385.
386.        def next(self):
387.            if self.index == 0:
388.                row_class, index = Road, 1
389.            elif self.index < 5:
390.                r = random()
391.                if r < 0.8:
392.                    row_class, index = Road, self.index + 1
393.                elif r < 0.88:
394.                    row_class, index = Grass, randint(0,6)
395.                elif r < 0.94:
396.                    row_class, index = Rail, 0
397.                else:
398.                    row_class, index = Pavement, 0
399.            else:
400.                r = random()
401.                if r < 0.6:
402.                    row_class, index = Grass, randint(0,6)
403.                elif r < 0.9:
404.                    row_class, index = Rail, 0
405.                else:
406.                    row_class, index = Pavement, 0
407.
408.            return row_class(self, index, self.y - ROW_HEIGHT)
409.
410.    class Pavement(Row):
411.        def __init__(self, predecessor, index, y):
412.            super().__init__("side", index, y)
413.
414.        def play_sound(self):
415.            game.play_sound("sidewalk", 1)
```

```
416.
417.        def next(self):
418.            if self.index < 2:
419.                row_class, index = Pavement, self.index + 1
420.            else:
421.                row_class, index = Road, 0
422.
423.            return row_class(self, index, self.y - ROW_HEIGHT)
424.
425.    class Rail(Row):
426.        def __init__(self, predecessor, index, y):
427.            super().__init__("rail", index, y)
428.            self.predecessor = predecessor
429.
430.        def update(self):
431.            super().update()
432.
433.            if self.index == 1:
434.                self.children = [c for c in self.children if c.x > -1000
435.                    and c.x < WIDTH + 1000]
436.
437.                if self.y < game.scroll_pos+HEIGHT and len(self.children) == 0 \
438.                    and random() < 0.01:
439.                    dx = choice([-20, 20])
440.                    self.children.append(Train(dx, (WIDTH + 1000 if dx < 0 else -1000, -13)))
441.                    game.play_sound("bell")
442.                    game.play_sound("train", 2)
443.
444.        def check_collision(self, x):
445.            if self.index == 2 and self.predecessor.collide(x):
446.                game.play_sound("splat", 1)
447.                return PlayerState.SPLAT, 8
448.            else:
449.                return PlayerState.ALIVE, 0
450.
451.        def play_sound(self):
452.            game.play_sound("grass", 1)
453.
454.        def next(self):
455.            if self.index < 3:
456.                row_class, index = Rail, self.index + 1
457.            else:
458.                item = choice( ((Road, 0), (Water, 0)) )
459.                row_class, index = item[0], item[1]
460.
461.            return row_class(self, index, self.y - ROW_HEIGHT)
462.
```

```
463.    class Game:
464.        def __init__(self, bunner=None):
465.            self.bunner = bunner
466.            self.looped_sounds = {}
467.
468.            try:
469.                if bunner:
470.                    music.set_volume(0.4)
471.                else:
472.                    music.play("theme")
473.                    music.set_volume(1)
474.            except:
475.                pass
476.
477.            self.eagle = None
478.            self.frame = 0
479.            self.rows = [Grass(None, 0, 0)]
480.            self.scroll_pos = -HEIGHT
481.
482.        def update(self):
483.            if self.bunner:
484.                self.scroll_pos -= max(1, min(3, float(self.scroll_pos + HEIGHT
485.                    - self.bunner.y) / (HEIGHT // 4)))
486.            else:
487.                self.scroll_pos -= 1
488.
489.            self.rows = [row for row in self.rows if row.y < int(self.scroll_pos)
490.                + HEIGHT + ROW_HEIGHT * 2]
491.
492.            while self.rows[-1].y > int(self.scroll_pos)+ROW_HEIGHT:
493.                new_row = self.rows[-1].next()
494.                self.rows.append(new_row)
495.
496.            for obj in self.rows + [self.bunner, self.eagle]:
497.                if obj:
498.                    obj.update()
499.
500.            if self.bunner:
501.                for name, count, row_class in [("river", 2, Water), ("traffic", 3, Road)]:
502.                    volume = sum([16.0 / max(16.0, abs(r.y - self.bunner.y)) for r in
503.                        self.rows if isinstance(r, row_class)]) - 0.2
504.                    volume = min(0.4, volume)
505.                    self.loop_sound(name, count, volume)
506.
507.            return self
508.
509.        def draw(self):
```

```
510.            all_objs = list(self.rows)
511.
512.            if self.bunner:
513.                all_objs.append(self.bunner)
514.
515.            def sort_key(obj):
516.                return (obj.y + 39) // ROW_HEIGHT
517.
518.            all_objs.sort(key=sort_key)
519.            all_objs.append(self.eagle)
520.
521.            for obj in all_objs:
522.                if obj:
523.                    obj.draw(0, -int(self.scroll_pos))
524.
525.            if DEBUG_SHOW_ROW_BOUNDARIES:
526.                for obj in all_objs:
527.                    if obj and isinstance(obj, Row):
528.                        pygame.draw.rect(screen.surface, (255, 255, 255),
529.                                pygame.Rect(obj.x, obj.y - int(self.scroll_pos),
530.                                screen.surface.get_width(), ROW_HEIGHT), 1)
531.                        screen.draw.text(str(obj.index), (obj.x, obj.y
532.                                - int(self.scroll_pos) - ROW_HEIGHT))
533.
534.        def score(self):
535.            return int(-320 - game.bunner.min_y) // 40
536.
537.        def play_sound(self, name, count=1):
538.            if self.bunner:
539.                sound = getattr(sounds, name + str(randint(0, count - 1)))
540.                sound.play()
541.
542.        def loop_sound(self, name, count, volume):
543.            if volume > 0 and not name in self.looped_sounds:
544.                full_name = name + str(randint(0, count - 1))
545.                sound = getattr(sounds, full_name)
546.                sound.play(-1)
547.                self.looped_sounds[name] = sound
548.
549.            if name in self.looped_sounds:
550.                sound = self.looped_sounds[name]
551.                if volume > 0:
552.                    sound.set_volume(volume)
553.                else:
554.                    sound.stop()
555.                    del self.looped_sounds[name]
556.
```

```python
557.        def stop_looped_sounds(self):
558.            for sound in self.looped_sounds.values():
559.                sound.stop()
560.            self.looped_sounds.clear()
561.
562.    key_status = {}
563.
564.    def key_just_pressed(key):
565.        result = False
566.        prev_status = key_status.get(key, False)
567.
568.        if not prev_status and keyboard[key]:
569.            result = True
570.
571.        key_status[key] = keyboard[key]
572.
573.        return result
574.
575.    def display_number(n, colour, x, align):
576.        n = str(n)
577.        for i in range(len(n)):
578.            screen.blit("digit" + str(colour) + n[i], (x + (i - len(n) * align) * 25, 0))
579.
580.    class State(Enum):
581.        MENU = 1,
582.        PLAY = 2,
583.        GAME_OVER = 3
584.
585.    def update():
586.        global state, game, high_score
587.
588.        if state == State.MENU:
589.            if key_just_pressed(keys.SPACE):
590.                state = State.PLAY
591.                game = Game(Bunner((240, -320)))
592.            else:
593.                game.update()
594.
595.        elif state == State.PLAY:
596.            if game.bunner.state != PlayerState.ALIVE and game.bunner.timer < 0:
597.                high_score = max(high_score, game.score())
598.
599.                try:
600.                    with open("high.txt", "w") as file:
601.                        file.write(str(high_score))
602.                except:
603.                    pass
```

Infinite Bunner
Coding Today

```
604.
605.                    state = State.GAME_OVER
606.                else:
607.                    game.update()
608.
609.            elif state == State.GAME_OVER:
610.                if key_just_pressed(keys.SPACE):
611.                    game.stop_looped_sounds()
612.                    state = State.MENU
613.                    game = Game()
614.
615.        def draw():
616.            game.draw()
617.
618.            if state == State.MENU:
619.                screen.blit("title", (0, 0))
620.                screen.blit("start" + str([0, 1, 2, 1][game.scroll_pos // 6 % 4]),
621.                    ((WIDTH - 270) // 2, HEIGHT - 240))
622.            elif state == State.PLAY:
623.                display_number(game.score(), 0, 0, 0)
624.                display_number(high_score, 1, WIDTH - 10, 1)
625.
626.            elif state == State.GAME_OVER:
627.                screen.blit("gameover", (0, 0))
628.
629.        try:
630.            pygame.mixer.quit()
631.            pygame.mixer.init(44100, -16, 2, 512)
632.            pygame.mixer.set_num_channels(16)
633.        except:
634.            pass
635.
636.        try:
637.            with open("high.txt", "r") as f:
638.                high_score = int(f.read())
639.        except:
640.            high_score = 0
641.
642.        state = State.MENU
643.        game = Game()
644.
645.        pgzrun.go()
```

CODE THE CLASSICS

1. Trains hurtle along the rail tracks
2. Get scrolled off the bottom of the screen and an eagle will swoop down for the kill
3. The digits used to show the current and high scores
4. Hedge must be constructed so there's a gap to pass through
5. Frames of the animation for falling into the water
6. Movement and splat animation frames for our bunny

Coding Today
Infinite Bunner

7 The game over screen features a flattened bunny

8 The scrolling backdrop is contructed from horizontal rows such as dirt, grass, and rail tracks

9 Various-coloured cars move right and left along the roads

10 Logs enable the bunny to safely traverse rivers

CODE THE CLASSICS

Chapter 4

Fixed Shooter

Some shooters confine the gameplay to a single screen while limiting the player's movement. Restrictions can build challenge and difficulty, making for truly addictive gaming

A fixed shooter is one style of shoot-'em-up game, restricting a player's character to a particular axis or a small section of a single screen. Many early titles made use of this gaming mechanic, from *Space Invaders* to *Galaxian*, and one of the most popular was *Centipede*, published by Atari in 1980. One of the first twitch games, the original arcade version made use of a mini-trackball as a controller, requiring lightning-fast reactions to prevent a long centipede from reaching the bottom of the screen. As well as shooting the centipede itself, players had to blast the fungi in its path to slow it down – munching on a mushroom would cause the centipede to fall to the next row. Accidentally hitting the centipede in the middle would cause it to split into two pieces, doubling the danger. Added insect enemies increased the tension and pace.

Inspiration

Centipede was developed for Atari by Dona Bailey and her superviser Ed Logg. Dona started her career working for General Motors, programming displays and cruise-control systems, but she became interested in games after playing the likes of *Space Invaders* and decided to join Atari's coin-op division. After being assigned the role of software engineer and creating *Centipede*, in 1982 she moved to Videa, which had been founded by several ex-Atari employees, and continued to write games. Meanwhile Ed – who had also produced *Asteroids* – went on to create *Millipede*, *Xybots*, *Gauntlet*, and many more early gaming classics throughout the 1980s.

Centipede

Released 1980

Platforms Arcade

Atari 2600

Atari 5200

Atari 7800

CODE THE CLASSICS

Other versions of Centipede were created by Atarisoft for home computers including the Apple II and Commodore 64, and it also appeared on the Sega Mega Drive, Game Gear, and Master System among others.

Other Notables Space Invaders / Galaxian / Galaxy Wars

Where do you start if you've never written a computer game before. Does lack of experience matter? Go back to the 1980s and you'll find scores of coders in exactly the same boat. It certainly didn't stop them from coming up with amazing ideas that would define gaming for years and decades to come: often, jumping feet-first into something is the best way to get started.

For many software engineers, Dona Bailey is an inspiration. Before 1980, she hadn't even played a video game. That year, she played her first game – *Space Invaders* – and she immediately realised that she'd found something special. It inspired her so much that she decided to leave her job as a 6502 assembly language programmer for General Motors in California, where she was coding sensors for the first Cadillac to carry an on-board microprocessor.

Dona saw that Atari was building video game arcade cabinets in Sunnyvale, California, and she applied for a job. The games developer took her on in June 1980, where she began a steep learning process, discovering the different programming approaches needed to create a game, and coming to understand concepts of what was fun and why.

> **I had to learn what seemed like thousands of details in order to begin working on a game**

"I had to learn what seemed like thousands of details in order to begin working on a game," Dona says. "At General Motors I had worked with teams of programmers who coded from well-defined specifications, and each person created limited segments of the total program. It was completely different at Atari, where each programmer was expected to code an entire game."

Devising ideas

Atari encouraged programmers to come up with ideas for games. It would hold mammoth brainstorming sessions, which prompted coders to open their minds, explore what worked and what didn't, and discuss the intricacies of design. An idea for the game that would become *Centipede* had already been jotted in a notebook by the time Dona arrived. "It was one sentence: 'A multi-segmented insect crawls onto the screen and is shot by the player,' " she recalls. She chose it as a game she wanted to develop.

The learning process started in earnest. "Before I could begin, I needed to be taught how to create the graphics for the game hardware, how to use the major and

1 The attract screen for the 1980 coin-op has the centipede moving down the side of the high score table

00	16543	00

HIGH SCORES
16543 EJD
15432 DFT
14320 CAD
13210 DCB
13010 ED
12805 DEW
12201 DFW
12102 GJR

1 COIN 1 PLAY

BONUS EVERY 12000

©1980 ATARI

minor interrupts for the 6502 microprocessor, how to set up the data structures for the motion objects in the game, how to use Atari's custom game controllers and custom sound chip – it went on and on," she says. "It was a really intense learning curve for me for at least six months when I started at Atari."

Dona says that she started at Atari with no real clue about what she wanted to do there. But that was very much a positive thing. Although having a solid structure in place for your game will save you lots of time, allow you to see the overall picture of a game, and understand how certain parts of it will affect other areas, many programmers like Dona jumped straight into coding and developed the game on-the-fly.

As we'll see later, this can work very well. As long as you understand any system constraints – *Centipede* was to be produced as a coin-operated arcade game, so Dona was assigned an extremely stable raster graphics board which displayed 16 motion objects on the screen at one time – a free-style approach enables the coder to visualise the game as she sees fit.

Looks and movement

Dona's first task was to work on the look of the centipede itself. "Based on the brief game description from the notebook, it just made sense to use as many motion objects as possible for segments of the centipede," she reveals. "I visualised the centipede as a string of connected 'pop beads' and I remember that I looked forward to the gliding motion I would create as the centipede turned when it encountered the edges of the screen. I was thinking much more about how it looked versus planning gameplay or pacing, especially in the early days of programming the game."

Once she had the right graphical look, it was time to work on the game itself, starting with the movement of the main character. "In the game, the multi-segmented centipede crawls along the screen at the top, travels to the other side of the screen, turns down the screen, and crawls back to the other side of the screen, repeating this process all the way down to the bottom." So movement was something to bear in mind: Dona decided to have the centipede automatically move from left to right, go down a row, turn, and then go the other way. By repeating this pattern, the centipede made its way from the top left of the screen to the bottom right.

Now Dona needed to create some level of interaction. The player is stationed at the bottom of the screen and is able to fire lasers at the centipede as it travels down. On the original arcade version, the player could be moved left to right using the mini-trackball, as well as up and down within a limited range ("the player

Learn from the master

Centipede lent some natural constructions which meant that some parts of the gaming process were dealt with almost by accident.

No time limit: *Centipede* didn't need to have an obvious time limit because the act of the creature moving rapidly down the screen meant players couldn't afford to take their time.

No platforms: By having the enemy character move down the screen itself, there was no need for set platforms to be included – the randomly positioned mushrooms did the job perfectly.

couldn't move higher than several rows from the bottom of the screen," explains Dona). At the same time, it could only fire one shot at a time.

"If the shot is in motion on the screen, then the player must wait until the shot graphic is returned to the player icon before being able to fire again," Dona says. "The player can use a rapid fire option by keeping the firing button depressed. The shot returns to the player icon to be used again when it either shoots something on the screen, including some portion of the centipede, or when it gets to the top of the screen."

Every shot counts

For players, this mechanic ensures that every shot is sacred. The centipede will be coming down at speed (exactly what speed you want for your fixed shooter game would be for you to work out in your code), so gamers will want every shot to have an impact. Missing wastes valuable time.

> **A game that can be played tactically works well for players, offering depth**

When a shot hits the centipede, the segment it comes into contact with disappears. The segment behind it then becomes the centipede head, creating two centipedes. The trailing centipede moves down a row and heads the other way while the other part continues on its journey. "A player may shoot and cause the centipede to break into more than one centipede travelling in different directions on different rows of the screen," says Dona. Players have to keep firing until the entire centipede is removed from the screen.

For all of this to happen, the programmer has to carefully consider what is going on with the centipede when it is shot. To start with, each segment has to be treated as a separate entity. It's not really one long centipede on the screen, but a set of individual components that act as one. You have to factor in that the sets have to move independently of each other after they are shot. And when they are shot and a piece disappears, you have to give the player another laser to fire. Bear in mind too that the player will be approaching the game in different ways.

"Some players liked to practise strategies where they shot only the head of a centipede by carefully picking off the head each time a new head appeared," notes Dona. "Other players liked to shoot randomly, hitting anything possible." A game that can be played tactically works well for players, offering depth and giving the player the feeling that it is a skilful, beatable game full of secrets to unlock.

Coding checks

But how do you program all of this? Dona says for *Centipede*, the main creature, the player, and the shot had to be displayed on the screen at all times for each level of the game. Each round is then set up to display the graphics, the player icon, the shot, and the various colours that the centipede head and body segments can appear in (by changing the colour from one level to the next, you can very quickly add variety). "The status of the trackball for any player motions is checked repeatedly so as to react to a player's intended movements," says Dona. "The status

2

3

of the firing button is checked repeatedly so as to react to the player's intentions of using the shot on screen."

Collision are detected next. "The centipede segments move incrementally at a steady rate in a consistent direction, and the program checks at each incremental movement for screen edges or for mushrooms," Dona explains. Which takes us neatly to the part that allows the gameplay of *Centipede* to move up a notch by adding a very compelling twist: the obstacles that the centipede interacts with.

Producing obstacles

The mushrooms are crucial to gameplay, making the centipede's behaviour more erratic. The game littered the screen with these obstacles, and the idea was that the centipede would hit one and be forced to move down a row much sooner than it would if the entire line had been clear. But Dona says the mushrooms in *Centipede* came about as a lucky accident.

"I was learning as I worked. I made a lot of mistakes in the code I wrote and I also made a lot of bad estimations because everything attempted was my first try," she says. "When I wrote the collision detection part of the code for the moving shot, I thought logically that I could just use arithmetic and count it as a hit if the shot actually touched a centipede head or body segment on the screen. I had no experience with how a collision looked compared to the arithmetic of an actual collision in numbers.

> **The first time I played this code to test it, I saw that it appeared, to my eyes, that a shot went straight through a centipede segment**

"The first time I played this code to test it, I saw that it appeared, to my eyes, that a shot went straight through a centipede segment. It turns out that the area that must count as a collision in order to appear correct visually is much greater than the area of actual arithmetic for a collision. I kept adjusting and after a bit of time and experimenting, I believed I had a collision routine that appeared valid visually."

Her struggle with collisions had shaken her confidence, but one morning, soon after getting the collision detection working, she says she found herself with a couple of free hours when no one was pushing her to start on new features. "I decided to pause for a moment because I wanted to further reassure myself that I was correctly handling the breaking apart and turning of centipede segments after a segment had been shot. I wanted to take time out to put a visual marker on the screen where a segment was shot, and I wanted to play the game and be certain the remaining part of the centipede turned at the place where the visual marker was placed."

She made a simple black box graphic in an 8×8 bitmap stamp pattern and wrote the code to place the black square where a centipede segment was shot. "I got the code compiled and a test PROM created and I raced back to the development cabinet to check it out," recounts Dona.

2 The centipede splits in two whenever it's hit in the middle, often resulting in multiple enemies to deal with

3 The Atari 2600 version of the game features simplified graphics, but the gameplay is largely the same

"I played the game and I was so relieved to see that the collision detection and subsequent movement of the centipede was working properly. I continued to play because it was making me happy to see the interesting patterns that developed on the screen as I shot more and more centipede segments and more and more square boxes made an ever-changing maze pattern that broke up the screen nicely. In just a few minutes, I understood that these test boxes had a lot of potential as a permanent feature."

New perspectives

Stepping back from a project and looking at it from a player's point of view can make you see the game from a different perspective, and remind you that you shouldn't always stick to a firm path. The best games programming is creative and flexible, growing organically as you become more familiar with the basic constructs. By experimenting and testing, Dona decided to replace the 8×8 pixel squares with a better-looking graphic.

She decided on rocks or boulders in brown at first, but dismissed them quickly. "It's almost impossible to make a good-looking rock in 8×8 pixels, and combined with the brown colour it appeared that the screen was littered with poop." She says she replaced them with simple mushrooms that had a cap and stem with an edge around them so she could use two colours for contrast.

"This turned out to be beautiful in my view, and I played the game, scattering a field of the shimmering mushrooms," Dona recalls. "Really tired from all the hurrying and effort of the morning, I left for lunch. By the time I came back, other guys in the coin-op department at Atari were playing *Centipede* and endorsing the addition of the mushrooms. The new feature had caught on and caused a little flurry of attention, and it was decided that the mushrooms could stay in the game."

But that wasn't the end of the tweaking. "We had a lot of fun with the new feature for the remainder of the development of the game," Dona continues. "We used the random number generator to vary the placement of the mushrooms when each new round is set up. After working for a long while with the mushrooms as permanent and non-eroding, we had the breakthrough idea during a game review to shoot the mushrooms away for points in order to clear the screen or to create new patterns."

The objectives

Short term: Begin by moving the characters that are on the screen at all times or most of the time. This is likely to include the player icon. For example, in *Centipede* the first objective was to move the centipede, then the player icon, and then the icon for the shot.

Medium term: Add other characters that appear less often; begin adding points for scoring; begin adding sound effects.

Long term: Add complexity to gameplay, such as more difficult higher levels based on scoring higher points or longer playing times. Polish the pacing and fun factor of the game. Polish scoring, sounds, and graphics. Test for bugs in gameplay as much, and with as many players, as possible.

Enemy movement

By shooting at the mushrooms, it was possible to prevent the centipede from moving down the screen too quickly. But before she had even got to work on the mushrooms, Dona had looked to increase the number of things a player had to deal with. She introduced a spider which moves at the bottom of the screen in diagonal directions, at angles and in time intervals that vary at random.

"Atari's custom sound chip contained a random number generator that I used to add variety to the spider's movement and timing so that each appearance of the spider is unpredictable, keeping gameplay fresh," she reveals. "I was taught and guided how to implement much of *Centipede*'s gameplay by more experienced programmers at Atari, and I benefited greatly from the advice and help of others, but using the random number generator in *Centipede* was my idea. I think the introduction of unpredictability makes the game more fun."

Because the system could only support 16 motion objects on the screen at one time, at least one centipede segment must be shot prior to bringing out the spider. "Until at least one centipede segment is shot, all motion objects are in use on the screen. When a centipede section is shot and removed from the screen, its unused motion object can then be utilised for the spider." But even with the spider in place, the management team in the coin-op department wanted more.

"Management generally liked the game, but there was a consensus that *Centipede* needed 'more'," says Dona. "More what?, we wondered. I seized on what it didn't have at the time, which was something that moved straight down the screen and something that moved straight across the screen, and that's how the ant (I believed I drew an ant, but it was immediately known as a flea) with its vertical movement and the scorpion with its horizontal movement were born. These two added challenge and difficulty in more advanced levels of the game."

More creatures meant more complexity, including the option to manipulate the mushrooms to work with these extra creatures. "After the decision to shoot away the mushrooms, we were able to add mushroom-related features to the ant, which lays down a column of new mushrooms, and to the scorpion, which poisons a row of mushrooms, and each poisoned mushroom causes the centipede to go into a free-fall on the screen after touching one."

Awarding points

In keeping with most games at the time, points were also awarded to players. They would gain a set number whenever a segment of the centipede was shot or if another creature was gunned down. There would be more points for mushrooms removed. A high score stayed on the screen along with the current player's score, and this incentivised gamers to try to beat the highest points tally.

"I believe that earning points and keeping score are elemental to any type of defined game, and I think most players enjoy the aspect of scoring and earning points," says Dona. "I think it's fun to offer some easily earned low-value points, as

> **I think most players enjoy the aspect of scoring and earning points**

CODE THE CLASSICS

Women in gaming

Back in the early days of games programming, too few women were employed as programmers. Carol Shaw is believed to have paved the way in 1978 when she joined Atari as Microprocessor Software Engineer before going on to work at Tandem Computers and Activision, but Dona Bailey was still the only woman in the coin-op division when she joined. Today, the situation is thankfully getting better. Amy Hennig, who was heavily involved in the acclaimed *Uncharted* series, is among many highly influential women in gaming. Robin Hunicke has produced some of gaming's most inspiring and creative titles, including the award-winning multiplayer co-op adventure game *Journey*.

well as some risky high-value points. Game creators should remember to offer those easy points but build in some difficult points in order to tie in with a maxim attributed to Nolan Bushnell, founder of Atari, stating that games should be easy to learn but hard to master."

4 A flyer for the 1980 arcade game features a female player

Centipede embodied that maxim: a pick-up-and-play title that translated well to consoles and joystick controls while lending the right dose of challenge and frustration to ensure players would keep going (or, in the case of the arcades, pump more money into the machines). It was a major triumph for Dona Bailey and co-creator Ed Logg and it brought fresh thinking to the shoot-'em-up genre. There are principles and concepts of gaming embedded in *Centipede* that can translate to many other games.

"When making a game, it's difficult for the programmer to back away from the familiar gameplay and weigh the game's strengths and weaknesses in order to revise and balance overall features," concludes Dona. "In 1980 when I worked on *Centipede*, I had played very few video games for only short amounts of time, and the field of game studies was unheard of at that point. Today's game programmers can play a wide variety of games, apply critical thinking to each game in order to carefully analyse its features, and study game programming as well as game studies."

It's difficult for the programmer to weigh the game's strengths and weaknesses

Dona advises you to enlist your friends, family, and critical game players as helpers. "In addition to formal studies, it's helpful to ask others to play your game, and it's also helpful if you ask other players to complete a questionnaire or to write responses on features you are testing," she says. "Game programmers learn to adjust and balance game features by playing other games, by consulting with other players, and by extensively practising the art of game development. Remember that every skill worth cultivating improves with extensive practice, and this is certainly true for game development."

Coding Today
Myriapod

Myriapod is our homage to *Centipede*. In this version of the game, the mushrooms have become rocks and the spider is a flying insect. The centipede is referred to as a myriapod – a word that categorises animals such as centipedes and millipedes. We've created classes for each of these, named `Rock` and `FlyingEnemy`. The classes inherit from Pygame Zero's `Actor` class, which keeps track of an object's location in the game world, as well as taking care of loading and displaying sprites. There's also an `Explosion` class, used when a bullet is destroyed.

The myriapod itself, rather than being a single entity, is made of multiple instances of the `Segment` class – each of which moves independently of the others, even if it may not initially look like it when they come onto the screen in a nice tidy row. The `Player` class handles player movement and animation, as well as dealing with what

Download the code

Download the fully commented *Myriapod* game code, along with all the graphics and sounds, from **rptl.io/ctc-one-code**

happens when the player is destroyed and then respawns. It also handles the creation of `Bullet`s.

The `Game` class is responsible for creating the flying enemy, the myriapod segments, and most of the rocks. It also maintains a reference to the player object, and creates a two-dimensional list to represent the grid – where each element is either a reference to a `Rock` object or the value `None`, which indicates there is no rock at this grid location. The `Game` class contains many key methods which are called from other parts of the game, such as `allow_movement` which ensures the player cannot drive through rocks.

The `update` and `draw` functions read the `state` variable and run only the code relevant to the current state. The `game` variable references an instance of the `Game` class as described above. The `__init__` (constructor) method of `Game` optionally receives a parameter named `player`. When we create a new `Game` object for the main menu, we don't provide this parameter, and the game will therefore run in attract mode. When we create a new `Game` object for the game itself, we supply a new `Player` object.

Segment movement

The most complex code in this game relates to how myriapod segments move, and how they decide where to go next. Each segment moves in relation to its current grid cell. A segment enters a cell from a particular edge (stored in `in_edge` in the `Segment` class). After five frames, it decides which edge it's going leave through (stored in `out_edge`). For example, it might carry straight on and leave through the opposite edge from the one it started at. Or it might turn 90 degrees and leave through an edge to its left or right. In the latter it initially turns 45 degrees and continues along that path for eight frames. It then turns another 45 degrees, at which point it is heading directly towards its next grid cell. A segment spends a total of 16 frames in each cell. Within the `update` method, the variable `phase` refers to where it is in that cycle – 0 meaning it's just entered a grid cell, and 15 meaning it's about to leave it.

Let's first imagine the case where a segment enters from the top edge of a cell and carries on in a straight line, eventually leaving from the bottom edge (**Figure 1**). Grid cells are 32×32 pixels, and segments take either 16 or 8 frames to travel through a cell (every fourth wave of myriapods is fast). For normal-speed segments, this means they just need to move two pixels in the relevant direction each frame.

Player sprite animation

When the player presses a key to start heading in a new direction, we don't want the sprite to just instantly change to facing in that new direction. That would look wrong, since in the real world vehicles can't just suddenly change direction in the blink of an eye. Instead, we want the vehicle to turn to face the new direction over several frames. For example, if the vehicle is currently facing down, and the player presses the left arrow key, the vehicle should first turn to face diagonally down and to the left, and then turn to face left.

Figure 1

in_edge: DIRECTION_UP

[Diagram: rectangle with downward arrow labeled "2px per frame"]

out_edge: DIRECTION_DOWN

Figure 2

in_edge: DIRECTION_LEFT

[Diagram: rectangle showing movement path with labels "2px/frame on primary axis", "1px/frame on both axes", "2px/frame on secondary axis"]

out_edge: DIRECTION_DOWN

Let's now imagine the case where a segment enters from the left edge of a cell and then turns to leave from the bottom edge (**Figure 2**). The segment will initially move along the horizontal (X) axis, and will end up moving along the vertical (Y) axis. In this case we'll call the X axis the primary axis, and the Y axis the secondary axis. It starts out moving at two pixels per frame on the primary axis, but then starts moving along the secondary axis based on the values in the list `SECONDARY_AXIS_POSITIONS` – which stores the total secondary axis movement that will have occurred at each phase in the segment's movement through the current grid cell. In this case we don't want it to continue moving along the primary axis – it should initially slow to moving at one pixel per frame (the diagonal part of the segment's movement), and then stop moving along that axis completely. In effect, the secondary axis steals movement from the primary axis – hence the variable `stolen_y_movement`.

The code starts off with the assumption that a segment is starting from the top of the cell. The primary and secondary axes would therefore be Y and X. Later, a calculation is applied to rotate these X and Y offsets, based on the actual direction the segment is coming from.

These are the essentials of how segments move – you can find more detail in the fully commented code at **rptl.io/ctc-one-code**. But how does a segment choose which cell it's going to move into next?

Although the myriapod initially looks like it moves as one unit, the individual segments are actually independent of each other. This becomes clear when you shoot a segment in the middle. Destroyed segments turn into rocks, which causes the segments behind to change direction and split off from the front segments.

As described above, each segment has a `phase` variable which indicates where it's at in its movement through its current grid cell. In the update method, when `phase` reaches 4, a decision needs to be made as to which grid cell it's going to try to move into next – and therefore, which edge of the current cell it will leave via, to be stored in `out_edge`.

Making waves

At the start of the game, or each time the player has destroyed all myriapod segments, a new wave is started. This occurs in the `Game.update` method. The first thing that happens is that rocks are randomly created throughout the level. Although we could create them all in one go, it's more aesthetically pleasing to create one per frame until we have the desired number. Once we have enough rocks (a number that increases each wave), we move on to creating the myriapod itself. Initially we create eight segments per myriapod, but every four waves this number increases by two. The segments are created just off the top left corner of the screen. In the first wave, we create a basic myriapod where each segment takes one hit to kill. On the second wave, every other segment takes two hits to kill. On the third, all segments take two hits. On the fourth, the segments take only one hit, but they move twice as fast. This sequence then repeats, but with a longer myriapod.

The `rank` method is key to understanding the decision-making process. Its purpose is to rank the possible directions in which a segment could move, in order of preference. It contains an inner/nested function, named `inner`, which it returns as its result. The returned function is passed to Python's `min` function in the `update` method, as the 'key' optional parameter. `min` then calls this function four times with the numbers 0 to 3, representing the four possible directions (see `DIRECTION_UP` etc., further up the code). We'll explain shortly why and how we're using `min`.

The `inner` function takes one parameter named `proposed_out_edge`, representing a direction. The function returns a tuple consisting of a series of factors determining which grid cell the segment should try to move into next. These are not absolute rules – rather, they are used to rank the four directions in order of preference, i.e. which direction is the best (or at least, least bad) to move in. The factors are Boolean (True or False) values. A value of False is preferable to a value of True. The order of the factors in the returned tuple determines their importance in deciding which way to go, with the most important factor coming first. Some examples of these factors are that a segment shouldn't try to go in a direction that takes it outside the grid, it shouldn't try to go through a rock unless absolutely necessary (in which case the rock will be destroyed), and it should usually prefer to move horizontally.

Back in the `update` method, `range(4)` generates all the numbers from 0 to 3 (corresponding to `DIRECTION_UP` etc). Python's built-in `min` function usually chooses the lowest number that it's given, so would usually return 0 as the result. But if the optional key argument is specified, this changes how the function determines the result. The `inner` function returned by the `rank` function is called by `min` to decide how the items should be ordered. The `inner` function returns a tuple of Boolean values – e.g. (True,False,False,True). When Python compares two such tuples, it considers values of False to be less than values of True, and values that come earlier in the sequence are more significant than later values. So (False,True) would be considered less than (True,False). Since it's `min` rather than `max` we're calling, the end result of all

this is that `out_edge` will be set to the direction which corresponds to the tuple with the lowest value.

The elements of the tuple are as follows:

- Does the proposed direction take us to a cell outside the grid?
- Does it take us back on ourselves – a 180 degree turn?
- Does it take us in a direction that's disallowed? (Can't go down if we're on the bottom row of the grid, can't go up if we're on row 18)
- Is there a rock in the new cell?
- Is the new cell already occupied by another segment, or is another segment trying to enter my cell from the opposite direction?
- A factor causing us to prefer to move horizontally, unless there's a rock in the way. If there are rocks both horizontally and vertically, we prefer to move vertically.
- A factor causing us to change direction from left to right and vice versa each time we move up or down.

Challenges

- In the original *Centipede*, only one bullet can exist at a time, and the player can fire again as soon as the current bullet is destroyed. If the player holds down the fire button, the fire rate will be very rapid while repeatedly shooting targets close to the player, and slower when shooting more distant targets. How would you achieve this behaviour in *Myriapod*?

- How would you change the code so that a wave could consist of multiple myriapods – created either simultaneously or at intervals?

- Currently, shooting a 'Totem' rock gives a score bonus, but what if it also dropped a power-up which could be collected – temporarily giving the player three bullets at once, for example?

- Award an extra life when the player scores 1000 points, then another after another 1200 points, then 1400, and so on. Play a sound effect when an extra life is gained.

- Keep track of the high score and save new high scores to a file, in a similar way to *Bunner*. On the game-over screen, display the player's score and either the current high score if it hasn't been beaten, or 'NEW HIGH SCORE!'

CODE THE CLASSICS

How to run the game

Open the **myriapod.py** file in a Python editor, such as IDLE, and select Run > Run Module.
For more details, see the 'Setting Up' section on page 170.

Download the code `rptl.io/ctc-one-code`

```
001.    import pgzero, pgzrun, pygame, sys
002.    from random import choice, randint, random
003.    from enum import Enum
004.
005.    if sys.version_info < (3,6):
006.        print("This game requires at least version 3.6 of Python. Please download"
007.              "it from www.python.org")
008.        sys.exit()
009.
010.    pgzero_version = [int(s) if s.isnumeric() else s
011.                      for s in pgzero.__version__.split('.')]
012.    if pgzero_version < [1,2]:
013.        print(f"This game requires at least version 1.2 of Pygame Zero. You are"
014.              "using version {pgzero.__version__}. Please upgrade using the command"
015.              "'pip install --upgrade pgzero'")
016.        sys.exit()
017.
018.    WIDTH = 480
019.    HEIGHT = 800
020.    TITLE = "Myriapod"
021.
022.    DEBUG_TEST_RANDOM_POSITIONS = False
023.    CENTRE_ANCHOR = ("center", "center")
024.
025.    num_grid_rows = 25
026.    num_grid_cols = 14
027.
028.    def pos2cell(x, y):
029.        return ((int(x)-16)//32, int(y)//32)
030.
031.    def cell2pos(cell_x, cell_y, x_offset=0, y_offset=0):
032.        return ((cell_x * 32) + 32 + x_offset, (cell_y * 32) + 16 + y_offset)
033.
034.    class Explosion(Actor):
035.        def __init__(self, pos, type):
036.            super().__init__("blank", pos)
037.            self.type = type
038.            self.timer = 0
039.
040.        def update(self):
```

Coding Today
Myriapod

```
041.            self.timer += 1
042.            self.image = "exp" + str(self.type) + str(self.timer // 4)
043.
044.    class Player(Actor):
045.        INVULNERABILITY_TIME = 100
046.        RESPAWN_TIME = 100
047.        RELOAD_TIME = 10
048.
049.        def __init__(self, pos):
050.            super().__init__("blank", pos)
051.
052.            self.direction = 0
053.            self.frame = 0
054.            self.lives = 3
055.            self.alive = True
056.            self.timer = 0
057.            self.fire_timer = 0
058.
059.        def move(self, dx, dy, speed):
060.            for i in range(speed):
061.                if game.allow_movement(self.x + dx, self.y + dy):
062.                    self.x += dx
063.                    self.y += dy
064.
065.        def update(self):
066.            self.timer += 1
067.
068.            if self.alive:
069.                dx = 0
070.                if keyboard.left:
071.                    dx = -1
072.                elif keyboard.right:
073.                    dx = 1
074.
075.                dy = 0
076.                if keyboard.up:
077.                    dy = -1
078.                elif keyboard.down:
079.                    dy = 1
080.
081.                self.move(dx, 0, 3 - abs(dy))
082.                self.move(0, dy, 3 - abs(dx))
083.                directions = [7,0,1,6,-1,2,5,4,3]
084.                dir = directions[dx+3*dy+4]
085.
086.                if self.timer % 2 == 0 and dir >= 0:
087.                    difference = (dir - self.direction)
```

```
088.                    rotation_table = [0, 1, 1, -1]
089.                    rotation = rotation_table[difference % 4]
090.                    self.direction = (self.direction + rotation) % 4
091.
092.           self.fire_timer -= 1
093.
094.           if self.fire_timer < 0 and (self.frame > 0 or keyboard.space):
095.                if self.frame == 0:
096.                    game.play_sound("laser")
097.                    game.bullets.append(Bullet((self.x, self.y - 8)))
098.                self.frame = (self.frame + 1) % 3
099.                self.fire_timer = Player.RELOAD_TIME
100.
101.           all_enemies = game.segments + [game.flying_enemy]
102.
103.           for enemy in all_enemies:
104.                if enemy and enemy.collidepoint(self.pos):
105.                    if self.timer > Player.INVULNERABILITY_TIME:
106.                        game.play_sound("player_explode")
107.                        game.explosions.append(Explosion(self.pos, 1))
108.                        self.alive = False
109.                        self.timer = 0
110.                        self.lives -= 1
111.        else:
112.           if self.timer > Player.RESPAWN_TIME:
113.                self.alive = True
114.                self.timer = 0
115.                self.pos = (240, 768)
116.                game.clear_rocks_for_respawn(*self.pos)
117.
118.        invulnerable = self.timer > Player.INVULNERABILITY_TIME
119.        if self.alive and (invulnerable or self.timer % 2 == 0):
120.           self.image = "player" + str(self.direction) + str(self.frame)
121.        else:
122.           self.image = "blank"
123.
124.    class FlyingEnemy(Actor):
125.        def __init__(self, player_x):
126.           side = 1 if player_x < 160 else 0 if player_x > 320 else randint(0, 1)
127.           super().__init__("blank", (550*side-35, 688))
128.           self.moving_x = 1
129.           self.dx = 1 - 2 * side
130.           self.dy = choice([-1, 1])
131.           self.type = randint(0, 2)
132.           self.health = 1
133.           self.timer = 0
134.
```

```python
SECONDARY_AXIS_SPEED = [0]*4 + [1]*8 + [2]*4
SECONDARY_AXIS_POSITIONS = [sum(SECONDARY_AXIS_SPEED[:i]) for i in range(16)]

DIRECTION_UP = 0
DIRECTION_RIGHT = 1
DIRECTION_DOWN = 2
DIRECTION_LEFT = 3

DX = [0,1,0,-1]
DY = [-1,0,1,0]

def inverse_direction(dir):
    if dir == DIRECTION_UP:
        return DIRECTION_DOWN
    elif dir == DIRECTION_RIGHT:
        return DIRECTION_LEFT
    elif dir == DIRECTION_DOWN:
        return DIRECTION_UP
    elif dir == DIRECTION_LEFT:
        return DIRECTION_RIGHT

def is_horizontal(dir):
    return dir == DIRECTION_LEFT or dir == DIRECTION_RIGHT

class Segment(Actor):
    def __init__(self, cx, cy, health, fast, head):
        super().__init__("blank")
        self.cell_x = cx
        self.cell_y = cy
        self.health = health
        self.fast = fast
        self.head = head

        self.in_edge = DIRECTION_LEFT
        self.out_edge = DIRECTION_RIGHT

        self.disallow_direction = DIRECTION_UP
        self.previous_x_direction = 1

    def rank(self):
        def inner(proposed_out_edge):
            new_cell_x = self.cell_x + DX[proposed_out_edge]
            new_cell_y = self.cell_y + DY[proposed_out_edge]

            out = new_cell_x < 0 or new_cell_x > num_grid_cols - 1 \
                or new_cell_y > 0 or new_cell_y > num_grid_rows - 1
```

```
                    turning_back_on_self = proposed_out_edge == self.in_edge
                    direction_disallowed = proposed_out_edge == self.disallow_direction

                if out or (new_cell_y == 0 and new_cell_x < 0):
                    rock = None
                else:
                    rock = game.grid[new_cell_y][new_cell_x]

                rock_present = rock != None

                occupied_by_segment = (new_cell_x, new_cell_y) in game.occupied \
                    or (self.cell_x, self.cell_y, proposed_out_edge) in game.occupied

                if rock_present:
                    horizontal_blocked = is_horizontal(proposed_out_edge)
                else:
                    horizontal_blocked = not is_horizontal(proposed_out_edge)

                same_as_previous_x_direction = \
                    proposed_out_edge == self.previous_x_direction

                return (out, turning_back_on_self, direction_disallowed, \
                    occupied_by_segment, rock_present, horizontal_blocked, \
                    same_as_previous_x_direction)

            return inner

    def update(self):
        phase = game.time % 16

        if phase == 0:
            self.cell_x += DX[self.out_edge]
            self.cell_y += DY[self.out_edge]
            self.in_edge = inverse_direction(self.out_edge)

            if self.cell_y == (18 if game.player else 0):
                self.disallow_direction = DIRECTION_UP
            if self.cell_y == num_grid_rows-1:
                self.disallow_direction = DIRECTION_DOWN
        elif phase == 4:
            self.out_edge = min(range(4), key = self.rank())

            if is_horizontal(self.out_edge):
                self.previous_x_direction = self.out_edge

            new_cell_x = self.cell_x + DX[self.out_edge]
```

```
323.                new_cell_y = self.cell_y + DY[self.out_edge]
324.
325.                if new_cell_x >= 0 and new_cell_x < num_grid_cols:
326.                    game.damage(new_cell_x, new_cell_y, 5)
327.
328.                game.occupied.add((new_cell_x, new_cell_y))
329.                game.occupied.add((new_cell_x, new_cell_y, \
330.                                   inverse_direction(self.out_edge)))
331.
332.            turn_idx = (self.out_edge - self.in_edge) % 4
333.
334.            offset_x = SECONDARY_AXIS_POSITIONS[phase] * (2 - turn_idx)
335.            stolen_y_movement = (turn_idx % 2) * SECONDARY_AXIS_POSITIONS[phase]
336.            offset_y = -16 + (phase * 2) - stolen_y_movement
337.
338.            rotation_matrices = [[1,0,0,1],[0,-1,1,0],[-1,0,0,-1],[0,1,-1,0]]
339.            rotation_matrix = rotation_matrices[self.in_edge]
340.            offset_x, offset_y = offset_x * rotation_matrix[0] \
341.                                 + offset_y * rotation_matrix[1], \
342.                                 offset_x * rotation_matrix[2] \
343.                                 + offset_y * rotation_matrix[3]
344.
345.            self.pos = cell2pos(self.cell_x, self.cell_y, offset_x, offset_y)
346.
347.            direction = ((SECONDARY_AXIS_SPEED[phase] * (turn_idx - 2)) \
348.                         + (self.in_edge * 2) + 4) % 8
349.
350.            leg_frame = phase // 4
351.
352.            self.image = "seg" + str(int(self.fast)) + str(int(self.health == 2)) \
353.                         + str(int(self.head)) + str(direction) + str(leg_frame)
354.
355.    class Game:
356.        def __init__(self, player=None):
357.            self.wave = -1
358.            self.time = 0
359.            self.player = player
360.            self.grid = [[None] * num_grid_cols for y in range(num_grid_rows)]
361.            self.bullets = []
362.            self.explosions = []
363.            self.segments = []
364.            self.flying_enemy = None
365.            self.score = 0
366.
367.        def damage(self, cell_x, cell_y, amount, from_bullet=False):
368.            rock = self.grid[cell_y][cell_x]
369.
```

```
370.            if rock != None:
371.                if rock.damage(amount, from_bullet):
372.                    self.grid[cell_y][cell_x] = None
373.
374.            return rock != None
375.
376.        def allow_movement(self, x, y, ax=-1, ay=-1):
377.
378.            if x < 40 or x > 440 or y < 592 or y > 784:
379.                return False
380.
381.            x0, y0 = pos2cell(x-18, y-10)
382.            x1, y1 = pos2cell(x+18, y+10)
383.
384.            for yi in range(y0, y1+1):
385.                for xi in range(x0, x1+1):
386.                    if self.grid[yi][xi] or xi == ax and yi == ay:
387.                        return False
388.
389.            return True
390.
391.        def clear_rocks_for_respawn(self, x, y):
392.            x0, y0 = pos2cell(x-18, y-10)
393.            x1, y1 = pos2cell(x+18, y+10)
394.
395.            for yi in range(y0, y1+1):
396.                for xi in range(x0, x1+1):
397.                    self.damage(xi, yi, 5)
398.
399.        def update(self):
400.            self.time += (2 if self.wave % 4 == 3 else 1)
401.            self.occupied = set()
402.            all_objects = sum(self.grid, self.bullets + self.segments \
403.                        + self.explosions + [self.player] + [self.flying_enemy])
404.
405.            for obj in all_objects:
406.                if obj:
407.                    obj.update()
408.
409.            self.bullets = [b for b in self.bullets if b.y > 0 and not b.done]
410.            self.explosions = [e for e in self.explosions if not e.timer == 31]
411.            self.segments = [s for s in self.segments if s.health > 0]
412.
413.            if self.flying_enemy:
414.                if self.flying_enemy.health <= 0 or self.flying_enemy.x < -35 \
415.                        or self.flying_enemy.x > 515:
416.                    self.flying_enemy = None
```

Coding Today
Myriapod

```
417.            elif random() < .01:
418.                self.flying_enemy = FlyingEnemy(self.player.x if self.player else 240)
419.
420.            if self.segments == []:
421.                num_rocks = 0
422.                for row in self.grid:
423.                    for element in row:
424.                        if element != None:
425.                            num_rocks += 1
426.                if num_rocks < 31+self.wave:
427.                    while True:
428.                        x, y = randint(0, num_grid_cols-1), randint(1, num_grid_rows-3)
429.                        if self.grid[y][x] == None:
430.                            self.grid[y][x] = Rock(x, y)
431.                            break
432.                else:
433.                    game.play_sound("wave")
434.                    self.wave += 1
435.                    self.time = 0
436.                    self.segments = []
437.                    num_segments = 8 + self.wave // 4 * 2
438.                    for i in range(num_segments):
439.                        if DEBUG_TEST_RANDOM_POSITIONS:
440.                            cell_x, cell_y = randint(1, 7), randint(1, 7)
441.                        else:
442.                            cell_x, cell_y = -1-i, 0
443.
444.                        health = [[1,1],[1,2],[2,2],[1,1]][self.wave % 4][i % 2]
445.                        fast = self.wave % 4 == 3
446.                        head = i == 0
447.                        self.segments.append(Segment(cell_x, cell_y, health, fast, head))
448.
449.            return self
450.
451.        def draw(self):
452.            screen.blit("bg" + str(max(self.wave, 0) % 3), (0, 0))
453.            all_objs = sum(self.grid, self.bullets + self.segments + self.explosions \
454.                           + [self.player])
455.
456.            def sort_key(obj):
457.                return (isinstance(obj, Explosion), obj.y if obj else 0)
458.
459.            all_objs.sort(key=sort_key)
460.            all_objs.append(self.flying_enemy)
461.
462.            for obj in all_objs:
463.                if obj:
```

```
464.                obj.draw()
465.
466.    def play_sound(self, name, count=1):
467.        if self.player:
468.            try:
469.                sound = getattr(sounds, name + str(randint(0, count - 1)))
470.                sound.play()
471.            except Exception as e:
472.                print(e)
473.
474. space_down = False
475.
476. def space_pressed():
477.     global space_down
478.     if keyboard.space:
479.         if not space_down:
480.             space_down = True
481.             return True
482.     else:
483.         space_down = False
484.     return False
485.
486. class State(Enum):
487.     MENU = 1,
488.     PLAY = 2,
489.     GAME_OVER = 3
490.
491. def update():
492.     global state, game
493.
494.     if state == State.MENU:
495.         if space_pressed():
496.             state = State.PLAY
497.             game = Game(Player((240, 768)))
498.
499.         game.update()
500.
501.     elif state == State.PLAY:
502.         if game.player.lives == 0 and game.player.timer == 100:
503.             sounds.gameover.play()
504.             state = State.GAME_OVER
505.         else:
506.             game.update()
507.
508.     elif state == State.GAME_OVER:
509.         if space_pressed():
510.             state = State.MENU
```

```python
            game = Game()

def draw():
    game.draw()

    if state == State.MENU:
        screen.blit("title", (0, 0))
        screen.blit("space" + str((game.time // 4) % 14), (0, 420))

    elif state == State.PLAY:
        for i in range(game.player.lives):
            screen.blit("life", (i*40+8, 4))

        score = str(game.score)

        for i in range(1, len(score)+1):
            digit = score[-i]
            screen.blit("digit"+digit, (468-i*24, 5))

    elif state == State.GAME_OVER:
        screen.blit("over", (0, 0))

try:
    pygame.mixer.quit()
    pygame.mixer.init(44100, -16, 2, 1024)

    music.play("theme")
    music.set_volume(0.4)
except:
    pass

state = State.MENU
game = Game()

pgzrun.go()
```

CODE THE CLASSICS

1 Varieties of the centipede's head are rendered at all possible angles

2 Body segments feature various angles for the turning motion

3 The insect baddies flap their wings as they fly around

Fixed Shooter – Coding Today: Myriapod

130

Coding Today
Myriapod

4 One of the three shades of cracked earth backdrop

5 The title graphic is shown on the starting screen

6 Rather than mushrooms, random rocks can be shot to clear them away

7 The wheeled player sprite has rotated and shooting variants

Fixed Shooter – Coding Today: Myriapod

CODE THE CLASSICS

Chapter 5

Football Game

Top-down games of pinball-style soccer built a huge cult following and kicked off a sports genre that's still going strong

Sensible Soccer was a fast-paced, top-down, arcade-action football game, While it looked a far cry from the realistic soccer renditions of the likes of *FIFA* today, it quickly won a legion of fans. The top-down view allowed players to see more of the pitch as they knocked the ball from end to end, attacking and defending. It also allowed Sensible Software to be creative: the game's greatest hallmark was arguably its tiny sprites, which not only ran like fury but were well-animated and responded elegantly to slide tackles and the other major physical aspects of the beautiful game. With an immersive atmosphere, underpinned by authentic live crowd noises, *Sensible Soccer* won huge popularity.

Inspiration

Sensible Soccer was created by Jon Hare and Chris Yates, who met during their school days. Having been in a band together, the pair began to code games, starting with the never-released *Escape From Sainsbury's*, and their first commercial game, *Twister: Mother of Charlotte*. They formed their own development company in 1986 called Sensible Software and went on to produce commercial games including *Parallax*, *Wizball*, and *SEUCK*. The pair's first stab at a football game came with *Microprose Soccer* in 1988. With other 1980s and 1990s staples like *Mega Lo Mania*, *Wizkid*, and *Cannon Fodder* in their stable, Hare and Yates are among Britain's gaming heroes.

Sensible Soccer

Released 1993

Platforms Amiga

Atari ST

Amiga CD32

Acorn Archimedes

Xbox Live Arcade

Windows

CODE THE CLASSICS

Sensible Soccer was followed up two years later by Sensible World of Soccer, which included all of the professional leagues and competitions and also had a strong management element.

Other Notables Microprose Soccer / Kick Off / Tehkan World Cup

How are you watching the game? Are you high up in the stands at Wembley Stadium, soaking up the atmosphere of the crowd on a summer's day, or are you wrapping up warm on the touchline in the pouring rain and shouting pleasantries in the park as the local Sunday league team get their usual thrashing? Perhaps you're watching live on the television from the comfort of your armchair or listening to over-excited commentary on the car radio. Or maybe you're playing a video game, in which case we'll ask again: how are you viewing it?

That's because, over the years, many different developers have had their own take on the adaptation of football as a video game. There have been side-on, top-down, and isometric views, as well as games stripped down to their bare bones and games adorned with flashy overlaid graphics and stacks of menus. The first big soccer title, *Pele's Championship Soccer* on the Atari 2600 in 1981, was a three-a-side affair which had players moving one block at a time. *Real Sports Soccer* finally introduced sprites which resembled humans a year later. But even though they were spartan, these games were unmistakably football.

Games like the classic 8-bit title *Match Day* skipped real-life features: substitutions and team names were missing along with concepts like formations and referees, but they were still very recognisably football games. Back in the day, the goal for games developers was often to simply get players to knock the ball into the back of the net. As long as players could rack up the scores, everyone – it seemed – was happy.

Compare *Sensible Soccer* to the top football games of today (so the likes of *FIFA* and *Pro Evolution Soccer*) and you'll see exactly what we mean. The contemporary blockbuster titles like to view football as a televised game with commentary, on-screen graphics, close-ups of goal celebrations, and realistic physics embedded within players that look as close as possible to their real-life counterparts. *Sensible Soccer*, meanwhile, had tiny players scurrying around a pitch that was viewed from the top down. It felt almost as much like pinball as it felt like football, with the 'ping, ping' action of the ball being passed around the pitch at a breakneck speed.

The mechanic worked spectacularly well. *Sensible Soccer* takes its place, even today, as one of the greatest football games ever produced in pixel form. What's more, co-creator Jon Hare makes no apologies for the presentation and mechanics of the game: everything, he says, was deliberate and he's pleased that it all worked out so well. "We used small sprites because that was our style at the time," he says. "We had tiny characters and a bigger semi-overhead view of the environment when we were making *Mega Lo Mania* and when we realised they worked, we used them in *Cannon Fodder* and

1 Fittingly, *Sensible Soccer* was a team effort, led by Jon Hare and Chris Chapman

2 The Sensible Software team doing some research at a football stadium

1

2

CODE THE CLASSICS

3 Stuart 'Stoo' Cambridge joined Sensible Software as a graphic artist

Sensible Golf." In fact, the first *Sensible Soccer* characters were *Mega Lo Mania* sprites with football kits on them.

Kicking off

Jon was the co-founder of Sensible Software, a company he formed with his friend Chris Yates. The pair had been introduced by a mutual friend when Jon was travelling back from a Rush concert in London and they became close. They had a shared love of music, and wrote and played songs together while they dreamed of becoming rock stars. Chris was studying computing at college. He would buy machines from a catalogue and spend a month frantically programming them. He'd then send them back, get a refund, and order a replacement. When money became even tighter, Chris took a job at LT Software and worked on a game called *Sodov The Sorcerer* for the ZX Spectrum. He asked Jon to create the artwork for it. That led to Jon being taken on too.

The pair worked on a number of games, including *Twister: Mother of Charlotte*, but they decided they would make more money if they left LT Software and set up their own company. They did so in March 1986, creating the games *Parallax*, *Wizball*, and *Shoot-'Em-Up Construction Kit* (*SEUCK*). Their first football game was *Microprose Soccer*, which they made with a new team member called Martin Galway, and it astounded gamers with its introduction of speed, a rain effect, and aftertouch. Inspired by the arcade game *Tehkan World Cup*, players could swerve the ball after kicking, see much of what was around them on the pitch, and replay their goals. The top-down view worked a treat, as did the simple controls.

This suited Jon. The staunch Norwich City fan had spent many an hour flicking plastic players around a metre-long felt Subbuteo pitch, so he was used to a bird's-eye perspective of soccer. Another game, *Kick Off*, already used the same viewpoint, but Jon and Chris Chapman, who had joined Sensible Software to work on *Mega Lo Mania*, felt they could do better. The team worked for nine solid months to ensure that *Sensible Soccer* was released in time for the 1992 UEFA European Football Championship.

We concentrated on the actual gameplay when we created Sensible Soccer

"We concentrated on the actual gameplay when we created *Sensible Soccer*," says Jon. "We didn't go down the path of flashy presentation and the emphasis on style over substance, which we eventually saw when *FIFA International Soccer* was released in 1993. We wanted a game where the player had to chase the ball and use skill to keep it. We certainly didn't want to replicate a televised game. We preferred to make players feel like they were on the pitch rather than an uninvolved member of a TV audience."

Sensible Soccer initially appeared on the Amiga and the Atari ST in June 1992 before later being converted to the PC, Mega Drive, and other platforms. It focused

mostly on European club football, adding a few international teams. Some versions had made-up player names and included some fictitious custom football teams. The game had great pace and required a high level of skill. *Sensible Soccer*'s beauty came from within.

Creating the beautiful game

The first thing Jon and his team did when creating the game was look at perfecting the controls. They thought about how people would play the game and the type of controller they would use, before starting to think about the best way for the action to evolve. At the time of development, most home platforms used eight-directional joysticks (left, right, up, down, and diagonals) with a single fire button.

"Every game, whether football or otherwise, should be designed around the hardware itself, so that's what we did well with *Sensible Soccer*," explains Jon. "We designed the controls around the limitations of the Commodore Amiga hardware, which was that eight-direction joystick and a single button. All the best games are designed that way and it helped to get things right."

With the controls in place, the developer was then able to deconstruct the real-life game of football itself so that it could be recreated in pixellated form. Basing the game on an existing sport helped enormously since it provided a set of ready-made rules, allowing Sensible Software to take a few design short cuts. By working in accordance with the sport's specific objects and established rules, the developer could concentrate on the skills needed by players and on the best ways of providing them with an adrenaline rush.

This is why some games have got away with stripping right back. You don't necessarily need leagues, cups, and tournaments, for instance, although they can provide a more immersive experience. You don't really need crowd noise, let alone commentary. Red and yellow cards can be done away with, as can over-the-top goal celebrations. As long as the ball moves as well as expected and the players can make their way reasonably quickly from one end to the next, football can be recreated convincingly on screen. The key is to get the behind-the-scenes elements right. "There's plenty of stuff in a game like *Sensible Soccer* other than what is straight out there on the football pitch," advises Jon. "The whole framework has to be there too, taking in the graphics and sound as well as the ball skills and gravity."

Learn from the master

Jon Hare offers some expert advice for making your football game a winner.

The right mindset: When you play sport, you're drawing on your whole body. In a football video game, you tend to use just your brain and hands. Jon advises getting into the player mindset.

Keep it simple: Psychologically, you think up and down the pitch when you play football – the goal behind you and in front of you.

Shots count: Always make the goals big enough for shots to have a chance of going in, otherwise frustrated gamers will lose the desire to keep playing.

Player movement

The joystick was used to move the players around the pitch and to indicate where the ball should travel when it was kicked. "The fire button would be tapped to pass the ball along the ground and held down to do something in the air," Jon says. These simple controls enabled the gamer to perform a large number of moves, depending on whether he or she was in possession of the ball. With possession of the ball, the player could pull back on the joystick or swiftly switch it from one direction to another in order to achieve chips, volleys, lobs, and headers. There were trick shots and a banana shot available too.

If gamers pushed forward, the sprite in possession would dribble the ball. If they pushed in a particular direction and tapped the fire button, the ball would be passed along the ground. By pressing longer, it would be kicked harder. There was a short amount of time following a kick for the gamer to lift and bend the ball by quickly moving the joystick. Depending on how it was done, this could result in straight or bending kicks: pulling down (i.e. in the opposite direction) quickly following a kick would send the ball high up into the air.

When a player had the ball, it stuck to his feet unless he turned too sharply. This was a conscious decision – the other way of doing it is to make the sprite bump into the ball repeatedly to edge it around the screen. "If you bounce the ball away from the player, the disadvantage is the animation means the player has to gather the ball as he turns," explains Jon. "The problem of bouncing four feet in front of him is that when he turns sharp left, the ball will drag with him. The closer it stays to his feet, Messi style, the more naturalistic it will look when he physically turns left or right. This is counterbalanced by allowing the player to lose the ball if he turns too sharply, dependent upon his ball control skill."

Off-the-ball mechanics

If the player was off the ball (i.e. defending) in *Sensible Soccer*, pressing fire would perform a sliding tackle in the direction faced; if the ball was overhead, hitting fire would attempt a header. Sensible Software made the game easier for the player by keeping the goalkeepers under the control of the computer. That way, the focus could remain on the outfield play.

Jon says the control system off the ball is just as important as when the player is in possession. "A good control system off the ball is vital because 50 percent of the time you are on the ball and 50 percent of the time you're not. So you want controls that enable the player to get to the ball as quickly as possible and a passing system that intelligently selects where the player is intending to play the ball."

Tackling is also vital when a player does not have the ball and this requires a routine. To make tackling work well, when the players that run towards the ball are within a certain number of degrees from alignment with it, they are automatically aimed directly at the ball. "Fifteen degrees is

Top tips

• Think about overall presentation. Jon Hare says game controls and the actual game are only a part of a professional package.

• Consider the different roles of players: do you want give your strikers different attributes than the defenders?

4 **The Sensible team enjoying a kickabout to promote the launch of SWOS**

TIME WARNER - PICTURES BY G. DAVIES

[5](#)

[6](#)

[7](#)

The objectives

Short term: Work on the controls so that each player is able to move around the pitch, kick and tackle, and score.

Medium term: Add in the goal scoring system, the amount of time you want there to be for each half, and the additional rules of the game.

Long term: To absorb players into the game, there needs to be something to pull them back in. Adding cups and leagues would do the trick.

the number we used," Jon reveals. "This means a slide tackle will be more accurate because the animation will be focused in the direction of the ball. The player slide-tackling should be slide-tackling to a projected position of the ball, possibly two or three frames ahead of where it currently is and not directly now. So it will be projecting in two or three frames time that the ball will be in this position, so the players slide-tackles towards that position. Then there are other calculations. If you tackle in front, it's a good clean tackle and the player wins the ball. If it's behind, the player concedes a foul, maybe even gets a yellow or red card. And from the side, it depends on the relative tackling and ball control skills of the players involved."

Ball in play

The *Sensible Soccer* development team needed to figure out what happened when the ball was being played, and build physics and graphics accordingly. "When the ball leaves the foot of a player, the programmer has to think about drawing a shadow underneath the ball," says Jon. "He or she also has to take into account the way the animation of the player is working and this basically operates on three levels: the floor height, which is your dribbling, kicking, slide tackles, and so on; the waist height, which is volleys and diving headers; and head height, which is mainly headers. So when the ball leaves the foot of a player, you take into account the arc of the ball. I guess it is harder to keep the ball down when it starts off already off the floor, but that is worked into the physics and gravity systems, so the main thing is the animations."

All of this helped to make *Sensible Socce*r as realistic as possible. Even though the sprites in the game were tiny, they ran smoothly and gamers could see tackles being carried out in an obvious way, with decent renditions of the players on the pitch. Many of the teams had made-up names because the official licences would have proven too expensive (try getting licensing deals for the likes of Manchester United, Barcelona, or Bayern Munich today and you'd certainly pay through the nose), but the *Sensible Soccer* developers had to consider the colours of the kit the players wore.

"The main thing we had to think about is that the players were against a green pitch, so it was about avoiding what colours worked badly," says Jon. "Pretty much the worst colour is green, understandably, but certain shades of yellow and maybe orange didn't work so well either. It made it harder to, say, recreate the Dutch national team or Blackpool FC, but most of the others worked fine."

5 **The console conversions feature this match intro screen**

6 **The top-down view is ideal for seeing where your teammates are**

7 **Scoring goals requires skilful ball control and a good passing game**

CODE THE CLASSICS

Top-down or side-on?

Sensible Soccer was viewed from the top down, but this wasn't to make it easier for the developers to code. According to Jon Hare, neither the top-down view or the side-on view is any more difficult than the other to program. The Sensible Software team decided on a top-down view because Jon believes it makes for a more realistic game when it is being played. "A top-down view gives you more of the viewpoint from a football player, and the side-on view gives you more of the viewpoint from a football spectator in a stadium or on television. That's why *Sensible Soccer* feels like a footballer's football game: because you feel like you're playing it."

A good frame rate kept the action flowing and an absence of too much on-screen clutter gave gamers the best possible view of the pitch and the positions of the players. Sensible Software decided not to bother having the score constantly displayed on the screen – it only appeared when a goal was scored or the ball left the pitch. "The score system for football was dead simple, though," says Jon. "Who scored the most goals won, and that's the only score system we needed. It can get complicated if you have figures evaluating players – so, a system based on how many tackles and passes and shots are accurately performed – but scoring is just 1-0, 2-0 and so on, and easily implemented."

It was easy to add flourishes like cards and substitutions. "Adding red and yellow cards was simple," he says. "They were created as part of the tackling system." The team wrote code which worked out the nature of the tackle and the opposition player's movement and position to detect whether there was foul play. "In *Sensible Soccer*, you only got a red or yellow card if you tackled from behind," Jon adds.

In Sensible Soccer, you only got a red or yellow card if you tackled from behind

Substitutions were activated by using either the joystick or the keyboard (Sensible Software was unafraid of making use of the keyboard to add greater control over non-action elements of the game). Pressing the up or down arrow key called up the bench, depending on the team, and the player could then select the substitute, indicating who was coming on and who was going off. "Players could call it up at any time when the ball was out of play," says Jon. "This was quite simple to do." Gamers were also able to save their games at any point, which avoided having to complete a tournament or league in one sitting.

Things became more complex from a development point of view when Sensible Software created a slightly improved version in 1993, called the *Sensible Soccer International Edition*. It also released a substantially more complex sequel, *Sensible World of Soccer*, in 1994, adding many more menus, 1400 teams, and 23,000 players from all over the world, along with a management section, taking advantage of the 1990s popularity of football management games like *Championship Manager*. "A football game has a lot of menus, league systems, team selections and so on, which are vitally important for more advanced titles," says Jon, whose own development

team was having lots of fun. As well as putting together a serious recreation of world football, they believed that an entertaining game should have off-beat elements, and kept the fun up by making it possible to compete in the Turkey Tournament or Booby League and see European Cities go up against Great Wars. They even included West Germany, even though the team ceased to exist in 1990 following German reunification.

Jon hasn't stopped developing football games, and this kind of philosophy is being carried over into his latest game, *Sociable Soccer*, now available on Steam and all major consoles. It retains all of the fast, slick playability of Jon's classic football games, but this time using cutting-edge technology, featuring online and offline play, 1000 teams from all over the world, more than 13,000 **FIFPRO**-licensed players, 80 real-world trophies to compete for, and collectable player cards.

In 2006, *Sensible World of Soccer* was honoured by Stanford University in California as one of the ten most influential computer games of all time, alongside such greats as *Spacewar!*, *Super Mario Bros. 3*, and *Tetris*. Upgraded regularly with annual iterations, *Sociable Soccer* has rebooted a 1990s classic into the modern era.

SUBSTITUTE SOCCER

▶ 1 PLAYER ◀
2 PLAYER

GOAL!

Coding Today
Substitute Soccer

Our final game, *Substitute Soccer*, is inspired by top-down-view football classics such as *Kick Off 2* and *Sensible Soccer*. It features both one- and two-player modes, as well as three difficulty settings. Each team has seven players – and as the pitch is larger than the game window, the viewport scrolls on both the X and Y axes.

As before, we'll start by looking at the classes which contain the bulk of the game's code. `Game`, `Ball`, `Player`, and `Goal` are all pretty self-explanatory – although we should note that the `Player` class is used by each of the 14 football players on the pitch, only one or two (depending on the game mode) of which are controlled by a human player at any one time. Whereas in, for example, *Myriapod*, an instance of the `Player` class is the manifestation of the human player in the game, in this game it makes more sense to think in terms of a particular team corresponding

Download the code

Download the fully commented *Substitute Soccer* game code, along with all the graphics and sounds, from **rptl.io/ctc-one-code**

to a human player, rather than a specific player on the pitch. `Difficulty` is used to store and refer to a number of parameters which are chosen based on the difficulty level. Controls deals with control inputs (arrow keys and **SPACE** for player 1, **WSAD** and left **SHIFT** for player 2). `Team` stores an instance of the `Controls` class, which determines the controls for the relevant player – computer-controlled teams use the value `None` here. The `Team` class also keeps track of the `active_control_player` – the player on the pitch currently being controlled by a human, indicated by an arrow over their head. When they don't have the ball, a human player can switch the `active_control_player` using the same key they use to kick the ball.

You may remember that *Bunner* had a class named `MyActor`, which inherited from Pygame Zero's `Actor` class, and was the base class of all objects in the game. Amongst other things, `MyActor` made sure that objects were displayed at the correct position on the screen, based on the scrolling of the level. This game also has a `MyActor` class – and while part of its job is to deal with scrolling, it has another important purpose. In *Boing!*, we introduced the concept of vectors. That game's `Ball` class defined a pair of attributes – `dx` and `dy` – which together formed a unit vector, indicating the ball's current direction of travel. In *Soccer*, we've made use of Pygame's `Vector2` class. Instances of this class store the X and Y components of a vector, and the class defines a number of useful methods such as `length` and `normalize`, and allows us to subtract one vector from another – which is necessary when we want to work out the position of an object in relation to another, or the distance between two objects. The `MyActor` class defines the attribute `vpos`, which stores an object's position using a `Vector2`. Having made the decision to store positions in this way, it's vital to remember to always access or change an object's position via `vpos`, and not via Pygame Zero's usual methods of accessing `Actor` positions, such as `pos` or `x` and `y`. The only time we set those is when it's time to actually draw the object on the screen. We also need to be careful when we want to copy the contents of one `Vector2` to another. As with any class in Python, instances of `Vector2` are reference types. Therefore, copying should be done like this – `v2 = Vector2(v1)` – rather than this: `v2 = v1`. The latter means that the variable `v2` will refer to the same object as `v1`, so changing one will change the other.

The `Game` class creates and maintains objects for the teams, players, goals, and ball. Its `reset` method is called at the start of the game and after each goal – it recreates the players, ball, and goals, and decides the initial positions of the players on the pitch. Amongst other things, `Game.update` detects goals being scored and assigns players to mark one another (including

Visualisation quest

With so many computer-controlled players running around once, it can be hard to verify that the AI code is doing what it's supposed to be doing – especially given that players can change roles multiple times within the space of a few seconds. One moment a player might be acting as a goalie, then he might be one of the 'lead' players trying to tackle the ball owner, then he might be marking a player on the opposite team. One way to help to confirm everything is working as it should is to use debug visualisations. Near the top of the code you'll see a number of constants such as `DEBUG_SHOW_TARGETS`. When set to True, `Game.draw` displays a line from each player, showing the position they're currently running towards. Debug visualisations can also be useful for learning how a game works. Try turning on each one – preferably one at a time.

Coding Today
Substitute Soccer

assigning a goalie on hard difficulty). If a team has the ball, it also chooses either one or two (depending on difficulty level) 'lead' players from the other team, who will try to intercept the ball.

As with the previous games, the final part of the code uses a simple state machine system to process interactions with the main menu, and trigger updating and drawing of the current `Game` instance. There are also a number of helper functions to do with ball physics, targeting, and angles. In this game, the numbers 0 to 7 are used for angles, with 0 representing up, 1 up and right, 2 right, and so on. Hence we have our own custom sine and cosine functions which work with those angles, as opposed to degrees and radians.

Counting the cost

When a computer player has the ball, there are two decisions it has to make each frame – which direction to run in, and whether to kick the ball. These decisions are made with the help of the `cost` function. Given a position on the pitch and a team number, it calculates the number representing how good or bad it would be for the ball to move to that position – the lower the better. The cost value is calculated based on the distance to our own goal (further away is better), the proximity of the position to players on the opposing team, a quadratic equation (don't panic too much!) causing the player to favour the centre of the pitch and their opponents goal, and a 'handicap' value.

The `cost` function is called in two places. First, when a player with the ball is deciding where to run, `cost` is called five times, each time being passed a position indicating where the player would be if they were to move slightly forward in a particular direction – the five directions being straight ahead, left or right 45°, and left or right 90°. `cost`'s optional third parameter, `handicap`, is used to slightly discourage the player from making turns – this ensures that the player doesn't exhibit unrealistic behaviour such as repeatedly turning left and right within the space of a fraction of a second. `cost` is also called when a player is deciding whether to pass the ball to a team-mate. A piece of code in `Ball.update` tries to find a suitable player to pass to, but the pass only goes ahead if the cost value for the target player's location is less than the cost value for the current player's location.

Coding Today
Substitute Soccer

I am very intelligent

The AI in the previous games has mostly been very straightforward. The bat in *Boing!* moves along a single axis, obeying just two rules – stay near the centre when the ball is far away; as the ball gets nearer, increasingly try to follow its movement. In *Cavern*, the robots move forward, randomly change direction, and randomly decide to shoot – with a higher probability if the player is at the same height as the robot. *Bunner* doesn't really have AI, and in *Myriapod* the segments choose their next cell based on a series of rules, with higher-priority rules taking precedence over others. Although the games are very different, *Soccer*'s AI is closest to that of *Myriapod*. Each frame, a computer-controlled player decides their next action based on a series of conditions. The first is whether anyone currently has the ball. If so, it must be owned by either that player, someone on their team, or someone on the opposite team. Each scenario has its own corresponding behaviour. Alternatively, it might be that no-one has the ball. This could be because kick-off is about to take place, in which case no players are allowed to move other than the player who is about to take the kick-off. Otherwise, all players who currently considered 'active' (i.e. are within 400 pixels of the ball on the Y axis) will attempt to intercept the ball by looking at its trajectory and calculating where to run to have the best chance of obtaining it.

Challenges

- Display a different message from the usual 'GOAL!' if an own goal is scored.

- Try enlarging the game window so you can see more of the pitch at once. Notice how certain aspects of the user interface do not display correctly after this change. How would you fix this?

- The game includes code allowing players to mark players on the opposing team – however, this is currently only enabled for computer-controlled teams. Try enabling this marking behaviour for human teams. Consider how this affects the gameplay and whether you feel the game is better or worse having made this change.

- Give each player a name. Display this above their head, using Pygame Zero's `screen.draw.text` method. You could also generate stats for each player, altering their speed in different circumstances – e.g. when running with or without the ball.

- Simulate a full-length match, including swapping ends at half-time. Display a timer on the screen indicating the number of minutes into the match. The timer could advance at, for example, one minute of game time for every five seconds of real time. Make sure that the timer is stopped during the kick-off phase – otherwise a player could run down the clock by refusing to kick-off!

CODE THE CLASSICS

How to run the game

Open the **soccer.py** file in a Python editor, such as IDLE, and select Run > Run Module.
For more details, see the 'Setting Up' section on page 170.

Download the code `rpt.li/ctc-one-code`

```
001.    import pgzero, pgzrun, pygame
002.    import math, sys, random
003.    from enum import Enum
004.    from pygame.math import Vector2
005.
006.    if sys.version_info < (3,6):
007.        print("This game requires at least version 3.6 of Python. Please download"
008.              "it from www.python.org")
009.        sys.exit()
010.
011.    pgzero_version = [int(s) if s.isnumeric() else s for s in pgzero.__version__.
012.    split('.')]
013.    if pgzero_version < [1,2]:
014.        print(f"This game requires at least version 1.2 of Pygame Zero. You are"
015.              "using version {pgzero.__version__}. Please upgrade using the command"
016.              "'pip install --upgrade pgzero'")
017.        sys.exit()
018.
019.    WIDTH = 800
020.    HEIGHT = 480
021.    TITLE = "Substitute Soccer"
022.
023.    HALF_WINDOW_W = WIDTH / 2
024.
025.    LEVEL_W = 1000
026.    LEVEL_H = 1400
027.    HALF_LEVEL_W = LEVEL_W // 2
028.    HALF_LEVEL_H = LEVEL_H // 2
029.
030.    HALF_PITCH_W = 442
031.    HALF_PITCH_H = 622
032.
033.    GOAL_WIDTH = 186
034.    GOAL_DEPTH = 20
035.    HALF_GOAL_W = GOAL_WIDTH // 2
036.
037.    PITCH_BOUNDS_X = (HALF_LEVEL_W - HALF_PITCH_W, HALF_LEVEL_W + HALF_PITCH_W)
038.    PITCH_BOUNDS_Y = (HALF_LEVEL_H - HALF_PITCH_H, HALF_LEVEL_H + HALF_PITCH_H)
039.
```

```python
040.    GOAL_BOUNDS_X = (HALF_LEVEL_W - HALF_GOAL_W, HALF_LEVEL_W + HALF_GOAL_W)
041.    GOAL_BOUNDS_Y = (HALF_LEVEL_H - HALF_PITCH_H - GOAL_DEPTH,
042.                    HALF_LEVEL_H + HALF_PITCH_H + GOAL_DEPTH)
043.
044.    PITCH_RECT = pygame.rect.Rect(PITCH_BOUNDS_X[0], PITCH_BOUNDS_Y[0],
045.                                  HALF_PITCH_W * 2, HALF_PITCH_H * 2)
046.    GOAL_0_RECT = pygame.rect.Rect(GOAL_BOUNDS_X[0], GOAL_BOUNDS_Y[0],
047.                                   GOAL_WIDTH, GOAL_DEPTH)
048.    GOAL_1_RECT = pygame.rect.Rect(GOAL_BOUNDS_X[0], GOAL_BOUNDS_Y[1] - GOAL_DEPTH,
049.                                   GOAL_WIDTH, GOAL_DEPTH)
050.
051.    AI_MIN_X = 78
052.    AI_MAX_X = LEVEL_W - 78
053.    AI_MIN_Y = 98
054.    AI_MAX_Y = LEVEL_H - 98
055.
056.    PLAYER_START_POS = [(350, 550), (650, 450), (200, 850), (500, 750), (800, 950),
057.                        (350, 1250), (650, 1150)]
058.
059.    LEAD_DISTANCE_1 = 10
060.    LEAD_DISTANCE_2 = 50
061.
062.    DRIBBLE_DIST_X, DRIBBLE_DIST_Y = 18, 16
063.
064.    PLAYER_DEFAULT_SPEED = 2
065.    CPU_PLAYER_WITH_BALL_BASE_SPEED = 2.6
066.    PLAYER_INTERCEPT_BALL_SPEED = 2.75
067.    LEAD_PLAYER_BASE_SPEED = 2.9
068.    HUMAN_PLAYER_WITH_BALL_SPEED = 3
069.    HUMAN_PLAYER_WITHOUT_BALL_SPEED = 3.3
070.
071.    DEBUG_SHOW_LEADS = False
072.    DEBUG_SHOW_TARGETS = False
073.    DEBUG_SHOW_PEERS = False
074.    DEBUG_SHOW_SHOOT_TARGET = False
075.    DEBUG_SHOW_COSTS = False
076.
077.    class Difficulty:
078.        def __init__(self, goalie_enabled, second_lead_enabled, speed_boost,
079.                     holdoff_timer):
080.            self.goalie_enabled = goalie_enabled
081.            self.second_lead_enabled = second_lead_enabled
082.            self.speed_boost = speed_boost
083.            self.holdoff_timer = holdoff_timer
084.
085.    DIFFICULTY = [Difficulty(False, False, 0, 120), Difficulty(False, True, 0.1, 90),
086.                  Difficulty(True, True, 0.2, 60)]
```

```
087.
088.    def sin(x):
089.        return math.sin(x*math.pi/4)
090.
091.    def cos(x):
092.        return sin(x+2)
093.
094.    def vec_to_angle(vec):
095.        return int(4 * math.atan2(vec.x, -vec.y) / math.pi + 8.5) % 8
096.
097.    def angle_to_vec(angle):
098.        return Vector2(sin(angle), -cos(angle))
099.
100.    def dist_key(pos):
101.        return lambda p: (p.vpos - pos).length()
102.
103.    def safe_normalise(vec):
104.        length = vec.length()
105.        if length == 0:
106.            return Vector2(0,0), 0
107.        else:
108.            return vec.normalize(), length
109.
110.    class MyActor(Actor):
111.        def __init__(self, img, x=0, y=0, anchor=None):
112.            super().__init__(img, (0, 0), anchor=anchor)
113.            self.vpos = Vector2(x, y)
114.
115.        def draw(self, offset_x, offset_y):
116.            self.pos = (self.vpos.x - offset_x, self.vpos.y - offset_y)
117.            super().draw()
118.
119.    KICK_STRENGTH = 11.5
120.    DRAG = 0.98
121.
122.    def ball_physics(pos, vel, bounds):
123.        pos += vel
124.
125.        if pos < bounds[0] or pos > bounds[1]:
126.            pos, vel = pos - vel, -vel
127.
128.        return pos, vel * DRAG
129.
130.    def steps(distance):
131.        steps, vel = 0, KICK_STRENGTH
132.
133.        while distance > 0 and vel > 0.25:
```

```python
            distance, steps, vel = distance - vel, steps + 1, vel * DRAG

    return steps

class Goal(MyActor):
    def __init__(self, team):
        x = HALF_LEVEL_W
        y = 0 if team == 0 else LEVEL_H
        super().__init__("goal" + str(team), x, y)

        self.team = team

    def active(self):
        return abs(game.ball.vpos.y - self.vpos.y) < 500

def targetable(target, source):
    v0, d0 = safe_normalise(target.vpos - source.vpos)

    if not game.teams[source.team].human():

        for p in game.players:
            v1, d1 = safe_normalise(p.vpos - source.vpos)

            if p.team != target.team and d1 > 0 and d1 < d0 and v0*v1 > 0.8:
                return False

    return target.team == source.team and d0 > 0 and d0 < 300 and \
                        v0 * angle_to_vec(source.dir) > 0.8

def avg(a, b):
    return b if abs(b-a) < 1 else (a+b)/2

def on_pitch(x, y):
    return PITCH_RECT.collidepoint(x,y) \
        or GOAL_0_RECT.collidepoint(x,y) \
        or GOAL_1_RECT.collidepoint(x,y)

class Ball(MyActor):
    def __init__(self):
        super().__init__("ball", HALF_LEVEL_W, HALF_LEVEL_H)

        self.vel = Vector2(0, 0)

        self.owner = None
        self.timer = 0

        self.shadow = MyActor("balls")
```

```python
182.    def collide(self, p):
183.        return p.timer < 0 and (p.vpos - self.vpos).length() <= DRIBBLE_DIST_X
184.
185.    def update(self):
186.        self.timer -= 1
187.
188.        if self.owner:
189.            new_x = avg(self.vpos.x, self.owner.vpos.x + DRIBBLE_DIST_X *
190.                        sin(self.owner.dir))
191.            new_y = avg(self.vpos.y, self.owner.vpos.y - DRIBBLE_DIST_Y *
192.                        cos(self.owner.dir))
193.
194.            if on_pitch(new_x, new_y):
195.                self.vpos = Vector2(new_x, new_y)
196.            else:
197.                self.owner.timer = 60
198.                self.vel = angle_to_vec(self.owner.dir) * 3
199.                self.owner = None
200.        else:
201.            if abs(self.vpos.y - HALF_LEVEL_H) > HALF_PITCH_H:
202.                bounds_x = GOAL_BOUNDS_X
203.            else:
204.                bounds_x = PITCH_BOUNDS_X
205.
206.            if abs(self.vpos.x - HALF_LEVEL_W) < HALF_GOAL_W:
207.                bounds_y = GOAL_BOUNDS_Y
208.            else:
209.                bounds_y = PITCH_BOUNDS_Y
210.
211.            self.vpos.x, self.vel.x = ball_physics(self.vpos.x, self.vel.x, bounds_x)
212.            self.vpos.y, self.vel.y = ball_physics(self.vpos.y, self.vel.y, bounds_y)
213.
214.        self.shadow.vpos = Vector2(self.vpos)
215.
216.        for target in game.players:
217.
218.            if (not self.owner or self.owner.team != target.team) and \
219.                    self.collide(target):
220.                if self.owner:
221.                    self.owner.timer = 60
222.
223.                self.timer = game.difficulty.holdoff_timer
224.                game.teams[target.team].active_control_player = self.owner = target
225.
226.        if self.owner:
227.            team = game.teams[self.owner.team]
```

```
228.                targetable_players = [p for p in game.players + game.goals if p.team ==
229.                                      self.owner.team and targetable(p, self.owner)]
230.
231.            if len(targetable_players) > 0:
232.                target = min(targetable_players, key=dist_key(self.owner.vpos))
233.                game.debug_shoot_target = target.vpos
234.            else:
235.                target = None
236.
237.            if team.human():
238.                do_shoot = team.controls.shoot()
239.            else:
240.                do_shoot = self.timer <= 0 and target and cost(target.vpos,
241.                        self.owner.team) < cost(self.owner.vpos, self.owner.team)
242.
243.            if do_shoot:
244.                game.play_sound("kick", 4)
245.
246.                if target:
247.                    r = 0
248.                    iterations = 8 if team.human() and isinstance(target, Player) else 1
249.
250.                    for i in range(iterations):
251.                        t = target.vpos + angle_to_vec(self.owner.dir) * r
252.                        vec, length = safe_normalise(t - self.vpos)
253.                        r = HUMAN_PLAYER_WITHOUT_BALL_SPEED * steps(length)
254.                else:
255.                    vec = angle_to_vec(self.owner.dir)
256.                    target = min([p for p in game.players if p.team ==
257.                            self.owner.team], key=dist_key(self.vpos + (vec * 250)))
258.
259.                if isinstance(target, Player):
260.                    game.teams[self.owner.team].active_control_player = target
261.
262.                self.owner.timer = 10
263.                self.vel = vec * KICK_STRENGTH
264.                self.owner = None
265.
266.    def allow_movement(x, y):
267.        if abs(x - HALF_LEVEL_W) > HALF_LEVEL_W:
268.            return False
269.
270.        elif abs(x - HALF_LEVEL_W) < HALF_GOAL_W + 20:
271.            return abs(y - HALF_LEVEL_H) < HALF_PITCH_H
272.
273.        else:
274.            return abs(y - HALF_LEVEL_H) < HALF_LEVEL_H
```

```python
275.
276.    def cost(pos, team, handicap=0):
277.        own_goal_pos = Vector2(HALF_LEVEL_W, 78 if team == 1 else LEVEL_H - 78)
278.        inverse_own_goal_distance = 3500 / (pos - own_goal_pos).length()
279.
280.        result = inverse_own_goal_distance \
281.                 + sum([4000 / max(24, (p.vpos - pos).length())
282.                 for p in game.players if p.team != team]) + ((pos.x
283.                 - HALF_LEVEL_W)**2 / 200 - pos.y * (4 * team - 2)) + handicap
284.
285.        return result, pos
286.
287.    class Player(MyActor):
288.        ANCHOR = (25,37)
289.
290.        def __init__(self, x, y, team):
291.            kickoff_y = (y / 2) + 550 - (team * 400)
292.            super().__init__("blank", x, kickoff_y, Player.ANCHOR)
293.
294.            self.home = Vector2(x, y)
295.            self.team = team
296.            self.dir = 0
297.            self.anim_frame = -1
298.            self.timer = 0
299.            self.shadow = MyActor("blank", 0, 0, Player.ANCHOR)
300.            self.debug_target = Vector2(0, 0)
301.
302.        def active(self):
303.            return abs(game.ball.vpos.y - self.home.y) < 400
304.
305.        def update(self):
306.            self.timer -= 1
307.            target = Vector2(self.home)
308.            speed = PLAYER_DEFAULT_SPEED
309.            my_team = game.teams[self.team]
310.            pre_kickoff = game.kickoff_player != None
311.            i_am_kickoff_player = self == game.kickoff_player
312.            ball = game.ball
313.
314.            if self == game.teams[self.team].active_control_player and \
315.                my_team.human() and (not pre_kickoff or i_am_kickoff_player):
316.
317.                if ball.owner == self:
318.                    speed = HUMAN_PLAYER_WITH_BALL_SPEED
319.                else:
320.                    speed = HUMAN_PLAYER_WITHOUT_BALL_SPEED
321.
```

Coding Today
Substitute Soccer

```
322.                    target = self.vpos + my_team.controls.move(speed)
323.
324.           elif ball.owner != None:
325.               if ball.owner == self:
326.                   costs = [cost(self.vpos + angle_to_vec(self.dir + d) * 3,
327.                                 self.team, abs(d)) for d in range(-2, 3)]
328.
329.                   _, target = min(costs, key=lambda element: element[0])
330.                   speed = CPU_PLAYER_WITH_BALL_BASE_SPEED + game.difficulty.speed_boost
331.
332.               elif ball.owner.team == self.team:
333.                   if self.active():
334.                       direction = -1 if self.team == 0 else 1
335.                       target.x = (ball.vpos.x + target.x) / 2
336.                       target.y = (ball.vpos.y + 400 * direction + target.y) / 2
337.                   else:
338.                       if self.lead is not None:
339.                           target = ball.owner.vpos + angle_to_vec(ball.owner.dir) * self.lead
340.                           target.x = max(AI_MIN_X, min(AI_MAX_X, target.x))
341.                           target.y = max(AI_MIN_Y, min(AI_MAX_Y, target.y))
342.
343.                           other_team = 1 if self.team == 0 else 1
344.                           speed = LEAD_PLAYER_BASE_SPEED
345.                           if game.teams[other_team].human():
346.                               speed += game.difficulty.speed_boost
347.
348.               elif self.mark.active():
349.
350.                   if my_team.human():
351.                       target = Vector2(ball.vpos)
352.                   else:
353.                       vec, length = safe_normalise(ball.vpos - self.mark.vpos)
354.
355.                       if isinstance(self.mark, Goal):
356.                           length = min(150, length)
357.                       else:
358.                           length /= 2
359.
360.                       target = self.mark.vpos + vec * length
361.           else:
362.               if (pre_kickoff and i_am_kickoff_player) or (not pre_kickoff and
363.                                                            self.active()):
364.                   target = Vector2(ball.vpos)
365.                   vel = Vector2(ball.vel)
366.                   frame = 0
367.
368.                   while (target - self.vpos).length() > PLAYER_INTERCEPT_BALL_SPEED *
```

```python
369.                                  frame + DRIBBLE_DIST_X and vel.length() > 0.5:
370.                        target += vel
371.                        vel *= DRAG
372.                        frame += 1
373.
374.                speed = PLAYER_INTERCEPT_BALL_SPEED
375.
376.            elif pre_kickoff:
377.                target.y = self.vpos.y
378.
379.        vec, distance = safe_normalise(target - self.vpos)
380.        self.debug_target = Vector2(target)
381.
382.        if distance > 0:
383.            distance = min(distance, speed)
384.            target_dir = vec_to_angle(vec)
385.
386.            if allow_movement(self.vpos.x + vec.x * distance, self.vpos.y):
387.                self.vpos.x += vec.x * distance
388.            if allow_movement(self.vpos.x, self.vpos.y + vec.y * distance):
389.                self.vpos.y += vec.y * distance
390.
391.            self.anim_frame = (self.anim_frame + max(distance, 1.5)) % 72
392.        else:
393.            target_dir = vec_to_angle(ball.vpos - self.vpos)
394.            self.anim_frame = -1
395.
396.        dir_diff = (target_dir - self.dir)
397.        self.dir = (self.dir + [0, 1, 1, 1, 1, 7, 7, 7][dir_diff % 8]) % 8
398.
399.        suffix = str(self.dir) + str((int(self.anim_frame) // 18) + 1) # todo
400.
401.        self.image = "player" + str(self.team) + suffix
402.        self.shadow.image = "players" + suffix
403.        self.shadow.vpos = Vector2(self.vpos)
404.
405.
406.
407. class Team:
408.     def __init__(self, controls):
409.         self.controls = controls
410.         self.active_control_player = None
411.         self.score = 0
412.
413.     def human(self):
414.         return self.controls != None
415.
```

Coding Today
Substitute Soccer

```
416.    class Game:
417.        def __init__(self, p1_controls=None, p2_controls=None, difficulty=2):
418.            self.teams = [Team(p1_controls), Team(p2_controls)]
419.            self.difficulty = DIFFICULTY[difficulty]
420.
421.            try:
422.                if self.teams[0].human():
423.                    music.fadeout(1)
424.                    sounds.crowd.play(-1)
425.                    sounds.start.play()
426.                else:
427.                    music.play("theme")
428.                    sounds.crowd.stop()
429.            except:
430.                pass
431.
432.            self.score_timer = 0
433.            self.scoring_team = 1
434.            self.reset()
435.
436.        def reset(self):
437.            self.players = []
438.            random_offset = lambda x: x + random.randint(-32, 32)
439.            for pos in PLAYER_START_POS:
440.                self.players.append(Player(random_offset(pos[0]),
441.                                           random_offset(pos[1]), 0))
442.                self.players.append(Player(random_offset(LEVEL_W - pos[0]),
443.                                           random_offset(LEVEL_H - pos[1]), 1))
444.
445.            for a, b in zip(self.players, self.players[::-1]):
446.                a.peer = b
447.
448.            self.goals = [Goal(i) for i in range(2)]
449.            self.teams[0].active_control_player = self.players[0]
450.            self.teams[1].active_control_player = self.players[1]
451.            other_team = 1 if self.scoring_team == 0 else 0
452.            self.kickoff_player = self.players[other_team]
453.            self.kickoff_player.vpos = Vector2(HALF_LEVEL_W - 30 + other_team * 60,
454.                                               HALF_LEVEL_H)
455.            self.ball = Ball()
456.            self.camera_focus = Vector2(self.ball.vpos)
457.            self.debug_shoot_target = None
458.
459.        def update(self):
460.            self.score_timer -= 1
461.
462.            if self.score_timer == 0:
```

```
463.                self.reset()
464.
465.           elif self.score_timer < 0 and abs(self.ball.vpos.y -
466.                                 HALF_LEVEL_H) > HALF_PITCH_H:
467.                game.play_sound("goal", 2)
468.
469.                self.scoring_team = 0 if self.ball.vpos.y < HALF_LEVEL_H else 1
470.                self.teams[self.scoring_team].score += 1
471.                self.score_timer = 60
472.
473.           for b in self.players:
474.                b.mark = b.peer
475.                b.lead = None
476.                b.debug_target = None
477.
478.           self.debug_shoot_target = None
479.
480.           if self.ball.owner:
481.                o = self.ball.owner
482.                pos, team = o.vpos, o.team
483.                owners_target_goal = game.goals[team]
484.                other_team = 1 if team == 0 else 1
485.
486.                if self.difficulty.goalie_enabled:
487.                     nearest = min([p for p in self.players if p.team != team],
488.                                    key = dist_key(owners_target_goal.vpos))
489.
490.                     o.peer.mark = nearest.mark
491.                     nearest.mark = owners_target_goal
492.
493.                l = sorted([p for p in self.players
494.                            if p.team != team
495.                            and p.timer <= 0
496.                            and (not self.teams[other_team].human() or p !=
497.                                 self.teams[other_team].active_control_player)
498.                            and not isinstance(p.mark, Goal)],
499.                          key = dist_key(pos))
500.
501.                a = [p for p in l if (p.vpos.y > pos.y if team == 0
502.                                      else p.vpos.y < pos.y)]
503.                b = [p for p in l if p not in a]
504.
505.                NONE2 = [None] * 2
506.                zipped = [s for t in zip(a+NONE2, b+NONE2) for s in t if s]
507.
508.                zipped[0].lead = LEAD_DISTANCE_1
509.                if self.difficulty.second_lead_enabled:
```

```
510.                    zipped[1].lead = LEAD_DISTANCE_2
511.
512.             self.kickoff_player = None
513.
514.         for obj in self.players + [self.ball]:
515.             obj.update()
516.
517.         owner = self.ball.owner
518.
519.         for team_num in range(2):
520.             team_obj = self.teams[team_num]
521.
522.             if team_obj.human() and team_obj.controls.shoot():
523.                 def dist_key_weighted(p):
524.                     dist_to_ball = (p.vpos - self.ball.vpos).length()
525.                     goal_dir = (2 * team_num - 1)
526.                     if owner and (p.vpos.y - self.ball.vpos.y) * goal_dir < 0:
527.                         return dist_to_ball / 2
528.                     else:
529.                         return dist_to_ball
530.
531.                 self.teams[team_num].active_control_player = \
532.                     min([p for p in game.players
533.                          if p.team == team_num], key = dist_key_weighted)
534.
535.         camera_ball_vec, distance = safe_normalise(self.camera_focus
536.                                                   - self.ball.vpos)
537.         if distance > 0:
538.             self.camera_focus -= camera_ball_vec * min(distance, 8)
539.
540.     def draw(self):
541.         offset_x = max(0, min(LEVEL_W - WIDTH, self.camera_focus.x - WIDTH / 2))
542.         offset_y = max(0, min(LEVEL_H - HEIGHT, self.camera_focus.y - HEIGHT / 2))
543.         offset = Vector2(offset_x, offset_y)
544.
545.         screen.blit("pitch", (-offset_x, -offset_y))
546.
547.         objects = sorted([self.ball] + self.players, key = lambda obj: obj.y)
548.         objects = objects + [obj.shadow for obj in objects]
549.         objects = [self.goals[0]] + objects + [self.goals[1]]
550.
551.         for obj in objects:
552.             obj.draw(offset_x, offset_y)
553.
554.         for t in range(2):
555.             if self.teams[t].human():
556.                 arrow_pos = self.teams[t].active_control_player.vpos - \
```

```
557.                         offset - Vector2(11, 45)
558.                 screen.blit("arrow" + str(t), arrow_pos)
559.
560.         if DEBUG_SHOW_LEADS:
561.             for p in self.players:
562.                 if game.ball.owner and p.lead:
563.                     line_start = game.ball.owner.vpos - offset
564.                     line_end = p.vpos - offset
565.                     pygame.draw.line(screen.surface, (0,0,0), line_start, line_end)
566.
567.         if DEBUG_SHOW_TARGETS:
568.             for p in self.players:
569.                 line_start = p.debug_target - offset
570.                 line_end = p.vpos - offset
571.                 pygame.draw.line(screen.surface, (255,0,0), line_start, line_end)
572.
573.         if DEBUG_SHOW_PEERS:
574.             for p in self.players:
575.                 line_start = p.peer.vpos - offset
576.                 line_end = p.vpos - offset
577.                 pygame.draw.line(screen.surface, (0,0,255), line_start, line_end)
578.
579.         if DEBUG_SHOW_SHOOT_TARGET:
580.             if self.debug_shoot_target and self.ball.owner:
581.                 line_start = self.ball.owner.vpos - offset
582.                 line_end = self.debug_shoot_target - offset
583.                 pygame.draw.line(screen.surface, (255,0,255), line_start, line_end)
584.
585.         if DEBUG_SHOW_COSTS and self.ball.owner:
586.             for x in range(0,LEVEL_W,60):
587.                 for y in range(0, LEVEL_H, 26):
588.                     c = cost(Vector2(x,y), self.ball.owner.team)[0]
589.                     screen_pos = Vector2(x,y)-offset
590.                     screen_pos = (screen_pos.x,screen_pos.y)
591.                     screen.draw.text(f"{c:.0f}", center=screen_pos)
592.
593.     def play_sound(self, name, c):
594.         if state != State.MENU:
595.             try:
596.                 getattr(sounds, name+str(random.randint(0, c-1))).play()
597.             except:
598.                 pass
599.
600. key_status = {}
601.
602. def key_just_pressed(key):
603.     result = False
```

```
604.          prev_status = key_status.get(key, False)
605.
606.          if not prev_status and keyboard[key]:
607.              result = True
608.
609.          key_status[key] = keyboard[key]
610.
611.          return result
612.
613.    class Controls:
614.        def __init__(self, player_num):
615.            if player_num == 0:
616.                self.key_up = keys.UP
617.                self.key_down = keys.DOWN
618.                self.key_left = keys.LEFT
619.                self.key_right = keys.RIGHT
620.                self.key_shoot = keys.SPACE
621.            else:
622.                self.key_up = keys.W
623.                self.key_down = keys.S
624.                self.key_left = keys.A
625.                self.key_right = keys.D
626.                self.key_shoot = keys.LSHIFT
627.
628.        def move(self, speed):
629.            dx, dy = 0, 0
630.            if keyboard[self.key_left]:
631.                dx = -1
632.            elif keyboard[self.key_right]:
633.                dx = 1
634.            if keyboard[self.key_up]:
635.                dy = -1
636.            elif keyboard[self.key_down]:
637.                dy = 1
638.            return Vector2(dx, dy) * speed
639.
640.        def shoot(self):
641.            return key_just_pressed(self.key_shoot)
642.
643.    class State(Enum):
644.        MENU = 0
645.        PLAY = 1
646.        GAME_OVER = 2
647.
648.    class MenuState(Enum):
649.        NUM_PLAYERS = 0
650.        DIFFICULTY = 1
```

```
651.
652.    def update():
653.        global state, game, menu_state, menu_num_players, menu_difficulty
654.
655.        if state == State.MENU:
656.            if key_just_pressed(keys.SPACE):
657.                if menu_state == MenuState.NUM_PLAYERS:
658.                    if menu_num_players == 1:
659.                        menu_state = MenuState.DIFFICULTY
660.                    else:
661.                        state = State.PLAY
662.                        menu_state = None
663.                        game = Game(Controls(0), Controls(1))
664.                else:
665.                    state = State.PLAY
666.                    menu_state = None
667.                    game = Game(Controls(0), None, menu_difficulty)
668.            else:
669.                selection_change = 0
670.                if key_just_pressed(keys.DOWN):
671.                    selection_change = 1
672.                elif key_just_pressed(keys.UP):
673.                    selection_change = -1
674.                if selection_change != 0:
675.                    sounds.move.play()
676.                    if menu_state == MenuState.NUM_PLAYERS:
677.                        menu_num_players = 2 if menu_num_players == 1 else 1
678.                    else:
679.                        menu_difficulty = (menu_difficulty + selection_change) % 3
680.
681.            game.update()
682.
683.        elif state == State.PLAY:
684.            if max([team.score for team in game.teams]) == 9 and game.score_timer == 1:
685.                state = State.GAME_OVER
686.            else:
687.                game.update()
688.
689.        elif state == State.GAME_OVER:
690.            if key_just_pressed(keys.SPACE):
691.                state = State.MENU
692.                menu_state = MenuState.NUM_PLAYERS
693.                game = Game()
694.
695.    def draw():
696.        game.draw()
697.
```

```python
        if state == State.MENU:
            if menu_state == MenuState.NUM_PLAYERS:
                image = "menu0" + str(menu_num_players)
            else:
                image = "menu1" + str(menu_difficulty)
            screen.blit(image, (0, 0))

        elif state == State.PLAY:
            screen.blit("bar", (HALF_WINDOW_W - 176, 0))

            for i in range(2):
                screen.blit("s" + str(game.teams[i].score), (HALF_WINDOW_W + 7
                                                            - 39 * i, 6))

            if game.score_timer > 0:
                screen.blit("goal", (HALF_WINDOW_W - 300, HEIGHT / 2 - 88))

        elif state == State.GAME_OVER:
            img = "over" + str(int(game.teams[1].score > game.teams[0].score))
            screen.blit(img, (0, 0))

            for i in range(2):
                img = "l" + str(i) + str(game.teams[i].score)
                screen.blit(img, (HALF_WINDOW_W + 25 - 125 * i, 144))

    try:
        pygame.mixer.quit()
        pygame.mixer.init(44100, -16, 2, 1024)
    except:
        pass

    state = State.MENU
    menu_state = MenuState.NUM_PLAYERS
    menu_num_players = 1
    menu_difficulty = 0

    game = Game()
    pgzrun.go()
```

CODE THE CLASSICS

1 GOAL!

2 RED team : BLUE team

3 ○

5

4

1. This graphic is only displayed when a goal is scored

2. The banner used for the scores at the top of the screen

3. This simple ball graphic is used throughout

4. Player sprites for both teams, for every animation frame and direction

5. The nets for the bottom and top of the pitch

6. Shadows are added to players for extra realism

6

Coding Today
Substitute Soccer

7 The menu screen enables the selection of number of players and one-player difficulty level

8 The pitch – only part of it is shown on screen at one time

9 Digits used for the team scores

10 An arrow is used to indicate which player is currently under control

11 The game-over screen shows the winning team and score

CODE THE CLASSICS

Setting Up

Learn how to run and edit the games in this book by installing Python, Pygame Zero, and an IDE

To run and edit the games in this book, you'll need three things:

1. The Python interpreter
This is the software that allows you to run programs written in Python.

2. Pygame Zero
An add-on package for Python which takes care of a lot of the essentials of game development, such as displaying graphics and playing sound.

3. An integrated development environment (IDE)
Software which includes a code editor and the ability to run a program from that editor. It's possible to get by without an IDE, but it's much more convenient to use one.

You must have at least version 3.6 of the Python interpreter. Note that when a new version of Python is released, it can take some time before Pygame Zero becomes compatible with it. At the time of writing, the most recent version of Python which can be used with Pygame Zero is 3.12.

There are many IDEs available; here we're going to look at three of them – IDLE, Thonny, and PyCharm. IDLE is a very simple IDE which comes bundled with Python for Windows and Mac, and is installed by default on some older versions of Raspberry Pi's operating system. Thonny has some additional features although is still geared towards beginners, and is installed by default on Raspberry Pi OS. PyCharm is an advanced IDE used by professional developers. We recommend Thonny or IDLE for beginners, and PyCharm for more experienced or confident users.

Occasionally, errors can occur while trying to get everything installed and running – especially on older computers. We're dealing with three separate pieces of software (plus the games themselves) which frequently change but have to work together. If you experience errors while trying to use a particular IDE or version of Python, try another IDE or Python version.

Windows

Installing Python

Windows does not come with Python pre-installed. If you think you may have installed Python previously, you can check this by looking for 'Python' in the Start menu or under 'Apps and Features' within Settings.

If you intend to use Thonny as your IDE, you can skip ahead to the 'Thonny' section as Python is automatically installed alongside it, and Pygame Zero can be installed via Thonny.

Go to **python.org** and mouse-over Downloads. You can choose the option to directly download the latest version, or you can click on 'Windows' to see a list which includes older versions. As mentioned, sometimes when a new version is released, Pygame Zero may not become compatible with it for a while. If this occurs, go to the full list of Windows releases, then under 'Stable Releases' find Python 3.12.2, and choose to download 'Windows installer (64-bit)'.

Once the download is complete, run the program either via your web browser or from your Downloads folder. Check the box next to 'Add Python [version number] to PATH'. Then click 'Install now' to install using the default options.

If you have any difficulties, full installation instructions can be found at **rptl.io/python-windows**.

> **Once the download is complete, run the program via your web browser or from your Downloads folder**

Installing Pygame Zero

If you intend to use PyCharm as your IDE, you can skip ahead to 'Installing PyCharm', as Pygame Zero can be installed via that software.

Otherwise, open a Command Prompt, Windows PowerShell, or Windows Terminal window. Enter the command `python --version` to confirm that Python has installed correctly. Then type `pip3 install pgzero`. This will download the Pygame Zero package, and other packages it requires. If this fails and you're using the very latest version of Python, try uninstalling and trying again with an older version.

Note – be sure to type 'pgzero' carefully. Malware creators sometimes upload fake versions of legitimate Python packages with very similar names, in the hope that people will download them when they mistype a package's name. This is known as typosquatting.

Mac

Installing Python

Recent versions of macOS do not come with Python pre-installed. Some older versions did come with a Python interpreter, but only version 2.7 which is not compatible with Pygame Zero.

Go to **python.org** and mouse-over Downloads. You can choose the option to directly download the latest version, or you can click on 'macOS' to see a list which includes older versions.

As mentioned previously, sometimes when a new version is released, Pygame Zero may not become compatible with it for a while. If this occurs, go to the full list of Mac releases, then under 'Stable Releases' find Python 3.12.2, and choose to download 'macOS 64-bit universal2 installer'.

Once the download is complete, run the program either via your web browser or from your Downloads folder. Install using the default options.

Installing Pygame Zero

If you intend to use PyCharm as your IDE, you can skip ahead to 'Installing PyCharm', as Pygame Zero can be installed via that software.

Otherwise, open a Terminal window. Enter the command `python3 --version` to confirm that Python has installed correctly. Then enter `pip3 install pgzero`. This will download the Pygame Zero package, and other packages it requires.

Raspberry Pi

Raspberry Pi OS comes with both Python and Pygame Zero already installed. The older Raspbian operating system also comes with these installed, although very old versions may have poorer performance, or may not have the correct version of Python or Pygame Zero. Even on more recent installs, it may be worth running a system update via the icon at the top right of the desktop, as updates may include newer versions of Pygame and Pygame Zero with bug-fixes or better performance.

Recent versions of Raspberry Pi OS come with Thonny, but do not include IDLE. PyCharm can be used on the Raspberry Pi – see the installation instructions for the Linux version on the PyCharm website: **rptl.io/pycharm-help**.

IDEs

IDLE

IDLE is a simple IDE which is automatically installed alongside Python. You can find it under the Python folder within the Start Menu on Windows, or by searching for 'IDLE'. Make sure you use the version of IDLE that corresponds to the version of Python you want to use.

Once IDLE starts, the first thing you'll see is a window titled 'Python [version number] Shell'. In this window, you can type a line of Python code and see it run straight away. For example, try entering:

```
x = 5
y = 3
x + y
```

You can use the File menu to open a Python file – for example, **boing.py**. You can then run the game by going to the Run menu and choosing Run Module – or by pressing **F5**. If an error occurs, text will be output to the Python Shell window.

Getting the games

Although you could try typing in the code of the five games presented in this book, this would be a lot of work and prone to errors. More importantly, a game can't be run without its set of image and sound files. Additionally, the code listings in this book don't include the comments which explain various aspects of how the games work.

The games can be downloaded from GitHub – a website for hosting projects stored using the git version control system. You can find the code at **rptl.io/ctc-one-code**. There are two options for downloading the games. The first is to click on the 'Code' button and choose 'Download ZIP' – this packages all the game's files into a ZIP file which can be extracted into a folder. The alternative is to download the games directly using the git version control system – download it from **git-scm.com** and install it using the default settings. On the GitHub page, copy the web address that comes up when 'Code' is clicked, then use git via the command prompt/terminal to download the project – enter `git clone` followed by the web address; alternatively, download it via the 'Get from VCS' option in PyCharm, if you intend to use that IDE.

Once you've downloaded a game, there are several ways you can run it. On Windows or Mac, you can simply double-click on the game's Python file in File Explorer / Finder. On any system, you can navigate to a game's folder in a command prompt/terminal window and type `pgzrun game.py` (replace game.py with the name of the Python file). Or you can run the game via an IDE.

If you have a computer with a low screen resolution, and if you are using the display scaling option on Windows or macOS, there is a chance of the game window being too big for the screen. In Windows, you can check to see if display scaling is turned on by going to the display settings – the relevant setting is 'Change the size of text, apps and other items'. If it's above 100%, and you are having difficulty with a game not fitting on the screen, try reducing this to 100%.

You can also try adding the following two lines at the top of the game's code file – although note that this will only work in Windows:

```
import ctypes
ctypes.windll.user32.SetProcessDPIAware()
```

Thonny

Thonny comes installed with Raspberry Pi OS. For Windows and Mac computers, you can download and install it from **thonny.org**. By default, Thonny uses a version of Python which comes packaged with it. If you've already downloaded Python separately and installed Pygame Zero, you can choose to use that version by going to the Run menu, clicking 'Select interpreter', changing the selected option to 'Alternative Python 3 interpreter or virtual environment', and then selecting the desired interpreter from the 'Python executable' drop-down list.

You can install Pygame Zero from within Thonny, by going to the Tools menu and selecting 'Manage packages'. In the text box, type 'pgzero' (without quotes) and then click the button to the right. Then click 'Install'. You don't need to do this on a Raspberry Pi as it should already be installed.

You can use the File menu to open a Python file – for example, **boing.py**. You can then run the game by clicking the 'Run current script' button, or by pressing **F5**. If an error occurs, the details will be output to the Shell area at the bottom of the screen.

Do not enable 'Pygame Zero mode' in the Run menu – this is only needed if the line `pgzrun.go()` is not present at the end of the code.

PyCharm

PyCharm is a powerful IDE with dozens of features. One of most useful is code completion, where the IDE tries to predict what you're going to type based on variable and function names, or class members. When PyCharm shows a list of suggestions, you can press **TAB** to accept the currently selected item. Another important feature is the debugger, which is very useful when you're trying to work out why a piece of code isn't working as expected.

Download PyCharm from **rptl.io/pycharm**. Make sure you get the Community edition, not the Professional edition. Once it's installed, run it and choose the default options. You should end up on a screen which gives you the option of creating a new project, opening an existing project, or checking out from version control. If you haven't already downloaded the games, the most convenient option is to choose 'Get from VCS' (version control system) – the address to enter in the URL text box is the one that can be found by clicking the 'Code' button on the games' GitHub page – see 'Getting the games'.

I **PyCharm is a more sophisticated IDE with a handy debugger tool**

2 PyCharm's project interpreter showing installed packages

If you have already downloaded the games, you can select 'Open' and choose the folder where you extracted the ZIP file. Make sure you select the folder which directly contains the game's files, not a folder which contains another subfolder of the same name, as can happen depending on how you unzipped the files.

The following instructions will assume you're trying to run the game *Boing!*.

Once the project has loaded, look for the 'Project' area near the top left of the window. Below the word Project, you should see the name of the folder, e.g. **boing**, with an arrow to the left. Click on the arrow to expand the folder. You should then see a list of files and folders, one of which will be the game's Python file – e.g. **boing.py**. Double-click this to load it.

If you haven't yet installed Pygame Zero, or you're not sure if you have the latest version, go to the File menu and select Settings (on Mac, PyCharm menu > Preferences). Expand 'Project: boing' and select 'Project interpreter'. Here you can choose which Python interpreter your project will use, and which external packages are available. If Pygame Zero is installed, you will see 'pgzero' in the list of packages, and its version number should be displayed alongside it. If it's there but the version number is less than 1.2, select pgzero and click the upward-pointing arrow at the right-hand side of the window. If pgzero is not present, click the plus icon near the top right of the window. Type 'pgzero' into the search box and click 'Install Package'. Wait for it to install, then close the window and click OK to close the settings window.

> You can choose which Python interpreter your project will use, and which packages are available

3 Running under the debugger helps you to pinpoint errors in the code

To run the game, right-click on the background of the code area (the main part of the window) and choose 'Run 'boing' '. If the option is greyed out, this is most likely because PyCharm is running some processes in the background which need to finish – wait until these are done (see the notification at the bottom of the screen) and then try again.

You can run the game in debug mode by choosing 'Debug 'boing' '. Running under the debugger can result in a worse frame rate, but provides a number of benefits. If an unhandled exception (a type of error which causes the program to stop) occurs, normally all you'll get is a text printout showing the details of the exception (at the bottom of the printout) and the call stack, which indicates the function and line number where the error occurred and the functions which called that function. In debug mode, an unhandled exception causes the program to pause – you can then use the debugger to see where the error occurred, and view the current contents of the variables and call stack. You can also manually break into the debugger by adding a breakpoint – click in the grey area to the right of a line number. You should see a red circle appear. When you run in debug mode, PyCharm will break into the debugger just before that line of code is about run. Now you can view the variables and the call stack as before, but you can also cause the code to run one line at a time by using commands such as Step Over and Step Into (via the Run menu or buttons in the Debug window).

Setting Up

177

CODE THE CLASSICS

An Introduction to **Python**

Key features that you'll need to know to understand how the games work

This book has been written assuming that the reader has at least some knowledge of the Python programming language. Although it is outside of the scope of this book to teach you Python, we'll go through some of the key features of the language that you'll need to understand.

Variables

A *variable* represents a small area of memory which can store a value. Every variable has a name and a type. A variable name may consist of letters, numbers, and underscores, but cannot start with a number. In Python the convention is to name variables in *snake case*, where we only use lower-case letters and use underscores to separate words. For example, if we wanted a variable which indicates whether the game is over, we might call it `game_over`.

Every variable has a type. The most commonly used types in Python are:

`int` — short for integer, i.e. a whole number

`float` — short for floating-point number, which can be a fraction

`string` — a piece of text consisting of zero or more characters

`bool` — short for Boolean, a value which can either be True or False

`NoneType` — a special type whose only value is None, which represents an unassigned object

A variable is created by writing its name followed by an equals sign, followed by its initial value. Creating or changing a variable in this way is called *assignment*. For example:

```
x = 5    # Create an integer variable named x and assign the value 5 to it
```

Unlike in some other languages like C, C++, C#, and Java, you don't need to specify the type of a variable to create it. Instead, Python works out what kind of variable it should be. There's something called *type hinting* where you can annotate your code to indicate the intended type of a variable, but Python does not enforce the type and we don't use this feature in this book.

A *string literal* is a value enclosed in quotes, e.g. `'dog'`. In Python you can use either single or double quotes for string literals, whereas many other languages only allow double quotes.

Constants

Some languages have the concept of a *constant*, which is a variable that can't be changed. Python doesn't actually have constants, but it's still useful to understand the concept. If you write a variable name all in upper-case, it's a signal to anyone reading the code that this variable is intended to be a constant and shouldn't be changed. Constants have a number of benefits, including helping to make the code more readable. For our games, we put most of the constants near the top of the code.

> **Python doesn't actually have constants, but it's still useful to understand the concept**

Lists, tuples, and dictionaries

These are ways of storing multiple items under the same variable name. A *list* is created using square brackets, e.g. `numbers = [10,20,30]`. You can access the items in the list (known as *elements*) by writing `numbers[0]`, `numbers[1]`, or `numbers[2]`. You can create an empty list by writing a pair of empty square brackets. Add to it using `.append`, and delete elements using `del`.

A *tuple* is like a list which can't be changed. Tuples are created using normal brackets instead of square ones. A tuple of one element must be created by placing a comma after that element, e.g. `my_tuple = (1,)`.

Lists and tuples can be created using *comprehensions*. For example, the line `multiples_of_two = [i * 2 for i in range(8)]` will generate the list [0,2,4,6,8,10,12,14].

A *dictionary* stores data as key-value pairs, where the key is used to look up the item and the value is stored alongside it. They are created using curly brackets – e.g. `word_definitions = {'dog':'Thing that says woof', 'cat':'Thing that says meow'}`. You can look up, add, or modify dictionary items like this: `print(word_definitions['dog'])`. In these examples, both the keys and values are strings, but most types can be used.

You can get the length (number of items) of a list, tuple, or dictionary using `len`, e.g. `len(numbers)`. This can also be used to find the number of characters in a string.

If statements and loops

An `if` statement allows different actions to be taken depending on a condition – a piece of code which results in either `True` or `False`. For example:

```
if health <= 0:
    print('You died!')
```

You can optionally follow an if-block with `elif` (else if) or `else`.

A `while` loop causes a block of code to be repeated until the condition is false. The following code example checks if the difference between two values is less than 40. If so, it will randomly choose a new value for one of them, and then repeat the process until the difference is 40 or more.

```
while abs(self.vpos.y - self.target.y) < 40:
    self.vpos.y = randint(MIN_WALK_Y, HEIGHT-1)
```

A `for` loop causes a block of code to repeat a certain number of times. One approach is to loop through a series of numbers:

```
for i in range(100):
    print(i)
```

This prints all the numbers from zero to 99. Python's `range` function generates a sequence of numbers, and the `i` variable will be assigned each of these in turn as we repeat the loop. The `range` function can optionally receive a start number (e.g. `range(5,10)`) and a step (e.g. `range(10,5,-1)` to go backwards – 10, 9, 8, 7, 6). Note that `for` can also be used to iterate through each element of a list or tuple:

```
for number in numbers:
    print(number)
```

Functions

A *function* is a block of code which can be called (run) on demand. It can receive inputs (stored in variables called *parameters*) and return a *result*.

```
def square(n):      # n is a parameter
    return n * n

x = square(5)       # x will be 25
```

Classes and objects

A *class* allows the programmer to create their own custom data type. A class is primarily made up of *methods*, which are functions that are defined within a class. On its own a class does nothing, in the same way that a function never does anything if it is never called. To use a class, you create what's called an *object* based on that class.

```
class Dog:
    def __init__(self, name, age):
        # constructor method - run on object creation
        self.name = name
        self.age = age

    def make_noise(self):
        print('Woof')

rover = Dog('Rover', 3)
rover.make_noise()
print(rover.name)
```

Classes can *inherit* from other classes. The class being inherited is referred to as the *superclass*, and the class doing the inheriting is the *subclass*. The subclass will have all the methods of the superclass, and can provide its own *overridden* versions of certain methods.

```
class Animal:
    def __init__(self, name, age):
        self.name = name
        self.age = age

    def make_noise(self):
        print('?')

class Dog(Animal):
    def __init__(self, name, age, breed):
        super().__init__(name, age)
        self.breed = breed

    def make_noise(self):
        print('Woof')

class Cat(Animal):
    # We can leave out the constructor method for a class if
    # it's the same as the super (parent) class method

    def make_noise(self):
        print('Meow')
```

The `self` parameter in a method refers to the object that we're currently dealing with. Many objects can be *instantiated* (made) based on the same class. In a game with a `Bullet` class, one `Bullet` object will be created for each bullet fired. The variables stored within an object are known as *attributes*.

Value and reference types

Simple variable types such and `int`, `float`, and `bool` are known as *value types*. This means that the variable contains the actual value stored. In the following code, when we set `y` to `x`, `y` contains a copy of the data that was in `x`. The `x` and `y` variables remain independent of each other.

```
x = 5
y = x
x = 3
print(y)     # prints 5
```

Objects, lists, and dictionaries are known as *reference types*. When you create a list, the data for the list itself is stored somewhere in memory, and the variable contains a reference that tells Python where to find that data. In the code below, when we copy `numbers` to `numbers2`, we're not making a copy of the actual list data; we're copying the reference. This means that `numbers` and `numbers2` refer to the same data.

```
numbers = [10, 20, 30]
numbers2 = numbers
numbers[0] = 100
print(numbers2[0])    # prints 100 - numbers and numbers2 refer to same list
```

The same thing applies when passing a reference type to a function or method. In fact, when you do a method call, e.g:

```
class Player:
    def update(self):
        …
player = Player()    # create a Player object, store its reference in player
player.update()
```

…the object reference held by the `player` variable is passed as the `self` parameter of the `Player.update` method. That's what `self` is and how it works. It's equivalent to writing `Player.update(player)`.

String formatting

We often want to embed data from variables into a string. There are four main ways to do this in Python:

1. Joining two strings with +

This is called *concatenation*. Let's say you have a game where the sprites for the player's run animation are named 'run0' to 'run7', and you're storing the current animation frame number in the variable `i`. You can't join an integer to a string in Python, but you can convert the integer into a string and then join it to another string: `sprite = 'run' + str(i)`

2. The percent sign
This is a very old technique which has been superseded. We don't use it in this book, so we won't go into the details here. If you see the percent sign (`%`) in code, its most common use is as the 'mod' operator which gets the remainder of a division.

3. str.format
Although this approach has also been superseded, it can be used to maintain compatibility with Python 3.5. You specify a 'format string', call the `.format` method on it, and specify which variables you want to embed in the string:

```
sprite = 'run{0}'.format(i)
```

4. f-strings
This is a form of *string interpolation* where the variables to be used are embedded directly into the string:

```
sprite = f'run{i}'
```

Exception handling

An *exception* is a type of error that can occur while the program is running. If, for example, you try to access a non-existent index within a list, you'll get an `IndexError` exception. Normally exceptions will stop the program, but you can write code which listens out for them and deals with them:

```
try:
    pygame.mixer.quit()
    pygame.mixer.init(44100, -16, 2, 1024)
    play_music("title_theme")
except Exception:
    # If an error occurs (e.g. no sound hardware), ignore it
    pass
```

We use code like this in our games to reconfigure the Pygame audio mixer on startup, since the default settings have been known to cause problems on some devices. However, a small number of devices don't have any sound hardware at all, and these devices will generate an exception when we try to reconfigure the mixer. The `except` line will catch all types of exception, although you can also choose to narrow down the types of exception you want to catch, e.g. `except IndexError:`.

CODE THE CLASSICS

An Introduction to
Pygame Zero

This user-friendly Python library
makes it easier to display graphics
and play sounds

Unless you only plan on making simple text-based games, there are certain things you always need to be able to do as a game developer: display images, play sound effects, and receive inputs from the keyboard or a game controller. In a basic Python installation, one of these is impossible and the others are hard to do in a way that works well for a real-time game.

To address this, there are various *libraries* available for Python. A library is a collection of functions which can be used in multiple projects. One of the most popular libraries for making games with Python is Pygame, which makes it easy to create a window, draw sprites, play sound effects, and get control inputs. However, Pygame projects require a bit of what is known as *boilerplate code* – code which is pretty much the same from project to project, and can be tedious to write. For example, code is required to create a game window, load sprites and sound effects, run a main game loop, handle events (such as the window's close button being clicked), and 'flip' the display so that graphics that have been drawn are shown to the user.

To reduce the amount of boilerplate code for our games, we're using the library Pygame Zero, which is built on top of the Pygame library. It automates many things that a game programmer would usually need to write themselves. While we cannot fully cover everything that Pygame Zero does, we'll give an overview of some of its most useful features. You can find a full guide to the library at **pygame-zero.readthedocs.io** – or just search online for 'Pygame Zero docs'.

Setup and game loop

There are three things you always need when writing a game: a window in which to display graphics (this could be a full-screen window), code which updates the game-state each frame, and code which draws the graphics to the window.

Pygame Zero creates a window for you: all you have to do in your program is create the constants `WIDTH` and `HEIGHT`, which specify the desired size of the game window in pixels. Note that if you're using display scaling in Windows or macOS, this will be applied to your game window so it will end up being bigger than you'd normally expect.

All code intended to be run each frame should be put in a function named `update`. Pygame Zero will call this function up to 60 times per second. The code in this function will need to make use of global variables to remember the game state between frames. The games in this book use the global variables `game` (representing an object which stores the current game state) and `state` (which tracks whether we're currently on the title screen, playing the game, or on the game-over screen). The `update` method can optionally have a parameter known as `dt` (short for delta time) which will provide the number of seconds that have passed since the previous frame.

Commercial games are always written to deal correctly with a variety of frame rates, but for the purpose of simplicity, our games are written with the assumption that `update` will be called 60 times per second, which most devices should be able to handle. If the frame rate of a game does drop below 60, it will run in slow motion. The limiting factor for frame rate is usually the number of sprites being drawn per frame in the `draw` function (see below), so some older devices may see some slowdown in specific situations – for example, when there are many enemies on screen at once.

You'll need to provide a function named `draw` – Pygame Zero will call this after each call to `update`. The code in this function should draw all desired sprites, text, and other visual elements to the game window. Items drawn later will appear on top of items drawn earlier, so usually backgrounds are drawn first, and user interface elements are drawn last.

> **You'll need to provide a function named draw – Pygame Zero will call this after each call to update**

Actors and sprites

Pygame Zero provides a very useful class named `Actor`, which can be used to represent any visible game object – a player, enemy, projectile, or anything else which has a position on the screen and needs to be updated and drawn each frame. A basic Actor object can be created by writing something like `my_actor = Actor('image', (50, 50))`. Pygame Zero automatically loads a sprite image named **image.png** from the **images** folder, and places the Actor 50 pixels from both the top and left of the window. You can then call `my_actor.update()` to update it for each frame (although by default this won't do anything) and `my_actor.draw()` to display it.

In our games, we primarily use the Actor class by subclassing it (i.e. creating our own custom classes which inherit from Actor). We can provide custom implementations of the `__init__` (constructor), `update`, and `draw` methods – although the last of these will only be overridden if we want draw something in addition to the object's sprite image, such as debug graphics. The most important Actor attributes are `pos` (a pair of numbers in brackets, known in Python as a tuple specifying its current X and Y coordinates), `image` (a string specifying the sprite image to be used), and `anchor` (a pair of strings or numbers in brackets which specify what should be considered the origin of the sprite; e.g. if a sprite is at coordinates (0,0), this indicates that the sprite should be drawn at the top left of the window – but which point of the sprite should be at that position: its centre, its top left, or some other point?).

There are multiple ways of getting and updating the position of an Actor. In addition to using `pos` as described above, you can get/set the X and Y coordinates individually using the `x` and `y` attributes. You can also used named points to both get and set the position. For example, if you want to ensure that the left edge of an Actor is aligned with the left edge of the screen, you can write `self.left = 0`. If you want to place the top left of the Actor at the top left of the screen, you can write `self.topleft = (0,0)`. Valid names are `topleft`, `midtop`, `topright`, `midleft`, `center`, `midright`, `bottomleft`, `midbottom`, and `bottomright`.

Images

One way of displaying an image is to create an Actor as shown above and set its `image` attribute to the name of the desired image. Another way is to write, for example, `images.tree`. This will cause Pygame Zero to look for and load a file named **tree** (with a file name extension of .png, .jpg, or .gif) in the **images** folder. This creates a Pygame Surface object, representing a bitmap image. It can then be displayed to the screen using the function `screen.blit`. You can get the width and height of a Surface in pixels using `get_width`, `get_height`, or `get_size`.

Sound effects and music

Pygame Zero allows the playing of sound effects by entering code such as `sounds.drum.play()`. This automatically loads a file named **drum.wav** or **drum.ogg** from the **sounds** folder and plays it. This is very convenient but is a bit inflexible as it doesn't allow a sound effect to be loaded based on a constructed string (e.g. some text followed by a randomly selected number), so our games have a helper function named `play_sound` which works around this issue – you can find a full explanation in the fully commented code on GitHub (**rptl.io/ctc-one-code**).

Music can be played by writing `music.play('filename')`, which looks for a file in the **music** folder named **filename.ogg** or **filename.mp3**.

Controls

Keyboard inputs can easily be checked by using Pygame Zero's `keyboard` object. You can write, for example, `if keyboard.left:` to check if the left arrow key is being pressed. Pygame Zero does not have built-in controller support, but you can access the relevant Pygame functions and classes (such as `pygame.joystick.Joystick`) to achieve that.

Skipping the middleman

While Pygame Zero acts as a very useful interface to the underlying Pygame library, we occasionally need to do things that require directly accessing Pygame. One example is that on startup of each game, we shut down the Pygame audio mixer (which is automatically set up by Pygame Zero) and restart it with different settings, which fixes audio glitches on certain devices.

In some games we use Pygame's Vector2 and Vector3 classes to store X, Y and Z coordinates in a single object. These classes have a number of useful methods for things such as calculating the distance between two points.

You can find a full online guide to the various Pygame modules at **pygame.org/docs**.

CODE THE CLASSICS

An Introduction to
Git and Version Control

Learn how to use the Git version control system to synchronise changes to your game code

words: **Andrew Gillett**

A personal story from the writer…

In late 1998 I started my first proper programming job, as the second employee of a formerly one-man company. We worked in a custom-built shed at the end of his garden, which had a carpet, electricity, and just enough space for two people and PCs. The place smelled of the strong cigars my boss smoked as a substitute for alcohol. It was truly impressive that he had been able to build a successful business after 20 years of alcoholism. Thankfully he didn't smoke the cigars in the shed, but his breath was unmistakable.

We were working on Visual Basic applications for various clients, and although this job didn't last long (he went out of business due to a client failing to pay him), I learned a very particular lesson about what can go wrong when working in a team. We were both working on the same set of code, but we didn't have a good way of synchronising our work. We would just copy files between our two machines. Everything seemed to be going fine until he asked me about a piece of work that I'd done a few weeks prior. It turned out that due to our very crude synchronisation techniques, the code I'd written had got overwritten at some unknown point and no version of it had survived on either of our machines.

A year later, I started working at a well-known UK game development studio. I learned about a system that they used to use to deal with the synchronisation of project files between team members, although they'd moved on to

a better system by the time I arrived. The project files were stored in a folder on a network drive. We'll refer to this folder as the repository. Developers would copy the files from the repository to their own machines so that they could work on the game. To ensure that only one person was working on a particular file at a time, they had a set of physical cards, each with the name of a file written on it. The cards were stored in a particular location in the office. If you wanted to edit a particular file, you had to take that file's card to your desk, thus claiming temporary ownership of that file. Once you'd updated a file, you'd copy the new version back to the repository, and return the card to the set. On a regular basis – perhaps every morning – all developers would re-copy the files from the repository so they were up-to-date with changes the other members of the team had made.

This system worked, but clearly it was very cumbersome. It might have been just about manageable when games in development consisted of a few dozen or hundred files, and were worked on by a handful of people, but modern games often consist of tens or hundreds of thousands of files, and are worked on by huge teams. Even for projects worked on by only one or two people, we need something better than this. Fortunately the better thing exists, and it's known as version control!

Computers are useful

It turns out that people have written all sorts of useful software for things we didn't realise we needed until we were told about them, at which point we could no longer imagine living without them. Although many prior systems already existed, I first learned of the concept of *version control systems* (**VCS**) when I started in the video game industry in 1999. The company was using software called **MKS** which stored project files on a server, known as the *repository*. Developers would use **MKS** client software to download the project files from the repository. If a developer made a change to a file, the **MKS** software would show them that their version of the file was different from the one in the repository. They could view the changes and then *commit* the changes to the repository, meaning the repository would now have the updated version of the file. Other developers would then be able to see through the **MKS** software that there was a new version of that file, and could download the new version of the file with a single click. They could also just get **MKS** to download all the changes since their last update.

The **MKS** version control system is no longer around, having been superseded by newer and better systems. Some of them, such as Subversion and Perforce, require the use of a server. These are known as centralised version control systems. The repository is stored on the server, and contains the entire history of the project. If you wanted to, you could *check out* an old version of a particular file, or even an old version of the entire project, which can be useful for finding out when a bug was introduced. The versions of the project on developers' machines are known as *working copies*.

```
1
.gitignore
 1  /.vs
 2  /Debug
 3  /Release
 4  /old
 5  /packages
 6  /Build
 7  *.exe
 8  *.log
 9  *.vcxproj.user
10  save.txt
11  butler.txt
12
```

In 2005, Linux creator Linus Torvalds created the Git version control system. Today it is by far the most widely used VCS. Git is a distributed version control system, meaning that it doesn't require the use of a server to store the repository. While a server can still be used (we'll talk about GitHub later), it's optional.

Using Git

To use Git, you first need to download and install the Git software from **git-scm.com**. It'll ask a lot of questions during the installation process – you can just choose the default options for everything. The next thing you need is a Git *client*. This is the software you use to carry out Git commands. You can use command-line commands such as `git clone` and `git commit`, but these are not very beginner-friendly, so you may prefer to use a graphical Git client. Git comes with a graphical client called Git GUI, although it's pretty basic and not the most user-friendly. There are many other standalone clients, and clients are also built into many IDEs, including PyCharm. My preferred client is called Fork, although it is a paid product with a free trial. Sourcetree, TortoiseGit, and GitHub Desktop are some examples of free standalone clients. Most of the screenshots and examples in this chapter will be from the PyCharm Git client. Note that to use Git within PyCharm, you'll first need to go to the VCS menu and select 'Enable Version Control Integration'. The VCS menu will then become the Git menu.

> There are many standalone Git clients, and clients are also built into many IDEs

Let's say you've started working on a project and you want to use Git to track versions. The first thing you need to do is create a repository (*repo* for short). In PyCharm, enabling version control integration for a project will automatically create a repo. On the command line, a repository can be created using `git init`. The repo is stored in a hidden folder named **.git** – you should never manually edit or delete any files in this folder. You can safely delete this folder if you no longer want to use Git with the project, or if something has gone wrong with the repo and you want to recreate it from scratch.

If, instead of creating a project from scratch, you want to copy/download a project from an existing repo, the command to copy a repo is `git clone`.

1. A .gitignore file lists files and folders you don't want to commit

2. The log view of the Fork Git client

Committing

Unless you're using an IDE which automatically adds files to the repo when it is initialised (Visual Studio does this), the repo will be empty. As mentioned previously, the files in your project's folder are known as your working copy. With an empty repo, all the files in your working copy will be classified as untracked, meaning that they're not in the repo. To add a file to the repo, it must be *committed*. A commit is always associated with a message, which should summarise what changes the commit has applied. In PyCharm you can go to the commit interface by going to the Git menu and choosing Commit.

Some Git clients, including the command line, feature the concept of *staging* changes. Staged changes are changes which are ready to be committed to the repo. On the command line, `git add <filename>` will stage a file. This could be an untracked file which wasn't already in the repo, or a file which was in the repo but has been modified. When you enter `git commit -m <message>`, all staged changes will be committed, alongside the provided message.

PyCharm doesn't feature the concept of staging; you just select which file or files you want to include in the commit, write a message in the box below, and click Commit. Before you commit, you can double-click a file in the list to see the changes that you've made to it. It's usually worth doing this to double-check that the changes in the file are definitely what you want to commit. Some clients, including PyCharm, allow you to select which changes within a file you want to commit. You also have the option of deciding to undo some or all changes to a file so that it matches the latest version from the repo. Different clients use different terms for this – in PyCharm the option is 'Rollback', in Fork it's called 'Discard changes', and in TortoiseGit it's called 'Revert' (not to be confused with `git revert` on the command line, which does something different).

> **Before you commit, you can double-click a file in the list to see the changes that you've made to it**

Viewing the repo history

It's often useful to be able to view a list of commits that have been made in a repo. In PyCharm this can be done by choosing 'Show log' from the Git menu. On each commit you'll see its associated message, the name of the person who made the commit, and a date and time. If you click on a commit, on the right you'll see the files that were added, modified or removed, and can double-click a file to see which changes were made. If you want to run an old version of your project, you can right-click a commit and choose 'Checkout Revision'. Note that this may put the repo into a state called a *detached HEAD*. The HEAD is like a tag which is attached to whichever commit

you have checked out. This will normally be the most recent commit of the default branch (more about those shortly). Once you've finished your journey back in time to the old commit, you can return to the present by checking out the default branch.

Branches

Branches are a bit like parallel universes where you can maintain different versions of your project. Each branch represents a distinct line of development, allowing you to make changes independently of other branches. Let's say you want to make a major change to your game, like adding a two-player mode. You might create a new branch named 'multiplayer' and check out that branch so you can work on it. You can switch between branches at will. The default branch in Git is named either main or master. There are many ways to make use of branches – some developers create branches for every feature they add to a project, and merge the changes into the default branch when the feature is complete.

We mentioned earlier that 'HEAD' is a tag attached to the currently checked-out commit. In Git, 'branch' has two meanings, the second being that a branch is also a tag that's attached to a commit. One consequence of this is that if you delete a branch, no actual commits are deleted – although it is possible (and sometimes desirable) for commits to become inaccessible if they're not part of any named branch's history.

Merging

If you've made some commits in a branch and want to bring those changes into a different branch (such as the default one), you can choose to *merge* a branch into the current branch. If the changes do not conflict with each other (e.g. the changes are in different files, or different parts of the same file), merging uses a straightforward process called fast-

3 Committing changes to the master branch in PyCharm

4 Git's diff function helps you compare versions

forward. If there are conflicts – e.g. two different changes were made in the same place in the same file – Git won't know how to merge the changes and you'll need to resolve the conflict manually. Most Git clients provide some kind of merge tool to assist in this process. Merging and merge conflicts may also occur when pulling changes from a remote.

Pushing, pulling, and remotes

If a team is to collaborate on a project using Git, there needs to be some way of synchronising the commits that each team member makes. Typically this is done by having a server which contains its own version of the project's repo. Team members connect to this server (known in Git as a remote) using their Git clients. The Git actions fetch, pull, and push are used to sync with a remote. Fetch downloads changes from the remote's repo into your repo, but leaves your working copy unchanged. Pull does a fetch and then checks out the latest commit for the current branch, incorporating those changes into your working copy. Push sends the commits you've made to the remote so that other team members can access your changes. The default name for the remote a repo was cloned from is 'origin', so you'll typically be pushing to or pulling from origin.

Even if you're working on a project on your own, it can be useful to have a server with which to sync your changes. It acts as a convenient backup system, and also allows you to sync the project on more than one device – e.g. a desktop PC and a laptop.

GitHub

The website GitHub acts as a server for Git projects. Repos on GitHub can be public or private. We've used GitHub to host the repo (**rptl.io/ctc-one-code**) for this book. One term you'll frequently see associated with GitHub is *fork*. Forking a repo is similar to cloning it, but the new repo is created on GitHub itself. You can then clone the new repo to your computer. GitHub remembers which repo your repo was forked from. This allows for another feature specific to GitHub, called 'pull requests'. If you've forked a repo and made some changes to it, you can create a *pull request* asking the owner of the original repo to pull your changes into their repo. Whether they choose to do so is up to them.

> **Forking a repo is similar to cloning it, but the new repo is created on GitHub itself**

GitHub includes many other features, one of the most useful being issue tracking. If you find a bug in a project, you can create an issue to report it. You should first check that the same issue has not already been reported. Some projects may have guidelines you should follow when creating issues.

.gitignore

Sometimes you'll have files which you don't want to commit to Git. For example, the PyCharm IDE creates the folder **.idea** which contains settings. Some people will use

5 Viewing the list of Git commits in PyCharm

Python *virtual environments*, stored in the **venv** folder. Projects using the Unity game engine will contain a **Library** folder, which contains compiled project assets (and is often huge). These folders are not an inherent part of your project and should never be committed to the repo. However, it's annoying to have to constantly see these folders in the list of files you might want to commit. Git allows you to create a text file named **.gitignore** which contains a list of files and folders which won't be listed when choosing what to commit.

Large files

Due to the way the repo stores data, Git is not well-suited to projects which want to track large files. By 'large', we're talking tens or hundreds of megabytes. The problem becomes particularly acute if you intend to frequently commit new versions of large files. Commits update the repo with by storing the changes between revisions of a file, so if you add a single line to a 10 kilobyte text file, it doesn't have to store an entire new copy of that file in the repo, just the line that was changed. This system breaks down when storing binary (non-text) files, such as images, sound, and video. If you commit a 200MB video file and then later make four commits, each making a minor update to that file (e.g. changing the audio volume or brightness), the repo will forever contain all five versions, totalling 1GB just for that one file. For this reason, GitHub won't allow you to push commits containing files over 100MB. There is a system named Git Large File Storage which changes how large files are stored, but this is not installed by default.

CODE THE CLASSICS

ARTISTICALLY SPEAKING

Talking graphics with Dan Malone

Today, we explore vast and beautiful game worlds without restriction. But how did graphic artists in gaming's early days replicate environments and characters with limited technology?

In the early days of gaming, graphics were everything. Players would gush about the cutting-edge graphics of the many coin-operated machines vying for their attention in arcades up and down the country. Certain games would push the visual boundaries of their home computers and consoles, and the screenshots on the back of game boxes were immensely important to players looking for something they could show off to their friends.

Graphical innovations formed the battle lines between machines as playground chatter turned to war over which computer was better. They spawned terms such as 'colour clash', particularly on the ZX Spectrum. They also had players reaming off numbers: 27 possible colours on an Amstrad CPC versus 4096 on a Commodore Amiga… Meanwhile, magazine reviewers dished out marks just for the look of a game, and debate would rage over whether graphics were more important than gameplay.

Despite the importance of such visuals, many games programmers in the early days tried to be a jack of all trades: writing code while also creating graphics and producing sound. So long as the graphics were representative, developers believed the job was done. This situation changed in the early 1980s, however, when dedicated graphic artists joined small development teams and poured many hours into producing visually impressive games. Nintendo's NES in particular saw graphics evolve spectacularly, while the 16-bit era brought with it intricate detail.

Many techniques were also introduced over the years, including Mode 7 on the SNES, which allowed backgrounds to be scaled and rotated; parallax scrolling for backdrops; 3D-rendered triangle-based geometry; and Full Motion Video. Pretty soon, realism became an objective, particularly in the PlayStation era of the mid-1990s, whereas in the beginning it had been left to the imagination of players (and, in many cases, descriptions in the accompanying game manuals).

One person who witnessed many of these changes is Dan Malone, a comic-book artist who inadvertently found himself working in the gaming industry, initially for Palace Software. He ended up working across a host of computers and consoles, from the 8-bit machines right through to the present-day platforms. In doing so, he was given access to increasingly complex hardware on which to flex his artistic talents and ended up working on some of the finest games ever made, from *Speedball 2: Brutal Deluxe* to *The Chaos Engine*. Dan has created the visual assets for all the games in this book.

Graphic artists joined small development teams and poured many hours into producing visually impressive games

CODE THE CLASSICS

You began your gaming career in 1985, but were you an artist prior to that?
Yes, I've been drawing comics since I could pick up a pencil and I've had a massive love for Marvel since I was a kid. Growing up in the 1960s and early 1970s, my dad would buy me many comics. When my parents split and my mum moved to Brussels, she'd send me a steady stream of American comics from an international bookshop that would sell anything from anywhere all over the world. I was truly inspired by the artistic talents of people such as John Severin and Jack Kirby and they really did have a massive influence on me.

But how did you progress from comics to producing art for games?
Well, that was an accident. Several months after I'd left art college, an old typography teacher sent me a cutting from an industry magazine called Campaign. It was an advertisement for a company called Palace Software which was looking for 2000AD-style artists and, because I was really into 2000AD which I think is the best British comic ever made, I knew I needed to respond. I got an interview but even at that stage, I didn't realise it had anything to do with games. It was a complete surprise to me.

> **I got an interview but even at that stage, I didn't realise it had anything to do with games**

Did you have any experience at all with games before then?
No, I wasn't really a gamer. I knew that games were around and I'd heard of the Spectrum, Commodore, and the Amstrad CPC, but I hadn't played a lot of computer games. My passion had been tabletop games of Dungeons & Dragons and I'd write my own D&D campaigns and illustrate them. It meant I had a knowledge of games and gaming in general, though.

What was it like working for Palace Software?
I was in London on my own for the first time as a young adult and it was especially great because we were working at the legendary independent Scala cinema in King's Cross. We worked with Pat Mills from 2000AD, which was really exciting because it let me combine gaming with comics. It was a bright new world for me in London, having been in college in Ipswich.

What was it like approaching art on 8-bit computers having had a background of using a pen?
It was a real scale down. Apart from the limitations, the number of frames and the variety of backgrounds, I was working with pixels, which I always felt was like working with large Lego bricks. But Palace Software had in-house sprite editors and another artist – Steve Brown, who arrived just before me – had pretty much set everything up by the time I got there, which eased me in. Palace was also very artist-led: the company was about what the artist could deliver and how the machine could achieve it.

Did you feel constrained by the technology?

Well, it was my first job so my approach was to just get into it and do my best, but it was still a big shock and I would constantly look at comics and think, "Blimey, I really want to get back into that." But I love animation and it was nice to use those skills, even though I was operating with a simple four-frame loop. I also seized the opportunity to create a little comic for *Sacred Armour of Antiriad*.

How closely did you work with the coders?

One of my jobs was to push the programmers at Palace and, after developing *Cauldron II*, I worked closely with a guy called Stanley Schembri on *Sacred Armour of Antiriad*. We sat side-by-side and I'd haggle for more graphics to do while they'd point out stuff that wasn't working, which meant I'd have to cut the frames down or do something else. But it was great fun and there were some nice friendly battles. For instance, the main character in *Sacred Armour of Antiriad* was two four-by-four sprites joined together and that proved a bit of a push to get in.

Was it frustrating to be told you couldn't do certain things?

You just have to readjust and realise that you're working within a limitation and that it is your job to make it work. In that sense, any frustration turned into a challenge, more so when you consider I had no artistic reference point because I wasn't really into any games. Coming to the job really fresh like that helped and it's why I pushed what I was doing as much as I could. I spent about six months on *Sacred Armour of Antiriad* in total and it was pretty intense.

1 A 1986 interview with Dan in CRASH magazine, when he was working for Palace Software

Creating new worlds

Looking at the many artistic elements that make up The Chaos Engine

1. ENEMY EXPLOSION
When an enemy is hit, it must react in some way. An explosion is a perfect visual because it's not only bright, thereby reinforcing what has just taken place, it is also mightily satisfying.

2. MAIN PLAYING AREA
Dan Malone says he kept the background surface area of the game mostly blank so that the sprites could stand out more clearly, something which is always helpful to the player.

3. PLAYER SPRITES
Gamers are going to spend a lot of time looking at the main character sprites, so they need to be attractive and instantly distinguishable from other objects. Dan Malone gave the characters shadows to help make them feel grounded and solid against the background. They also had different characteristics defined by skill, stamina, speed, and wisdom.

4. STATUS AREA
Whether you have a button to call up the current stats on a separate page or having it as part of the main playing screen, a status area is vital for displaying the current score, health, and pick-up in a game like this.

5. MANY PUZZLES
It's always a good idea to challenge players, so as well as providing lots of enemies, *The Chaos Engine* let you pick up goodies such as keys, food, and treasure. Indicators would tell players when an exit was open or locked.

6. MAPS
Big games need maps, but *The Chaos Engine* kept things simple by showing a view of the three-screen square area around the character rather than the whole level.

- Solid background areas – must stand out clearly from play area
- Level area
- Node (level exit key) unlocked
- Node (level exit key) locked
- Level map
- Extra life
- Shield
- Impact FX to show when an enemy sprite is hit
- Enemy sprites

Were you always looking to develop little tricks with your art?

Not so much on the 8-bit computers because the pixels were massive and you really only had four colours and one transparent to play around with. But with the 16-bit stuff there was a little bit more you could push here and there, with little techniques such as anti-aliasing that ensured the graphics would look smooth and not overly pixellated.

2 *The Chaos Engine* was devised by The Bitmap Brothers

Did you also work on the design of games?

Yes, it was my mandate to come up with gaming concepts for *Sacred Armour of Antiriad* and *Superthief* and develop ideas that would make them playable. To do this, I'd start by sketching the whole thing out on paper and there were periods where I'd just keep drawing until someone said, "Right, we're starting development properly now." At that point, I'd sort some graphics for the programmer to work with all the ideas bristling in my head.

Why did you design on paper first rather than launch straight in?

I can always think better when I'm drawing by hand. In fact, more often than not, I don't have an idea in mind when I get down to drawing and so it helps them to emerge. The only exception is when I actually do have a strong idea and I'm itching to get it down, but I'm still very much old-school in my use of pen and paper, even though I know a lot of people draw on tablets and that I should maybe get into that.

Where did you get your ideas from?

Well, I'd started to play a few games by this point so I was getting a feel for what would and wouldn't work. *Sacred Armour of Antiriad*, for example, had prehistoric characters and alien technology and while it proved to be similar to another game called *Turrican* (even though I was designing it independently, miles away), it showed that I was on the right lines.

I think it helped that I knew so much about games such as Dungeons & Dragons and understood what made a game a game. I also like sport and I saw games as a competition that worked within a set of rules. So that was my main influence, with comics always in the background. I'd read somewhere that writing a good book was as simple as getting readers to turn the page, so I felt that we should always encourage players to push on to the next level. I'd do this by including little teasers.

3 **Sacred Armour of Antiriad** on the ZX Spectrum

There are lots of college courses everywhere catering for game design, 3D modelling, and storyboarding making, so there is now a clearer route to employment. But it's a hard one. You need to be committed and sacrifice things along the way.

Dan Malone

Did you find working on 16-bit computers rather liberating?

It certainly brought a lot of stuff to the table: greater resolution, more memory and more colours, for starters, and that was a big deal because you could anti-alias better. I remember that I was always looking at arcade machines with a view to bringing that vibe to the home computer. With 16-bit, it was suddenly possible to do that and it was such a breakthrough. I couldn't wait to get involved.

Was there a big difference in the types of graphics you were expected to produce for a 16-bit computer and a 16-bit console?

At the time, we would always start by producing games on home computers, so we'd create them on the Amiga and Atari ST first and then port the graphics backwards and forwards on to other formats. On one occasion, when I was producing *Speedball 2*, I created two separate palettes – one for the Atari ST and the other for the Amiga – but I held everybody up doing that. With the consoles, on the other hand, we were just porting games straight across before touching them up. We needed to get them to look good, which wasn't always easy because the colours on the consoles were very garish and saturated. It was also harder to get nice, smooth anti-aliasing, but the good news is that we had a bit more memory on some of them when compared to the Amiga.

You moved from Palace to join the Bitmap Brothers. Was it a special company to work for?

It was a major highlight for me, definitely. At the time, Palace was on the verge of closing, but I'd already seen the Bitmaps' *Speedball* and fallen in love with it. I thought the music, the graphics and the gameplay were just astounding and so I was really pleased to go straight in on *Speedball 2* when I joined the Bitmap Brothers. It was very exciting, especially because the company had always been seen to be very cool. Not that Palace Software wasn't like that – it was a great company to work for too – but it was just unfortunate that it ended because it could have been something really special.

> **I was always looking at arcade machines with a view to bringing that vibe to the home computer**

Were you given a lot of freedom at the Bitmap Brothers?

Yes, and it's a beautiful thing. I've always said that design by committee is not the best way of creating a standout product and I was very pleased by that. *Speedball II*, and *The Chaos Engine*, come to that, gave me a lot of freedom to do my thing. I think those games became my best work because of that.

Of all of the games, which appealed most in terms of art?

The Chaos Engine was a real favourite of mine. The Victorian feel and the steampunk vibe were good fun and I was given a lot of freedom with the characters, which meant the game became very close to my heart. I'd even go as far as saying the game was my baby, even though it was a Bitmap game and Eric Matthews was in charge of it. Just being allowed to get on with things is always good.

When you approached *The Chaos Engine* and you were developing the steampunk style, what influenced you?

There was a story in 2000AD which had a kind of Victorian steampunk vibe, but it was Steve Wilcox who pretty much conceptualised *The Chaos Engine*. I'd be sitting beside him drawing while he'd say, "Try this out, try that out." Even so, it was very much a case of me following my nose because there wasn't much to base the game around apart from a comic strip. I also had to adapt because I knew that I wouldn't be able to get the sort of detailing you'd find in comics into a game at that time. But that's why the characters in the game have always been a big favourite of mine and why I love those backgrounds. I'm particularly proud of the tile set for *The Chaos Engine*.

2 Working on *Speedball 2* was a thrill for Dan

As games became more advanced and development teams grew in size, did that affect how you approached your subsequent games?

I started to became more of a creative director as time went on and that really entailed starting with a blank sheet of paper and inspiring the team, getting them to know what they were working on and why they were working on it. I was still drawing a lot – mainly the characters and the backgrounds – but I was mainly there to create a story with my games. It was like the Dungeons & Dragons thing again: we were creating rich worlds populated with characters and I had to get things ready for a deadline. It was all about making the artists and modellers share the same view.

Creating a character

Dan Malone works through six main stages when he creates art for his games. With this character, for instance, he'll start by creating initial rough sketches that show the figure in various poses – for example, left, right, back, front, running, and standing still. Once he is satisfied, he'll move on to the clean-up process, penning the lines that will be visible in the final character. With the image scanned into a computer, shadows and highlights are added and it's time to lend some colour. The sprite can finally be scaled down for use in-game.

Stage 1: initial rough sketches Stage 2: finished sketch Stage 3: clean line Stage 4: shadows and highlights added Stage 5: full colour finished Stage 6: scaled down to create in-game sprite

When did things really change?
With the PlayStation. The development teams for the console were still tiny by today's standards but very large for the day, with about 15 people in each. For me, it was a watershed moment and when I eventually joined Sony itself and got a blue PlayStation development kit, I was blown away. I'd play *Wipeout* and *Tekken* with my jaw dropping to the floor. I particularly remember the intro for *Tekken* blowing me away because it was so cinematic.

Did it open your eyes to new approaches?
In an environment like the one I was working in at Sony, it's inevitable. I was alongside many other people and the job became a lot more about communicating ideas efficiently. But I was also checking other people's work and delegating, which I had never done before.

Was there a lot of pressure to showcase the PlayStation in the best light?
It was still a case of giving each project the best you had, but it was a much bigger deal because more people were involved in the decision process and it would take a lot more time to get things passed. I worked on a licensed game called *Porsche Challenge* and that brought extra pressure because I also had to contend with Porsche having its own idea of how the game should look. That brought clashes because I wanted stuff like crazy paint jobs on the cars, but Porsche didn't and that is basically why I left. It also pained me to see that another game I was working on – an original game – was canned in favour of a licence: *NBA 97*. I knew those games were bringing the money in, but in my mind this was Sony and I felt it should be leading the way.

> **The development teams for the console were still tiny by today's standards but very large for the day**

What was the game?
It was a skate-surf hybrid – a precursor of sorts to *Tony Hawk* which came out a couple of years later and blew up the scene. I thought we'd missed a trick and I still think it was a shame we didn't get to develop that.

So did you feel constrained having to work with real models on *Porsche Challenge*?
We had a good car modeller who worked closely with the Porsche specs and it was more for me to build a story around it. But Porsche had a lot of influence over its licence and, for me, it ultimately didn't work. The game was OK, but it could have been more playable and a nod to street-level culture.

7 *Harry Potter and the Chamber of Secrets* on the GBA

Porsche was conservative in what it wanted.

You also created *Harry Potter and the Chamber of Secrets* for the Game Boy Advance. What was it was like working in 2D again?

It was like going back to the 16-bits really, although with a bigger palette and a similar resolution to the Amiga screen. But it was also a return to what I'd been doing several years before and it was also straightforward. Working with the Game Boy Advance was simply a case of reducing the graphics down to fit a small screen. The same rules of creating art applied.

8 Dan worked on the character concepts for *SSX Blur* on Nintendo Wii

Was there a different expectation of graphics in the 2000s, though?

Yes, a lot more realism came into it. We had greater polygon counts and texture maps and special effects, and there was more of a lean towards cinematic realism, certainly in the big games. In fact, it was all about big games, big teams, and big pressures.

Was it refreshing to revise classics such as *Broken Sword* with its 2D graphics?

Yes, it was nice working with Charles Cecil and Dave Gibbons, who is a great British comic artist. I ended up working over his stuff and pretty much processing sprites and portraits from his artwork.

So what should somebody seeking a career in games art do today to get their foot on the ladder?

There are lots of college courses everywhere catering for game design, 3D modelling, and storyboarding making, so there is now a clearer route to employment. But it's a hard one. You need to be committed and sacrifice things along the way. You also need to be aware that you don't always get the fun stuff to start with – you may end up in a large team drawing rocks every day. But it's a great job and working in the games industry is rewarding. Anyone with talent will do very well.

9 *Broken Sword: Shadow of the Templars* on Nintendo Wii

CODE THE CLASSICS

SOUNDING OFF

Talking music with Allister Brimble

Music and sound effects can make a massive difference to the experience of playing a game. We chat to the musician who has created sound for games from the 1980s to the present day

Video games don't work if you can't display something on a screen. They can, however, be enjoyed without any sound. This imbalance makes for one of the most frustrating elements of a game musician's job, as well as one of the most challenging. The overriding aim is to create audio that will have players wanting to crank up the volume rather than hit the mute button.

At first, in gaming, audio played second fiddle to graphics and gameplay. Music would be used sparingly, perhaps for an intro or to introduce a level, and then basic effects would kick in although there were exceptions. *Space Invaders*, for instance, had a pulsating background sound accompanied by shooting noises whenever fire was pressed – but nothing you could call music. Melodies were few and far between.

Part of the issue was the rudimentary technology to hand, combined with a lack of memory, forcing developers to compromise. It therefore took a few years for dedicated musicians to emerge but when they did, they were at least able to work with ever more advanced sound chips: the programmable sound generator chip for the Commodore 64, known as SID, has even been likened to a musical instrument.

As time went on, audio just got better and better. Composers such as Rob Hubbard, David Whittaker, Martin Galway, and Ben Daglish became well known in gaming circles. Nintendo also saw the benefit of audio when it designed the NES with five channels, and there were experiments with sampled sound. The term 'chiptunes' was coined to describe synthesized electronic music created on 8-bit machines. Audio was given a further boost on the 16-bit platforms.

The term 'chiptunes' was coined to describe synthesized electronic music created on 8-bit machines

The MOD computer file format came into being when *Ultimate Soundtracker* was released for the Commodore Amiga in 1987. Music could be based on digitised samples and it allowed songs to be created with vocals. The 16-bit consoles also had a greater number of sound channels and effects. When the CD format was introduced with 32-bit machines, quality jumped yet again, and some games would allow gamers to play their own compact discs.

Audio remains crucial to games today and good musicians are highly prized among development teams. Games need music, sound effects, and spoken dialogue to work seamlessly and create an immersive environment for the player, in tandem with the on-screen action and narrative.

British video game composer Allister Brimble has a career that tracks every generation of gaming. He began his career in the mid-1980s and continues to work, right through to the current day. Ever played *Superfrog*, *Fantasy World Dizzy*, *Alien Breed*, *Sensible Golf*, *Driver*, *Colin McRae Rally*, *Micro Machines V4*, or even *Goat Simulator*? Then you've heard some of his amazing output.

Allister wrote the audio assets for all the games you program in this book.

CODE THE CLASSICS

You've been creating music for games for a long time. What was your musical background prior to entering the industry?
I'd been interested in music from a young age and I was influenced by my parents who worked in the theatre. From the age of seven, I had piano lessons and although I wasn't particularly good at them, I enjoyed playing, as I still do today. I did O-level music at school, which in those days was very difficult on the theory side and I failed it. But the music in early computer games inspired me to want to create my own.

What initial steps did you take?
I used to record games music on to tape and slow it down to hear how things were done. But in 1985, Melbourne House released *Wham! The Music Box*, and it allowed me to start experimenting with music. Even so, it wasn't until the Commodore Amiga was released that I was really able to unlock my creativity with programs like *Aegis Sonix* and *Sound Tracker*. At that time, I had seen an article in a magazine in which a company called 17 Bit Software was asking for music that would be released for free into the public domain. I sent in some music and got a letter back saying they enjoyed it – 17 Bit later turned into a games company called Team 17 and I went on to produce music for some of its biggest titles.

What was expected of a games musician in those early days? Did software houses treat music and sound as important parts of a game?
With the early 8-bit and 16-bit games, you had to be able to work within limitations. For the 8-bit machines, music may have to fit in is as little as 2kB of memory and this meant typing patterns of notes one by one into a text editor and then sequencing these patterns to create a longer piece of music. You not only had to be a musician but to be aware of coding and the limitations of the hardware as well. The games were much simpler than today, so we generally just needed one piece of music and a few sound effects. However, with only one tune to rely on, we did have to make sure it was really good. Games composers came up with some inspired tunes in those days. Players appreciated the technical limitations and were often amazed at what was possible, so I think the music and sound was treated as an important part of the game, often even advertised on the game boxes.

Which 8-bit machine allowed you to unleash your musical talent the most?
The Spectrum 128K could play three tunes at the same time with full pitch and volume control and that was a massive jump from the ZX Spectrum 48K's single-channel beeper.

1 This Amiga Format issue's cover disk included 'Brimble's Beats': some of Allister's game music

2 The Commodore Amiga featured a four-channel sound chip

One of the most prolific composers at the time, David Whittaker showed us all how it was done in games such as *Glider Rider* and he inspired me to want to create my own game music. Recently, *Glider Rider*'s music featured in my own remake album, *The Spectrum Works* (**rptl.io/brimble**).

You worked at Codemasters in the early days, but how would you set about creating music for computer games there?

Image credit: © Bill Bertram 2006, CC-BY-2.5

My first titles for Codemasters were on the Commodore Amiga. The games usually had a very strong theme such as football or driving and I'd be shown early versions of the game where possible. I'd need to be aware of whether the music was for the title screen or in-game or both, so as to correctly match with the gameplay. The music for the Amiga was done on a music editor called *Sound Tracker*. I'd first go about creating an instrument set of short, sampled sounds that would fit into the required memory allowance of around 40kB. I'd then set about composing the music and creating the sound effects.

Were you producing music solely for home computers?

Codemasters soon started producing games for the Nintendo NES. I was invited up to their offices in Leamington Spa and I was sat in front of a text editor and asked to compose some music. This was a far cry from the Amiga music I'd done before and I had to ask for help. I was shown how to create the various patterns and sequences as text and then test it out on a specially modified NES console. The specs for these games were much different, often requiring eight or ten tunes.

> **The music for Treasure Island Dizzy was done in something like 5kB of memory**

You worked on some iconic games such as the *Dizzy* series. How would sound be used to enhance these titles and what limitations were you working under?

Typically, the more graphically diverse games such as the *Dizzy* titles had a lot less memory left for audio. The music for *Treasure Island Dizzy*, for example, was done in something like 5kB of memory, which equates to five pages of text – compare that to 20 or 30 megabytes for audio today! I therefore had to create short, real-time synth instruments that took only 32 bytes of memory each for the Amiga.

CODE THE CLASSICS

Did the switch to the Atari ST and Amiga take your approach to music to a different level?
The Atari ST had much the same sound chip as the Spectrum 128 and its music sounded pretty much identical. However, the big jump forwards was the Amiga, which wasn't limited to single bleeps but instead featured four-channel sampled sound, previously only available on very expensive synthesizers of the time, like the Fairlight CMI. Programs such as *Sound Tracker* allowed full sample manipulation, which inspired a whole new generation of musicians.

Much of your work was on the Game Boy series of handhelds. Given that these machines were as likely to have been enjoyed without headphones as with, did you take into consideration that others would be more likely to overhear a handheld game being played and that, potentially, your audience could be a group of non-gamers sitting on public transport?
Well, I have to apologise to everyone for those annoying tunes whilst sitting on public transport. I admit it's my fault [laughs]. While it didn't

> **The Amiga wasn't limited to single bleeps but instead featured four-channel sampled sound**

change my approach to making music, I did have to take into account that the sound was probably playing on the tiny built-in speakers. These had almost no bass response so some sounds – bass instruments or deep explosions – could just disappear unless you treated them correctly, almost having to turn them into a tinny radio sound to be heard at all. This did mean, though, that headphone users didn't get the best experience.

How did the consoles alter the approach to in-game music, though?
The Amiga CD32 followed by the PlayStation were the really big changes with the advent of the CD player built in. This meant that music no longer had limitations and it became, well, just music played from a CD.

Songs by pop and rock musicians began to be used in gaming soundtracks. What effect did that have on you?
Having pop music works in some types of game. It's good for racing games, for example, where you have a radio in your car and it makes sense to have popular tracks playing. But game music on the whole needs to be composed to fit a game and, these days, be adaptive; I don't think many licensed tracks have achieved this. But recently I think we've been moving back to dedicated game composers who understand the likes of adaptive music. Of course, there will still be some popular rock and pop composers out there who still do a good job at this.

Did their involvement alter the way music in games was perceived?
For many, music lost its appeal in games for a bit. With no limitations, you could no longer be impressed by what was coming out of your speakers. But it was soon

Create classic tunes like a pro

Allister Brimble gives us his top musical tips to help you create some hits

TIP 1 Most 8-bit computers and consoles only had three channels for sound, meaning you could play three notes at the same time, so it's important to remember to limit your compositions to only a few parts at any one time in order to give an 8-bit limited feel.

TIP 2 Use fast arpeggios, also known as 'single-channel chords' – quickly alternating between several notes of a chord allows us to create the impression of chords on one channel, and it thus became the iconic sound of 8-bit. Some of the best examples are to be heard in *Glider Rider* by David Whittaker for the ZX Spectrum 128.

TIP 3 Keep the sounds short, fast, and snappy. Short sounds work much better for 8-bit tunes because you can fit more into the same space. The exception to this might be a long, flowing lead instrument.

TIP 4 Use plenty of effects. We would use echo effects on higher-pitched sound to give a sense of space. We'd also use pitch vibrato, especially on melody sounds, often delaying the vibrato for half a second before it kicked in. This made simple sounds much richer and smoother. On the whole we would avoid effects on the bass, which was better-sounding kept simple and therefore a more solid foundation to the track.

TIP 5 A classic technique was to share a single channel for both bass and percussion, often placing a snare drum in-between the gaps in the bass-line. A little bit of white noise was also added to the start of the bass sound to create the impression of hi-hat percussion and had the side effect of giving extra attack to the bass.

Image credit: Evan Amos

4 Left to right: *Glider Rider*, a Commodore 64, and Allister's album, *The Spectrum Works*

* *You can hear examples of how Allister Brimble has recreated 8-bit tracks to modern-day standard on his album, The Spectrum Works, available at* **allisterbrimble.bandcamp.com** *and on most current streaming platforms. He often overlays new parts which shadow the original 8-bit recordings for a much richer sound.*

I have always believed that music
should not be bigger than the game.
We need to listen to game music for a
long time and, let's face it, it's going to
be turned off once it gets annoying!

Allister Brimble

3 Allister first started experimenting with music using *Wham! The Music Box* by Melbourne House

realised that streamed CD audio did hold its own limitations, in that it was always linear, start-to-end, and could not adapt to gameplay.

So when did adaptive music become integral to a gaming experience and what did it force musicians to consider?

Adaptive music has been possible since the days of the Xbox and the PlayStation 2, but it has taken a while to take off and is still not fully utilised today in many cases. There are a few ways to do it, though, and the musician needs to consider how each game may benefit from each method.

Most games simply have several parts to a track: a main looping part, a transition part that can hide the join to another part, and so on. Each part can be transitioned to depending on what's happening during the game. This works for a lot of games. We can also break each part into layers – say, percussion, melody, and backing – and have different versions of each layer that can be switched between for varying levels of action. In a recent title I worked on, *Scrat's Nutty Adventure*, there's a skydiving game where you could fall at different speeds. I included music that would evolve based on a timeline 0 to 100. Various looping parts would fade in and out, and a bomb-dropping sound was introduced at the end. However fast you fell, the music would still seemingly play from start to end.

> **Good in-game audio puts the sound effects and ambience first and the music in the background**

What makes for good music and sound in games, then, and how has that evolved?

Since my early days working for Team 17, I have always believed that music should not be bigger than the game. We need to listen to game music for a long time and, let's face it, it's going to be turned off once it gets annoying! Good in-game audio puts the sound effects and ambience first and the music in the background and it is written so as not to be annoying in the long run. In the old days, we'd have a big melody as that was our only chance to impress, but today we try and back off from melody and let the music do its job to enhance the gameplay. For sound effects, we try to introduce as much random variation as possible. For instance, a footstep sound might be made of 50 or more individual samples that vary each time of playing.

For a spell in your career, you produced audio tracks which were distributed on the disks which came with some Amiga magazines. Can you tell me more about how they came about?

Martyn Brown, the project manager at Team 17 software, had some connections with Amiga Format magazine and asked me to create a piece of music for one of their cover disks. The September 1990 issue included my track composed on the *Game Music Creator* software. It was a variation on Bach's *Prelude in C* and Charles Gounod's *Ave Maria*. I then made my own new version based on both, including guitar and rock beats! I've had people ask for it to be played at their funeral; I'm not sure if that's good or not!

Brimble's Best

1. ALIEN BREED
(for Team 17 on the Commodore Amiga)

This music was a hybrid of 8-bit synth and Amiga sampled sounds, something rarely heard on the Amiga. I created several tiny but complex 64 byte looping wave forms, including choral sounds and applied 8-bit techniques such as ADSR, vibrato, tremolo, and echoes. This created a unique *Alien*-esque atmosphere, and also meant that 20 minutes of music fitted into 39kB of memory, which was some achievement at the time.

2. SUPER FROG
(for Team 17 on the Commodore Amiga)

I was inspired by the C64 classics by Rob Hubbard and was asked to create some cute and funny themes for this game. The opening title was like the *Superman* theme but with a frog croak added after the intro fanfare for laughs. The Amiga had four sound channels, so the music had to be carefully composed so that channel four could be overwritten by sound effects and the listener not notice anything dropping out.

3. ROLLERCOASTER TYCOON
(for Chris Sawyer on the PC)

Chris Sawyer's famous game was a lot of fun to compose for. Each ride in the theme park had its own themed piece of music to go along with the sound effects. This meant that as you panned around the map, different tunes would fade in and out, based on proximity the various rides. The music therefore never became boring and the ambience created really helped to bring the game alive.

4. ICE AGE: SCRAT'S NUTTY ADVENTURE
(for Just Add Water & Outright Games on PS4, Xbox One, Nintendo Switch)

This is my most recent title, and in this game I used techniques learnt over my whole career using some software called *FMOD Studio*, an audio interface that sits between the composer and the game. This allowed me to create adaptive music. The music for the skydiving part of the game evolves depending on how fast the player falls, and in the temple scene the music is randomly generated, sounding different each time. I also used additional layers for action so that when you fight enemies, the music becomes more intense.

CODE THE CLASSICS

5 The Amiga CD32 – consoles with CD drives enabled music to played from the disc

6 The Game Boy's tiny built-in speakers required careful treatment of sound and music

Image credit: Evan Amos

Of all of the games that you have made, which stand out musically for you and why?

I'm probably most pleased with the music from *Scrat's Nutty Adventure*, released in the autumn of 2019. It includes full interactive music and even some randomly generated music in the temple.

Roller Coaster Tycoon for PC was another I was pleased with. Each ride had its own music that would fade in as you got close. It meant you were not listening to one piece of music all the time – it would be constantly changing. The sounds of the roller-coasters were also lovely once the game engine starting pitching them up and down with the loops and ramps.

Which of your games would suffer most if the sound was turned off? And how much of a challenge is it to ensure that gamers would want that sound up loud?

I think all of them would suffer! But the games that suffer most are fighting games. With no punch and kick impacts, it feels like you are hitting with cotton wool, so I would have to say *Body Blows* by Team 17 on the Amiga, or *Dragon: The Bruce Lee Story* by Virgin Games on the SNES.

To keep the sound up loud, sound effects have to be the main consideration and music has to be rich and varied and fully adapt to the gameplay. Repetition means the music will be sure to be turned off.

Is the use of in-game audio heading in the right direction, would you say?

Yes, just recently we have seen music in console games improve considerably. This is due to freely available middleware such as *FMOD* or *Wwise*, which composers can utilise to create adaptive music with an easy-to-use graphical user interface. I find that coming from an 8-bit or 16-bit background is now a big advantage in utilising this software, as I learnt how to be

Image credit: Evan Amos

creative within limitations back then. Applying your own set of limitations is now the key to focus how you want things to sound.

And how have you adapted to working with so many formats over the years?
It started with a lot of limitations. Three notes at the same time, limited memory, and so on. Things slowly got better with the Amiga, and then the Super Nintendo where I could play eight sounds at once. It was a fairly easy transition up to there. We then got to the PlayStation and beyond. Now I needed a full music studio to create my music, but I was prepared as I'd already produced my first CD album in 1992, called *Sounds Digital*. In around 2000, I started to work more and more on handheld audio. This has now gone full circle back to the days of limitations, but it meant that I was one of the few remaining composers left with the old-school skills needed to fully utilise their audio capabilities. Today we are back to music produced in a studio but within the confines of adaptive music – a blend of old and new skills, and probably my favourite era so far.

What is the biggest difference between then and now?
It's strange. Things have come full circle. I used to be able to create 8-bit music on one computer. That changed dramatically when I needed a full studio for PlayStation music. These days, though, I'm back to one computer with all my instruments and sounds contained in one place.

If I had to pick one difference, it would be in the choices I now have at my fingertips. At any moment I can pull in any sound I need without having to worry about how I will make it. There are so many rich and varied instrument and sound libraries out there that you are almost spoilt for choice.